The Spirit of America

American Art
from 1829 to 1970

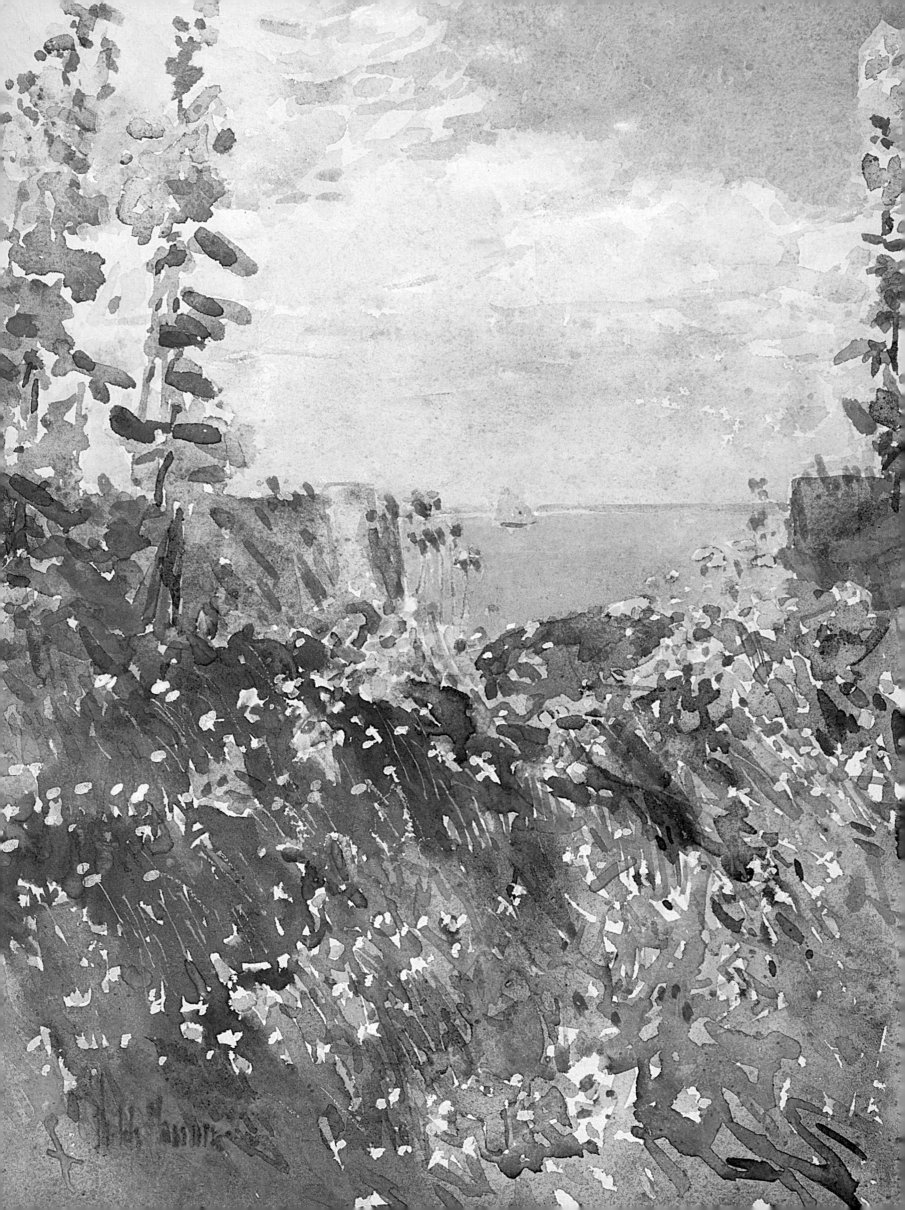

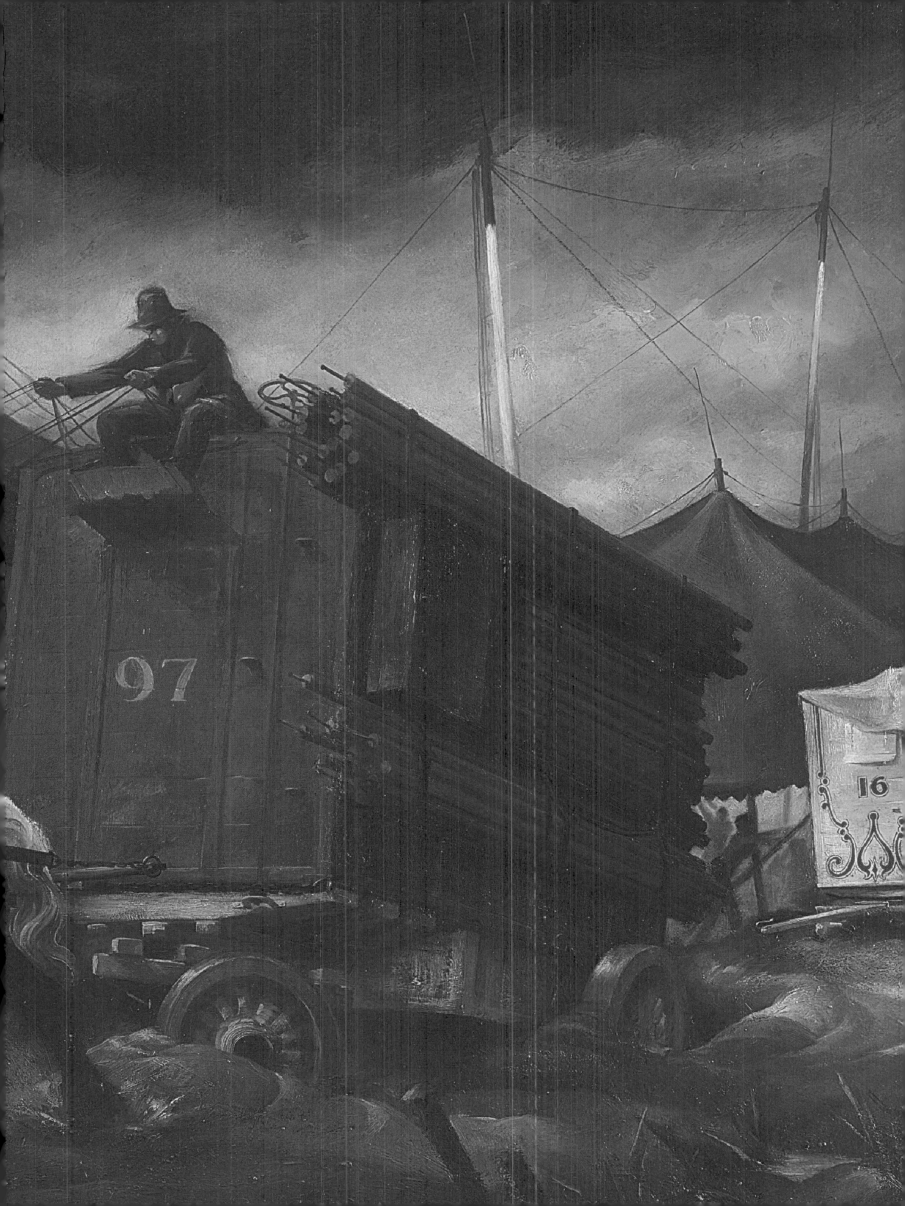

The Spirit of America

American Art from 1829 to 1970

November 1, 2002–February 15, 2003

Spanierman Gallery, LLC

www.spanierman.com

45 East 58th Street New York, NY 10022

Tel (212) 832-0208 Fax (212) 832-8114 susannelly@spanierman.com

COVER:
Philip Leslie Hale (1865–1931)
Niagara Falls (detail of cat. 50)

FRONT ENDLEAF:
Robert Edward Weaver (1914–1991)
Wagon "97" (detail of cat. 83)

FRONTISPIECE:
Childe Hassam (1859–1935)
Isles of Shoals Garden (detail of cat. 48)

BACK ENDLEAF:
Arthur Wesley Dow (1857–1922)
Goldenrod and Asters (detail of cat. 60)

Published in the United States of America in 2002 by
Spanierman Gallery, LLC, 45 East 58th Street, New York, NY 10022.

Library of Congress Control Number: 2002112758

ISBN 0-945936-52-4

Design: Marcus Ratliff
Composition: Amy Pyle
Photography: Roz Akin
Color imaging: Center Page
Lithography: Meridian Printing

Acknowledgments

W E ARE PROUD to present the catalogue of our current exhibition and sale, *The Spirit of America: American Art from 1829 to 1970*. This exhibition, consisting of ninety works, captures a dynamic period, when American art was the standard bearer for the spirit of the nation. Challenged by the dramatic changes in their homeland, artists led the country's cultural tide and expressed its changing ideals and intellectual currents. Using a multitude of styles and formats, they responded to the artistic movements of the day, while cultivating their individual modes of expression. Their work reveals the fascinating variety of our artistic tradition from the Jacksonian years through the last century's modern era.

I wish to thank all of the Spanierman Gallery staff for their superb efforts in producing this exhibition and catalogue. In particular I would like to mention Susan Nelly, the exhibition curator and catalogue coordinator, as well as Roz Akin, Bill Fiddler, Amy La Placa, Carol Lowrey, Erica Meyer, Lisa N. Peters, Deborah Spanierman, and Christina Vassallo. I am also grateful, as always, to Marcus Ratliff, our catalogue designer, and his associate Amy Pyle.

Ira Spanierman

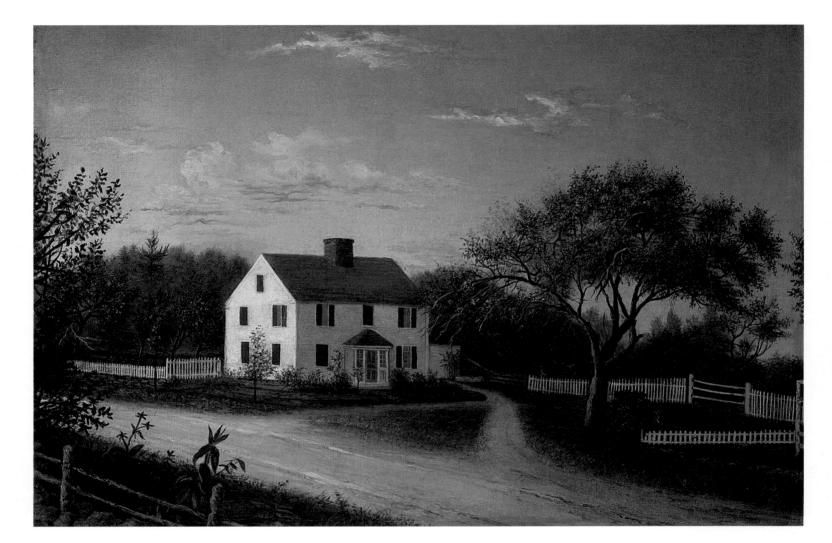

1. **Mary Blood Mellen** (1817–1882)
Blood Family Homestead, ca. 1859, oil on canvas, 13 × 20 inches

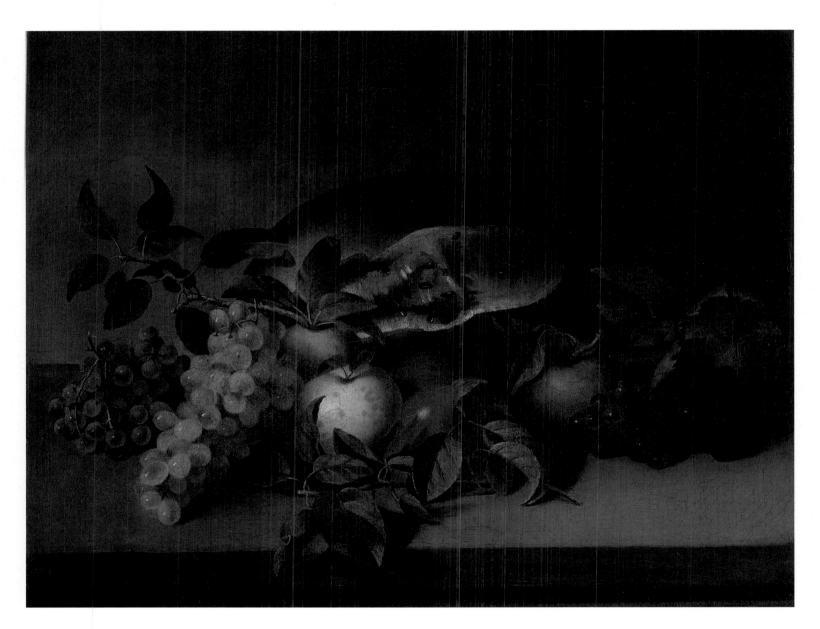

2. **James Peale** (1749–1831)
Still Life with Fruit, 1829, oil on canvas, 20 × 26½ inches
Inscribed on verso: *Property of M. A. Peale/Painted by James Peale/in the 8oth Year of his age/1829/Presented to [illeg.]/183*

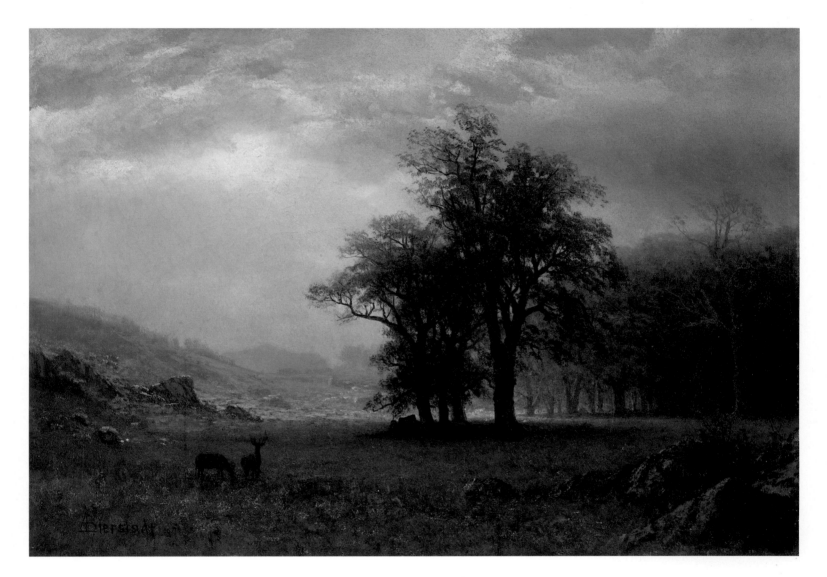

3. **Albert Bierstadt** (1830–1902)
The Open Glen, ca. late 1870s, oil on board, 14 × 19¾ inches
Signed with the artist's monogrammed signature lower left: *ABierstadt*

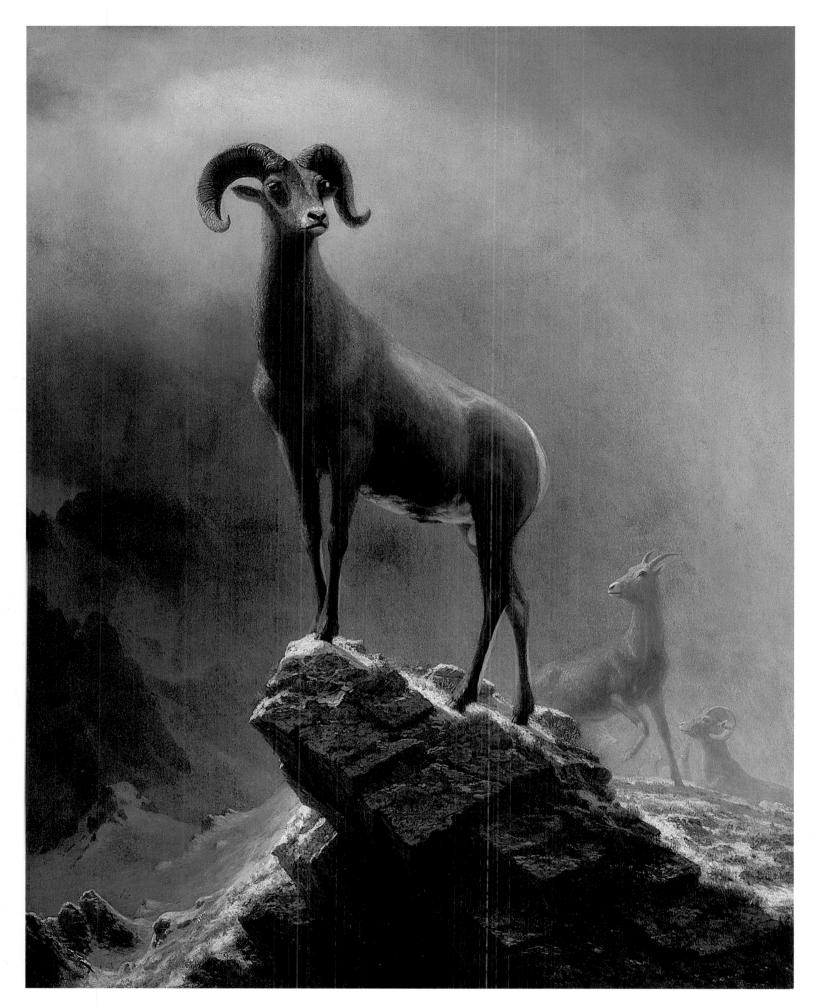

4. **Albert Bierstadt** (1830–1902)

Rocky Mountain Sheep, ca. 1882–83, oil on canvas, 48¼ × 38¼ inches

Signed with the artist's monogrammed signature lower right: *ABierstadt*.

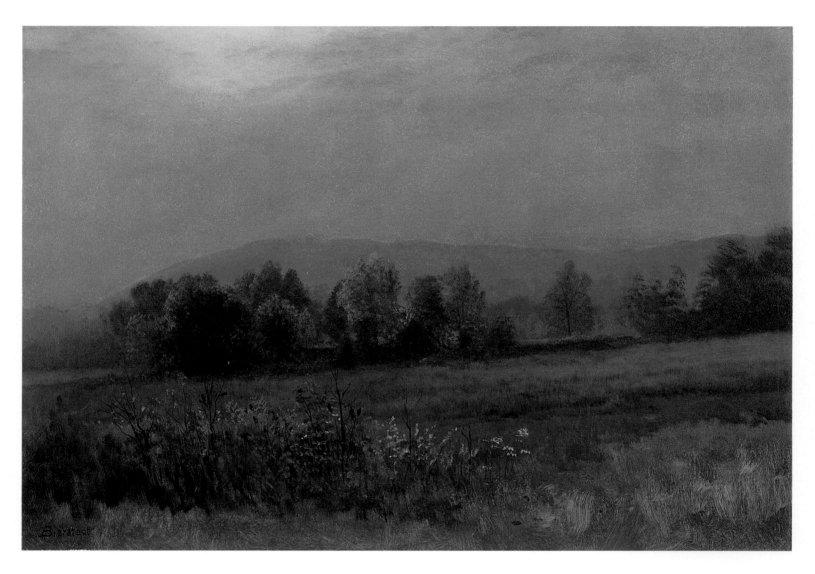

5. **Albert Bierstadt** (1830–1902)
New England Landscape, ca. 1880s, oil on board, 18¾ × 27 inches
Signed with the artist's monogrammed signature lower left: *ABierstadt*

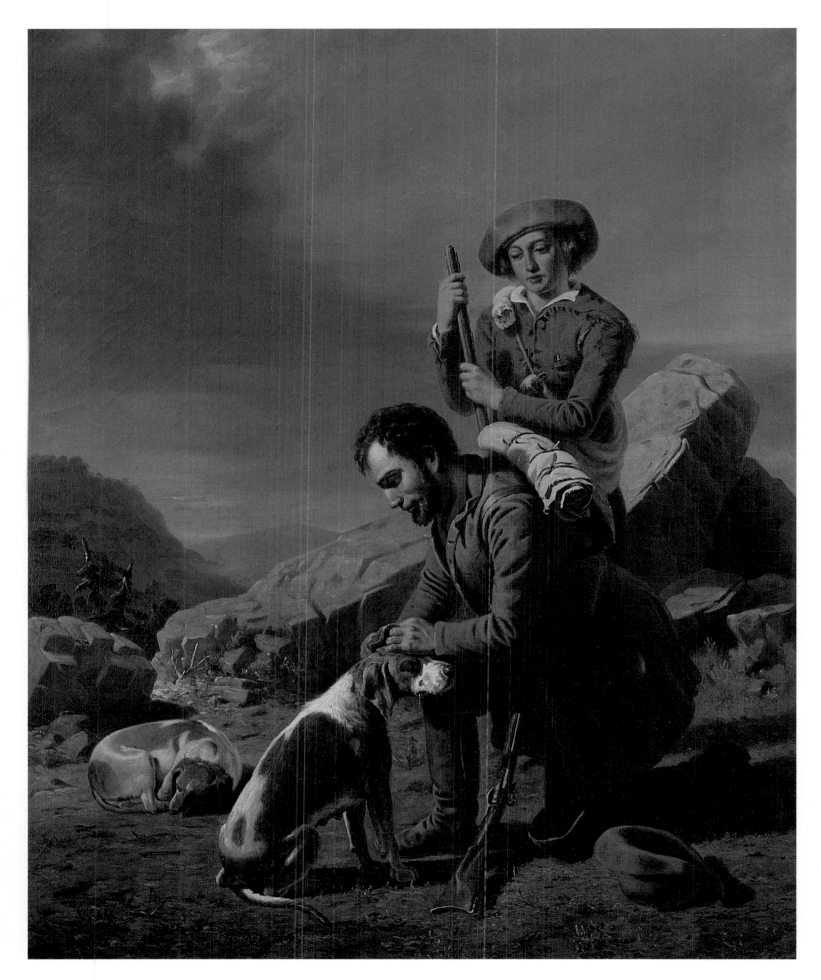

6. **William Tylee Ranney** (1813–1857)
The Wounded Hound, 1850, oil on canvas, **30** × 25 inches
Signed lower left: *W. Ranney*; signed and dated on verso: *W. Ranney / 1850*

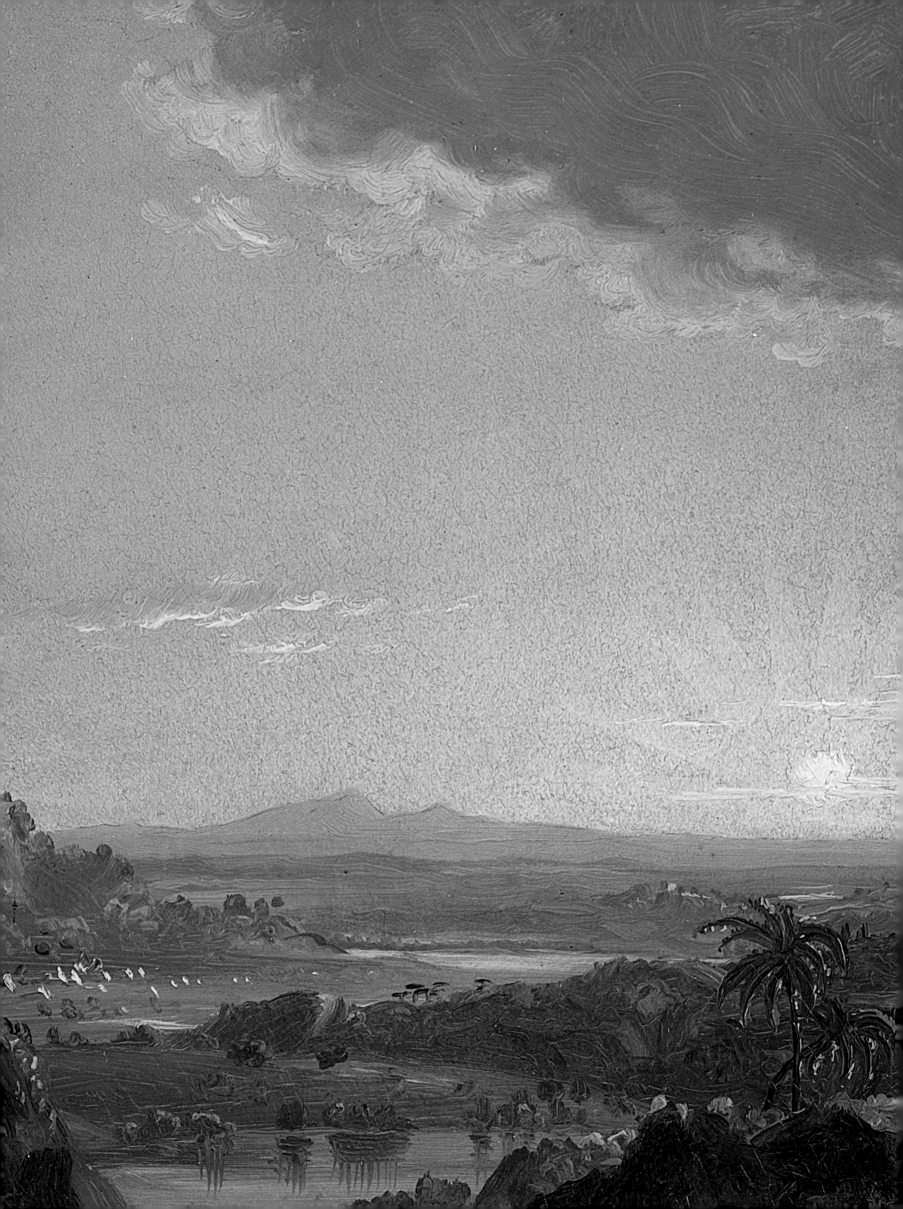

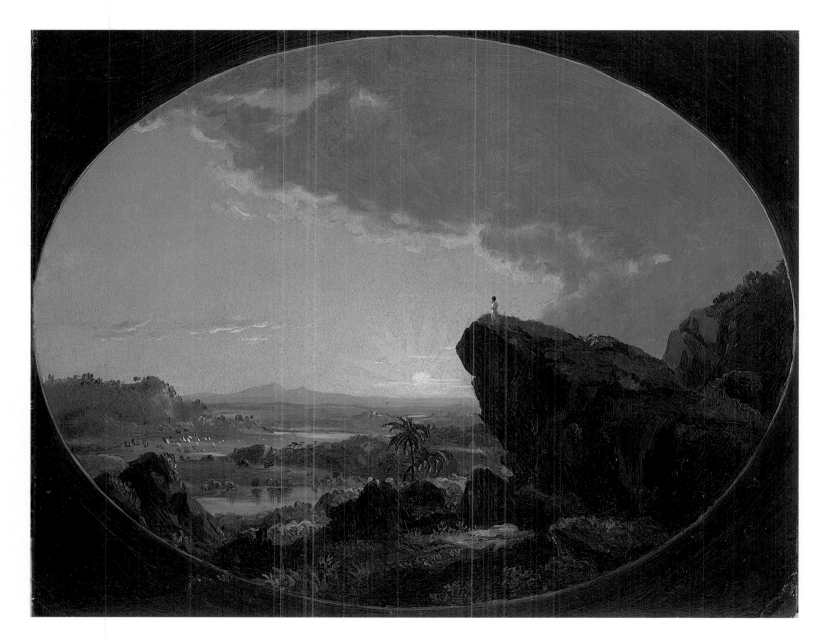

7. **Frederic Edwin Church** (1826–1900)
Moses Viewing the Promised Land, 1846, oil on board, 9⅝ × 12½ inches
Signed lower left: *F. Church*; dated lower right: *1846*

8. **Thomas Moran** (1837–1926)
Childe Roland to the Dark Tower Came, 1859, oil on canvas, 29¼ × 44 inches
Signed and dated lower right: *T. Moran / 1859.*

9. **Jasper Francis Cropsey** (1823–1900)
Fisherman's House, Greenwood Lake, 1877, oil on canvas, 12 × 20 inches
Signed and dated lower right: *J. F. Cropsey 1877*

10. **Martin Johnson Heade** (1819–1904)
Marsh Sunset, ca. 1860–61, oil on canvas, 10⅛ × 22¼ inches
Signed lower right: *M. J. Heade*

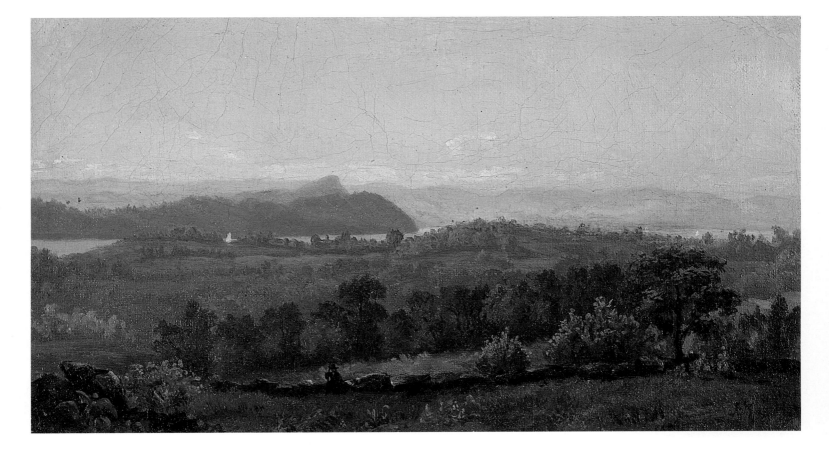

11. **John F. Kensett** (1816–1872)
Hudson River Looking towards Haverstraw, ca. 1850s, oil on canvas, 5 × 9 inches
Signed lower right with monogrammed initials: *JFK*

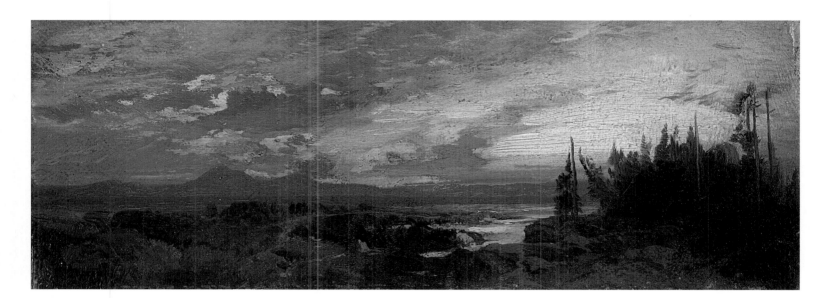

12. **Thomas Moran** (1837–1926)
Sunset on the Great Salt Lake, Utah, 1877, oil on board, 3 × 8 inches
Dated and inscribed on verso: *"Sunset on the Great Salt Lake, Utah." / painted by / Thos. Moran / 1877*

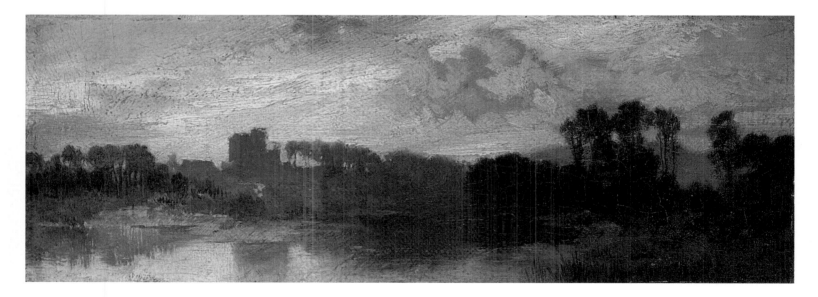

13. **Thomas Moran** (1837–1926)
Environs of Salt Lake, Utah, 1877, oil on board, 3 × 8 inches
Dated and inscribed on verso: *"On Barnard's towers are purple still ! To Those who gaze from Taller Hill." /*
Rokeby – Walter Scott ! painted by Thos. Moran – 1877

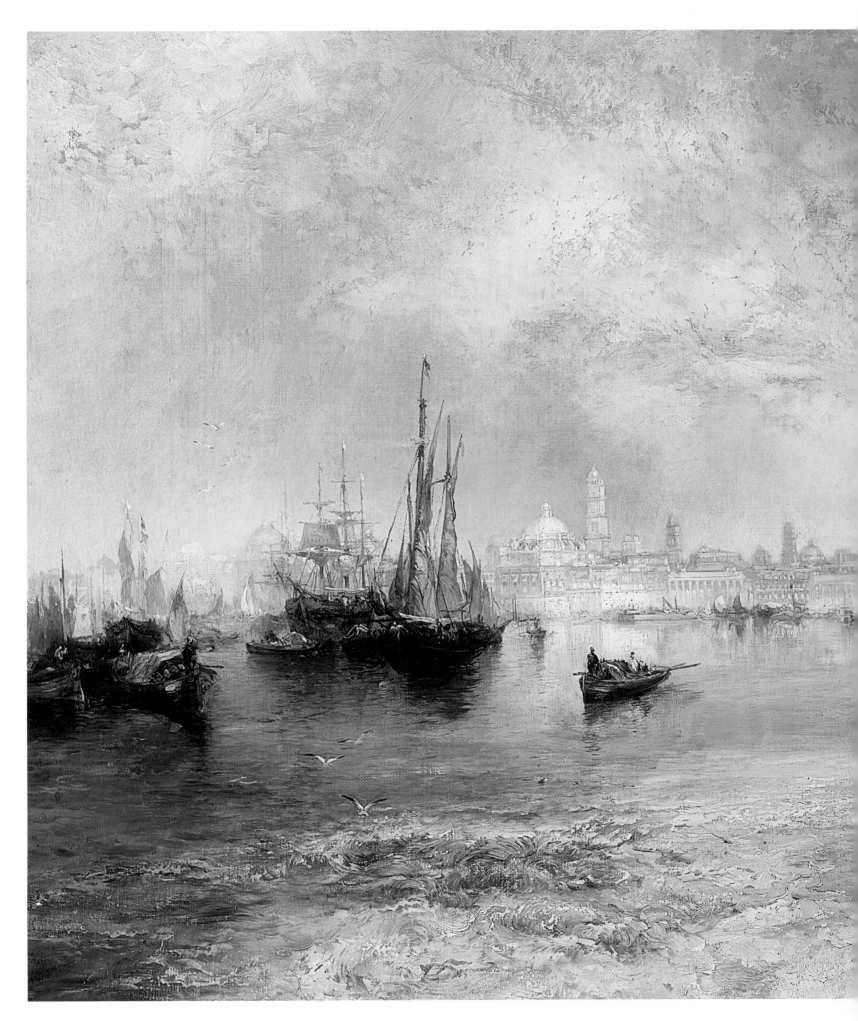

14. **Thomas Moran** (1837–1926)
Harbor at Vera Cruz, Mexico, 1883, oil on canvas, 20⅛ × 30⅛ inches
Signed with the artist's monogrammed signature and dated lower right: *TMoran 1883*

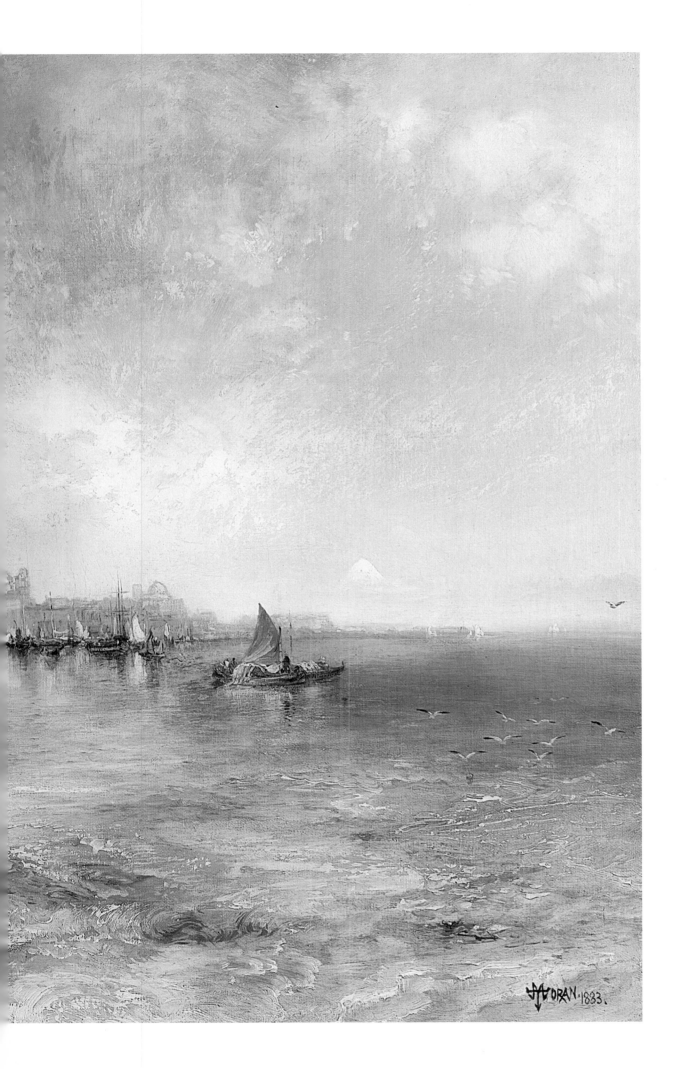

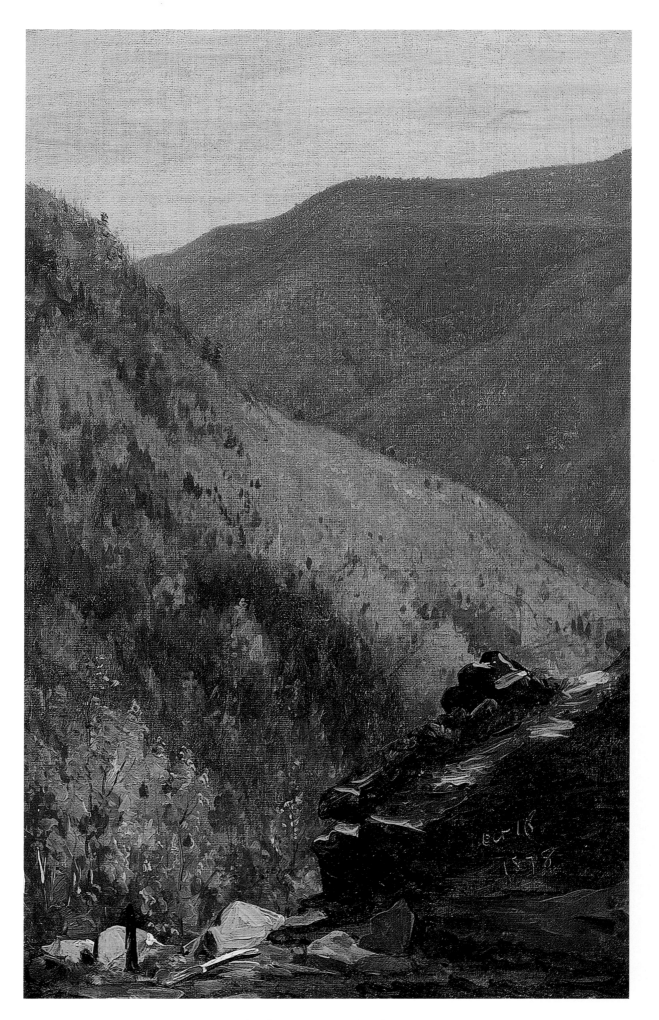

15. **Sanford Robinson Gifford** (1823–1880)
View near Kauterskill Clove, 1878, oil on canvas, 15 × 9½ inches
Dated lower right: *Oct. 18 / 1878*

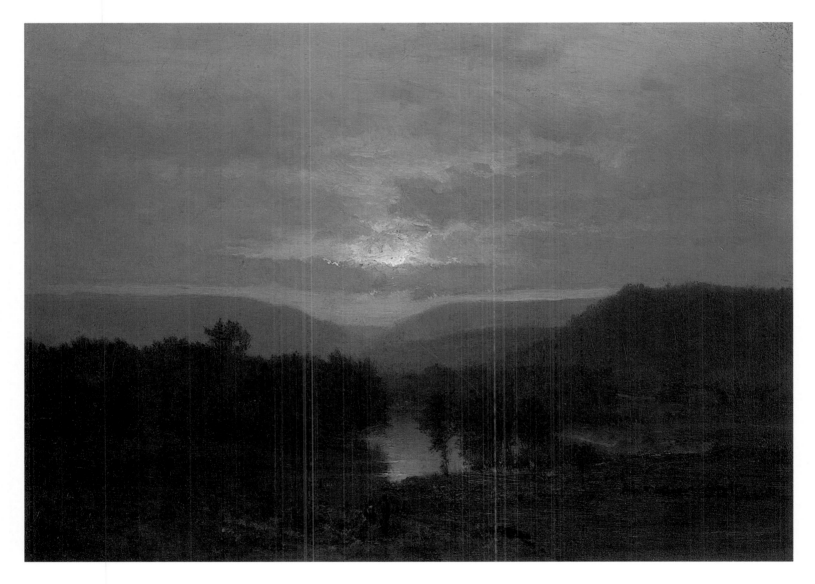

16. **George Inness** (1825–1894)
Sunset, ca. 1860–65, oil on board, 10¼ × 14½ inches
Signed lower left: *G. Inness*

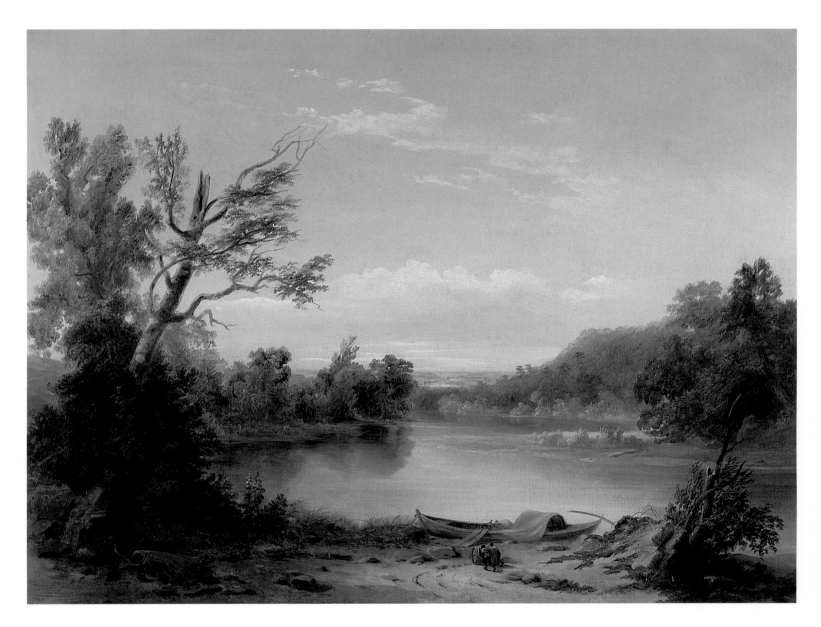

17. **John La Farge** (1835–1910)
On the Bayou Teche, Louisiana, ca. 1860, oil on canvas, 28½ × 38¾ inches
Signed lower right: *John La Farge*

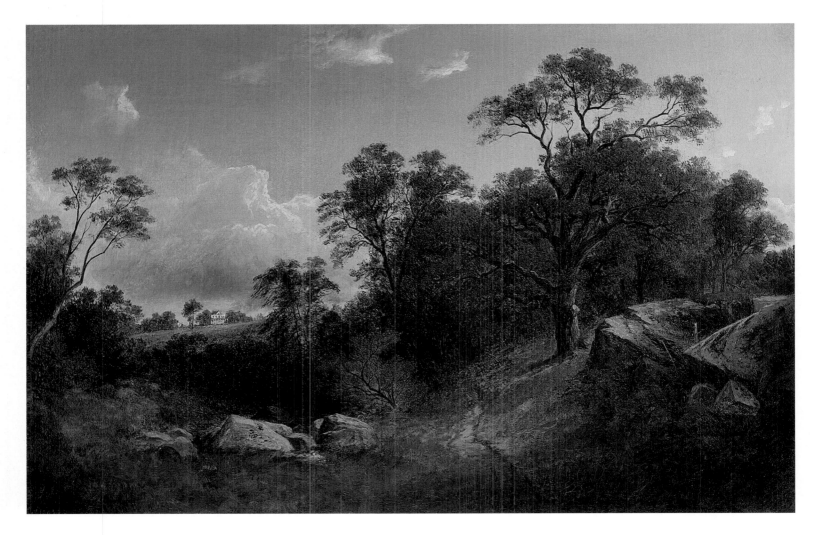

18. **David Johnson** (1827–1908)
Landscape (White Mansion in the Distance), 1863, oil on canvas, 18 × 28 inches
Signed with the artist's initials and dated lower left: *D. J. / 1863*

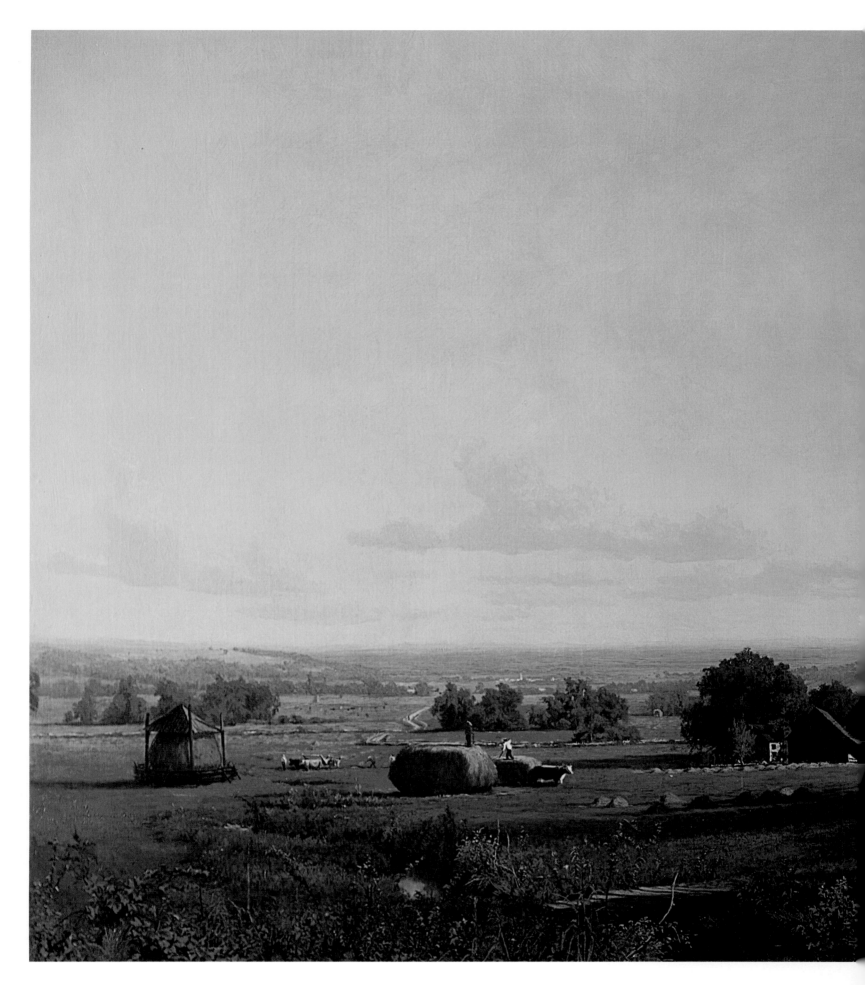

19. **Hugh Bolton Jones** (1848–1927)
Adams County, Pennsylvania, 1870, oil on canvas, 30 × 54 inches
Signed and dated lower right: *H. Bolton Jones / 1870*

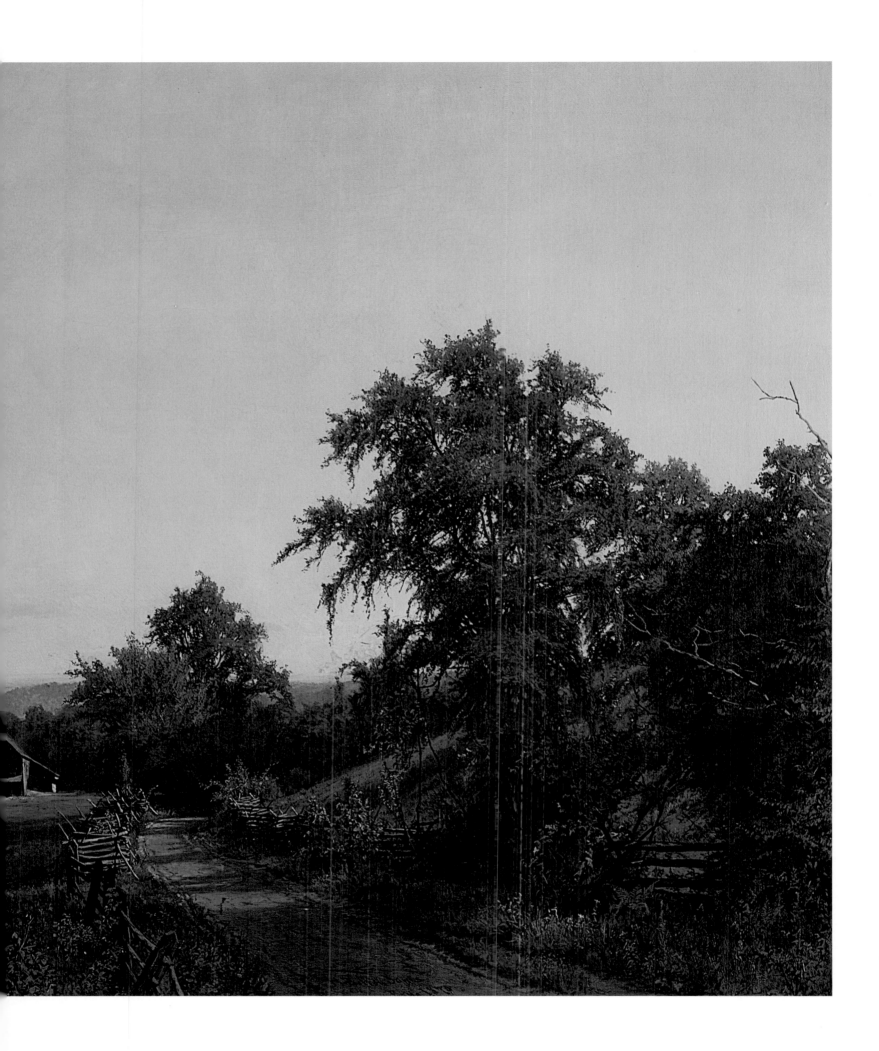

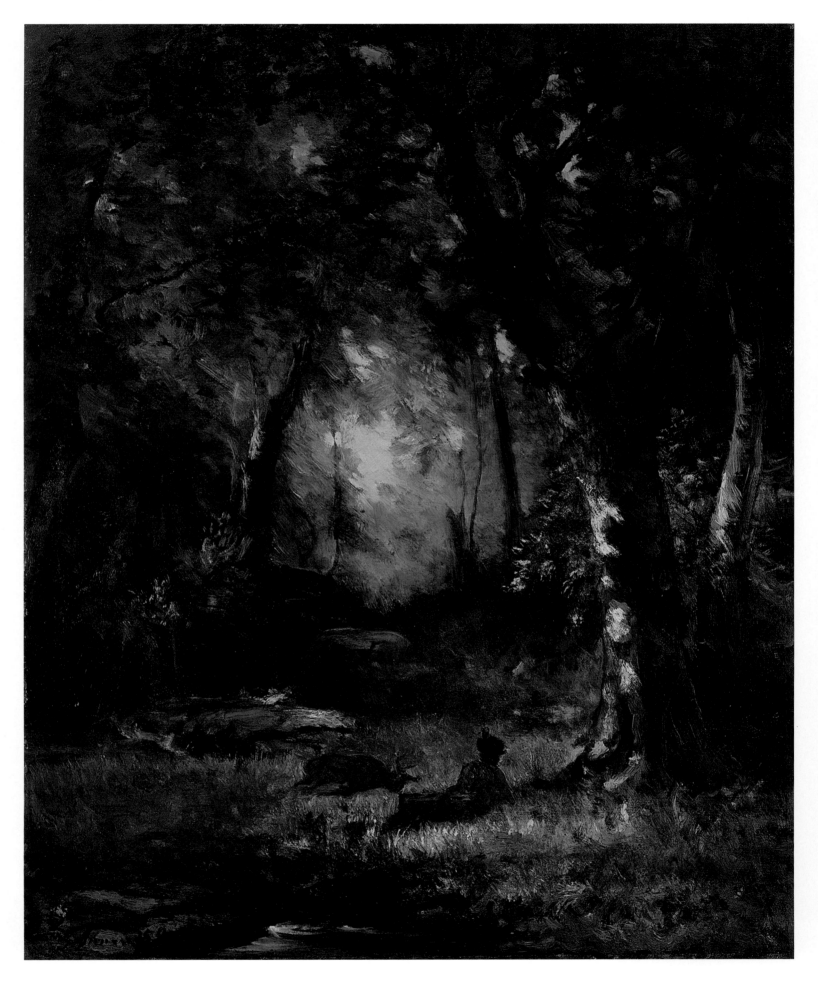

20. **George Inness** (1825–1894)
The Huntsman, 1859, oil on canvas, 30 × 25 inches
Signed and dated lower left: *G. Inness 59*

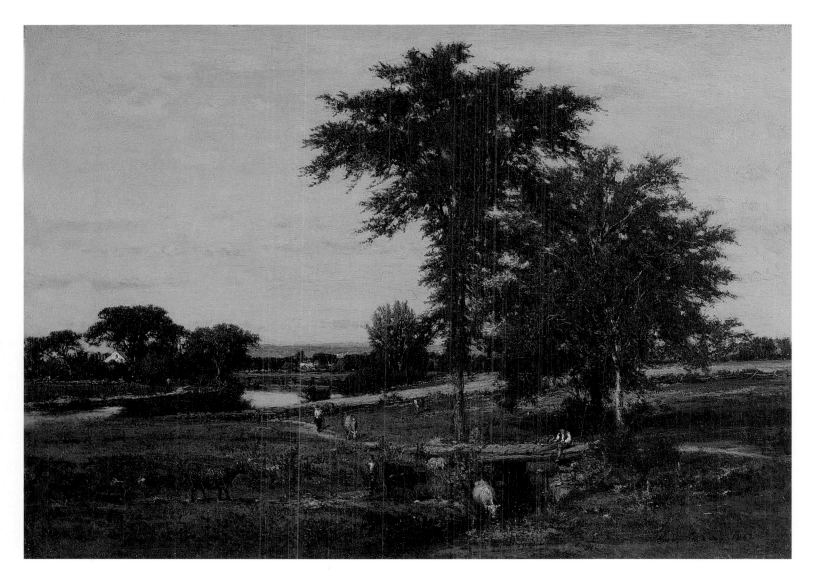

21. **George Inness** (1825–1894)
Midsummer, 1862, oil on canvas, 14 × 20 inches
Signed and dated lower left: *G. Inness—1862*

Spanierman Gallery, LLC

45 East 58th Street New York, NY 10022-1617
Telephone (212) 832-0208 Fax (212) 832-8114
E-mail info@spanierman.com
www.spanierman.com

The Spirit of America:
American Art from 1829 to 1970

November 1, 2002–February 15, 2003

All works can be viewed at the gallery and online at

www.spanierman.com

George Bellows (1882–1925)
Head of a Boy (Gray Boy), ca. 1905
Oil on canvas, 26¼ × 20½ inches
Signed lower left: *Geo. Bellows.*
PRICE ON REQUEST

Frank W. Benson (1862–1951)
Portrait of Mary Sullivan, 1902
Oil on canvas, 84 × 54 inches
Signed and dated lower left:
F. W. Benson. 1902
PRICE ON REQUEST

Albert Bierstadt (1830–1902)
New England Landscape, ca. 1880s
Oil on board, 18¾ × 27 inches
Signed with the artist's monogrammed
signature lower left: *ABierstadt*
$450,000

The Open Glen, ca. late 1870s
Oil on board, 14 × 19¾ inches
Signed with the artist's monogrammed
signature lower left: *ABierstadt*
PRICE ON REQUEST

Rocky Mountain Sheep, ca. 1882–83
Oil on canvas, 48¼ × 38¼ inches
Signed with the artist's monogrammed
signature lower right: *ABierstadt.*
PRICE ON REQUEST

Abraham J. Bogdanove (1886–1946)
Eric's Hunting Ground—
The Golden Dory, Monehan Harbor,
Maine, ca. 1920s–30s
Oil on canvasboard, 20 × 24 inches
Signed lower right: *A. J. Bogdanove*
$40,000

Boston School
Woman Reading, ca. 1890s–1910s
Oil on canvas, 28 × 36 inches
$125,000

George L
Effect near
Along the A
Oil on canva
Signed, date
G. L. Brown R
PRICE ON REQ

Emil Carlsen (185
A Clearing beyond
Oil on canvas, 50 ×
Signed and dated lo
Emil Carlsen. 1928.
PRICE ON REQUEST

William Merritt Chase (
Reflections, Holland, 1883
Pastel on paper, 24 × 30 i
Signed lower left: *Wm. M.*
PRICE ON REQUEST

ca. 1895
s
hase

73)

Interior, ca. 1880s
vas, 29 × 36 inches
gned and inscribed lower right:
M. Colin / Paris
PRICE ON REQUEST

[The following text appears on a tilted invitation card overlaying the price list:]

The Spirit of America:
American Art from 1829 to 1970
A Benefit Reception and Private Viewing of the Exhibition for
Guild Hall of East Hampton
Thursday, November 7, 2002 from 6 to 8 pm
Spanierman Gallery, LLC
45 East 58th Street, New York, NY 10022
Tickets are $50 each, but we urge our friends
to contribute as generously as possible.

_____ ticket(s)
for _____

Enclosed is my check for $ _____
☐ I cannot attend but enclosed is a contribution of $ _____
Please make checks payable to the Guild Hall of East Hampton.

Name _____
Address _____
City/State/Zip _____
Telephone (day) _____
Telephone (evening) _____

Contributions are wholly tax-deductible to the extent allowed by the law.
10% of any sales made that evening will be donated to Guild Hall by the
Spanierman Gallery.

For further information, please contact Susan Nelly at
susannelly@spanierman.com. If you plan to attend, please respond by
telephone, (212) 832-0208. Donations will also be accepted at the door.

(continued on page 2)

Paul Cornoyer (1864–1923)
Studio Garden, East Gloucester, ca. 1900
Oil on canvas, 18½ × 24 inches
Signed lower left: *Paul Cornoyer*
$150,000

Francis Hyman Criss (1901–1973)
Still Life, 1930
Oil on canvas, 20¼ × 24½ inches
Signed and dated lower left: *Criss 30*
$60,000

Jasper Francis Cropsey (1823–1900)
Fisherman's House,
Greenwood Lake, 1877
Oil on canvas, 12 × 20 inches
Signed and dated lower right:
J. F. Cropsey 1877
PRICE ON REQUEST

Arthur Bowen Davies (1862–1928)
Builders of the Temple, ca. 1890s
Oil on canvas, 26½ × 40 inches
Signed lower left: *A. B. Davies*
$75,000

Dawson Dawson-Watson (1864–1939)
Setting Sun, ca. 1910s
Oil on canvas, 23½ × 28½ inches
Signed lower right: *Dawson-Watson*
$75,000

Willem de Kooning (1904–1997)
Abstraction, ca. mid-1970s, oil on paper
mounted on canvas, 29½ × 18¾ inches
Signed lower right: *de Kooning*;
dedicated bottom left: *too Francis / love*
Lisa and Bill
$100,000

Untitled (Figures), ca. early 1970s
Charcoal on paper, 18½ × 23½ inches
Signed lower right: *de Kooning*;
dedicated lower right: *to Francis /*
love Bill
$80,000

Xmas to Frances
ca. late 1960s – early 1970s
Mixed media on paper mounted on
canvas, 42 × 29½ inches
Signed and dedicated lower right:
Xmas to Frances / Bill de Kooning
PRICE ON REQUEST

Paul de Longpré (1855–1911)
Pansy Waltz, 1896
Watercolor on paper, 9½ × 35 inches
Signed and dated lower left:
Paul de Longpré 1896.
$75,000

Raoul de Longpré (b. 1843)
Roses on a Marble Tabletop, ca. 1890s
Gouache on paper, 21 × 28½ inches
Signed lower right: *Raoul M. de*
Longpré, fils
$45,000

Thomas W. Dewing (1851–1938)
Lady in a Lavender Dress, ca. 1910
Pastel on paper, 10¼ × 6½ inches
Signed and numbered lower right:
T. W. Dewing / 7
$135,000

Arthur Wesley Dow (1857–1922)
Flood Tide, Ipswich Marshes,
Massachusetts, ca. 1900
Oil on canvas, 18 × 32 inches
Signed lower left: *Arthur W. Dow*
PRICE ON REQUEST

Goldenrod and Asters, ca. 1910s
Oil on canvasboard, 14 × 20 inches
Signed lower right: *Arthur W. Dow*
PRICE ON REQUEST

Victor Dubreuil (active 1880–1910)
Grover Cleveland, ca. 1890s
Oil on canvas, 12 × 10 inches
Signed lower left: *V. Dubreuil*
$45,000

Charles Warren Eaton (1857–1937)
The Shawangunk Valley, ca. 1900
Oil on canvas, 30 × 36¼ inches
Signed lower left: *Chas Warren Eaton*
$75,000

William Forsyth (1854–1935)
The Sunset Hour, 1932
Oil on canvas, 32 × 24 inches
Signed and dated lower right:
W. Forsyth 32
PRICE ON REQUEST

Alexis Jean Fournier (1865–1948)
Autumn Gold, 1907
Oil on canvas, 19¾ × 23½ inches
Signed and dated lower right:
Alex Fournier 1907
$58,000

Sears Gallagher (1869–1955)
Fish Beach, Monhegan Island,
Maine, ca. 1910s–30s
Watercolor on paper, 14 × 20 inches
Signed lower left: *Sears Gallagher*
SOLD

Samuel Lancaster Gerry (1813–1891)
Calm Pond, ca. 1860s
Oil on canvas, 20¼ × 27 inches
Signed lower right: *S L Gerry*
$45,000

Sanford Robinson Gifford (1823–1880)
View near Kauterskill Clove, 1878
Oil on canvas, 15 × 9½ inches
Dated lower right: *Oct. 18 / 1878*
$150,000

Emile A. Gruppe (1896–1978)
View from Portugee, Gloucester,
Massachusetts, ca. 1920s
Oil on canvas, 24 × 36 inches
Signed lower right: *Emile A. Gruppe*
$35,000

Edwin H. Gunn (1876–1940)
Highbridge, The Harlem River, ca. 1907
Oil on canvas, 25 × 30 inches
Signed lower right: *Edwin Gunn.*
$85,000

Philip Leslie Hale (1865–1931)
Niagara Falls, ca. 1902
Oil on canvas, 35 × 41¼ inches
PRICE ON REQUEST

Childe Hassam (1859–1935)
Bridge in a Landscape—Mill Dam,
Old Lyme, Connecticut, 1903
Oil on canvas, 30 × 34 inches
Signed and dated lower right:
Childe Hassam 1903
PRICE ON REQUEST

Isles of Shoals Garden, ca. 1895
Watercolor on paper, 10 × 7¾ inches
Signed lower left: *Childe Hassam*
PRICE ON REQUEST

Rue Montmartre, Paris, ca. 1888
Oil on canvas, 18 × 15 inches
Signed lower right: *Childe Hassam.*
PRICE ON REQUEST

Martin Johnson Heade (1819–1904)
Marsh Sunset, ca. 1860–61
Oil on canvas, 10⅛ × 22¼ inches
Signed lower right: *M. J. Heade*
PRICE ON REQUEST

George Inness (1825–1894)
Hudson Valley, 1875
Oil on canvas, 20¼ × 30½ inches
Signed and dated lower left:
G. Inness 1875
PRICE ON REQUEST

(continued on page 3)

The Huntsman, 1859
Oil on canvas, 30 × 25 inches
Signed and dated lower left: *G. Inness 59*
$150,000

Midsummer, 1862
Oil on canvas, 14 × 20 inches
Signed and dated lower left:
G. Inness—1862
$200,000

*An Old Roadway (Montclair,
New Jersey—Landscape)*, ca. 1880
Oil on canvas, 48 × 72 inches
Signed lower right: *G. Inness*
PRICE ON REQUEST

Sunset, ca. 1860–65
Oil on board, 10¼ × 14½ inches
Signed lower left: *G. Inness*
$175,000

David Johnson (1827–1908)
*Landscape (White Mansion in the
Distance)*, 1863
Oil on canvas, 18 × 28 inches
Signed with the artist's initials and
dated lower left: *D. J. / 1863*
$135,000

Hugh Bolton Jones (1848–1927)
Adams County, Pennsylvania, 1870
Oil on canvas, 30 × 54 inches
Signed and dated lower right:
H. Bolton Jones / 1870
$150,000

John F. Kensett (1816–1872)
*Hudson River Looking towards
Haverstraw*, ca. 1850s
Oil on canvas, 5 × 9 inches
Signed lower right with monogrammed
initials: *JFK*
PRICE ON REQUEST

Rockwell Kent (1882–1971)
Ancient Elm, ca. 1961–62
Oil on canvas, 38 × 44 inches
Signed lower right: *Rockwell Kent*
$140,000

Daniel Ridgway Knight (1839–1924)
Stopping for Conversation, ca. 1880s
Oil on canvas, 26 × 32 inches
Signed and inscribed lower right:
Ridgway Knight / Paris
PRICE ON REQUEST

John La Farge (1835–1910)
On the Bayou Teche, Louisiana, ca. 1860
Oil on canvas, 28½ × 38¾ inches
Signed lower right: *John La Farge*
PRICE ON REQUEST

William Langson Lathrop (1859–1938)
Forest Glade, ca. 1938
Oil on board, 24 × 29 inches
Signed lower right: *Lathrop*
$70,000

Winter Marshes, ca. 1920
Oil on canvas, 22 × 25 inches
Signed lower right: *W. Lathrop*
$30,000

Jonas Lie (1880–1940)
Brittany Fisher Boats, ca. 1931
Oil on canvas, 15 × 23½ inches
Signed lower left: *Jonas Lie*
$40,000

Dodge MacKnight (1860–1950)
*Shoreline View, No. 1
(Grand Manan Island)*, ca. 1890s
Watercolor on paper, 15½ × 22½ inches
Signed lower right: *Dodge MacKnight*
$32,000

Fletcher Martin (1904–1979)
Lullaby, ca. 1942
Oil on masonite, 31 × 48 inches
Signed lower right: *Fletcher Martin*
PRICE ON REQUEST

Mary Blood Mellen (1817–1882)
Blood Family Homestead, ca. 1859
Oil on canvas, 13 × 20 inches
$45,000

Willard L. Metcalf (1858–1925)
Venice, 1887
Oil on panel, 11⅜ × 6¼ inches
Signed lower left: *W. L. Metcalf*
$75,000

Louis Charles Moeller (1855–1930)
"Sign Here," ca. 1890s
Oil on canvas, 30 × 40 inches
Signed lower right: *Louis Moeller N.A.*
$75,000

Thomas Moran (1837–1926)
*Childe Roland to the Dark Tower
Came*, 1859
Oil on canvas, 29¼ × 44 inches
Signed and dated lower right:
T. Moran / 1859.
PRICE ON REQUEST

Environs of Salt Lake, Utah, 1877
Oil on board, 3 × 8 inches
Dated and inscribed on verso:
*"On Barnard's towers are purple still /
To Those who gaze from Taller Hill." /
Rokeby – Walter Scott / painted by
Thos. Moran – 1877*
$110,000

Harbor at Vera Cruz, Mexico, 1883
Oil on canvas, 20⅛ × 30⅛ inches
Signed with the artist's monogrammed
signature and dated lower right:
TMoran 1883
PRICE ON REQUEST

Sunset on the Great Salt Lake, Utah, 1877
Oil on board, 3 × 8 inches
Dated and inscribed on verso:
*"Sunset on the Great Salt Lake, Utah." /
painted by / Thos. Moran / 1877*
$110,000

John Francis Murphy (1853–1921)
Autumnal Landscape, 1898
Oil on canvas, 12 × 16 inches
Signed and dated lower left:
J. Francis Murphy. '98
$45,000

Robert Emmett Owen (1878–1957)
Farmhouse in Winter, ca. 1910s–30s
Oil on canvas, 26 × 36½ inches
Signed lower right: *R. Emmett Owen*
$34,000

James Peale (1749–1831)
Still Life with Fruit, 1829
Oil on canvas, 20 × 26½ inches
Inscribed on verso: *Property of M. A. Peale /
Painted by James Peale / in the 80th Year
of his age / 1829 / Presented to [illeg.] / 183*
PRICE ON REQUEST

Alexander Pope (1849–1924)
In Charge, ca. 1890s
Oil on canvas, 26⅛ × 36⅛ inches
Signed and titled upper center:
In Charge painted by Alexander Pope
PRICE ON REQUEST

Edward Henry Potthast (1857–1927)
Bathers by a Rocky Coast, ca. 1915
Oil on canvas mounted on board
8 × 10 inches
Signed lower right: *E. Potthast*
$55,000

(continued on page 4)

Bathers in the Surf, ca. 1910s–20s
Oil on board, 12 × 15¾ inches
Signed lower left: *E. Potthast*
$175,000

Levi Wells Prentice (1851–1935)
Basket of Apples, ca. 1890
Oil on canvas, 12 × 16 inches
Signed lower right: *L. W. Prentice*
$65,000

Hovsep Pushman (1877–1966)
Serenade to Silence, ca. 1930s
Oil on board mounted on canvas
25½ × 27½ inches
Signed lower right: *Pushman*
$150,000

William Tylee Ranney (1813–1857)
The Wounded Hound, 1850
Oil on canvas, 30 × 25 inches
Signed lower left: *W. Ranney*; signed
and dated on verso: *W. Ranney / 1850*
SOLD

Joseph Raphael (1869–1950)
By the Stream, Papekasteel, ca. 1915
Oil on canvas, 22 × 27⅛ inches
Signed lower right: *Jos Raphael*
$150,000

Theodore Robinson (1852–1896)
Saint Martin's (Summer), Giverny, 1888
Oil on canvas, 18 × 22 inches
Signed and dated lower left:
Th. Robinson / 1888
PRICE ON REQUEST

Severin Roesen (ca. 1815–ca. 1872)
Still Life, ca. 1860–65
Oil on canvas, 30 × 25 inches
Signed lower right: *Roesen.*
PRICE ON REQUEST

Albert Pinkham Ryder (1847–1917)
Old Mill by Moonlight, ca. 1885
Oil on canvas, 8⅛ × 11¼ inches
PRICE ON REQUEST

Chauncey F. Ryder (1868–1949)
Chestnut Hill, ca. 1910s
Oil on canvas, 22 × 28 inches
Signed lower left: *Chauncey F. Ryder*
$75,000

William Starkweather (1879–1969)
Cliff at Grand Manan, Canada, 1934
Oil on canvas, 24 × 28 inches
Signed lower right: *William [illeg.]
Starkweather*; signed, dated, and
inscribed on verso: *Cliff at Grand
Manan Island. N.B. Canada / Painted
1934 by William Starkweather*
$25,000

Annie Gooding Sykes (1855–1931)
Art Museum, Cincinnati, ca. 1918
and *Wash Day*, ca. 1910s:
a double-sided watercolor
Watercolor on paper, 22¼ × 17⅛ inches
Signed recto lower right: *AG Sykes*
$26,000

Dwight William Tryon (1849–1925)
End of Day, ca. 1890s
Oil on canvas, 32 × 48 inches
Signed lower left: *D. W. Tryon*
PRICE ON REQUEST

John H. Twachtman (1853–1902)
November Haze, ca. 1890s
Oil on canvas, 25 × 30 inches
Estate stamped lower left:
Twachtman Sale
PRICE ON REQUEST

John H. Twachtman (1853–1902)
Tulip Tree, Greenwich, ca. 1890s
Oil on canvas, 43¼ × 30¼ inches
PRICE ON REQUEST

Robert Edward Weaver (1914–1991)
Wagon "97," 1937
Oil on masonite, 31 × 48 inches
Signed and dated lower left:
R. E. Weaver / 1937
$175,000

John Whorf (1903–1959)
Fisherman, ca. 1930s
Watercolor and gouache on paper,
21⅝ × 26 inches
Signed lower right: *John Whorf*
SOLD

Guy Carleton Wiggins (1883–1962)
Manhattan Winter, 1934
Oil on canvas, 20 × 16 inches
Signed lower left: *Guy Wiggins.*;
signed, dated, and titled on verso:
Manhattan Winter / Guy Wiggins / 1934
$140,000

22. **George Inness** (1825–1894)
An Old Roadway (Montclair, New Jersey—Landscape), ca. 1880, oil on canvas, 48 × 72 inches
Signed lower right: *G. Inness*

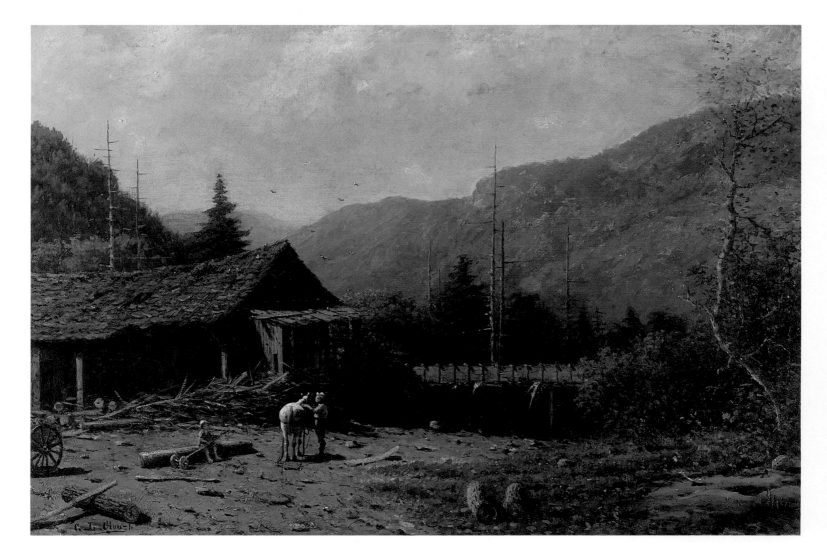

23. **George Lafayette Clough** (1824–1901)
The Saw Mill, Adirondacks, ca. 1860s, oil on canvas, 24 × 36 inches
Signed lower left: *G. L. Clough*

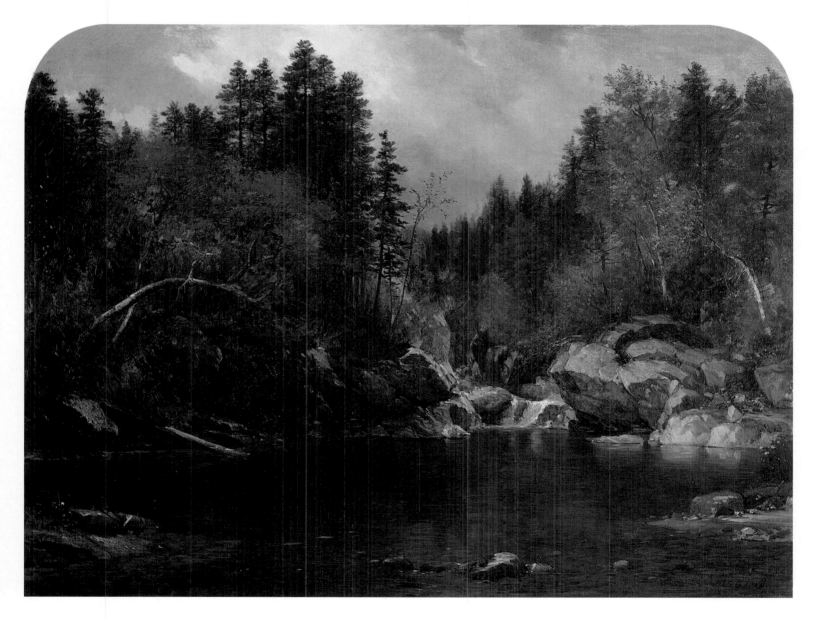

24. **Samuel Lancaster Gerry** (1813–1891)
Calm Pond, ca. 1860s, oil on canvas, 20¼ × 27 inches
Signed lower right: *S L Gerry*

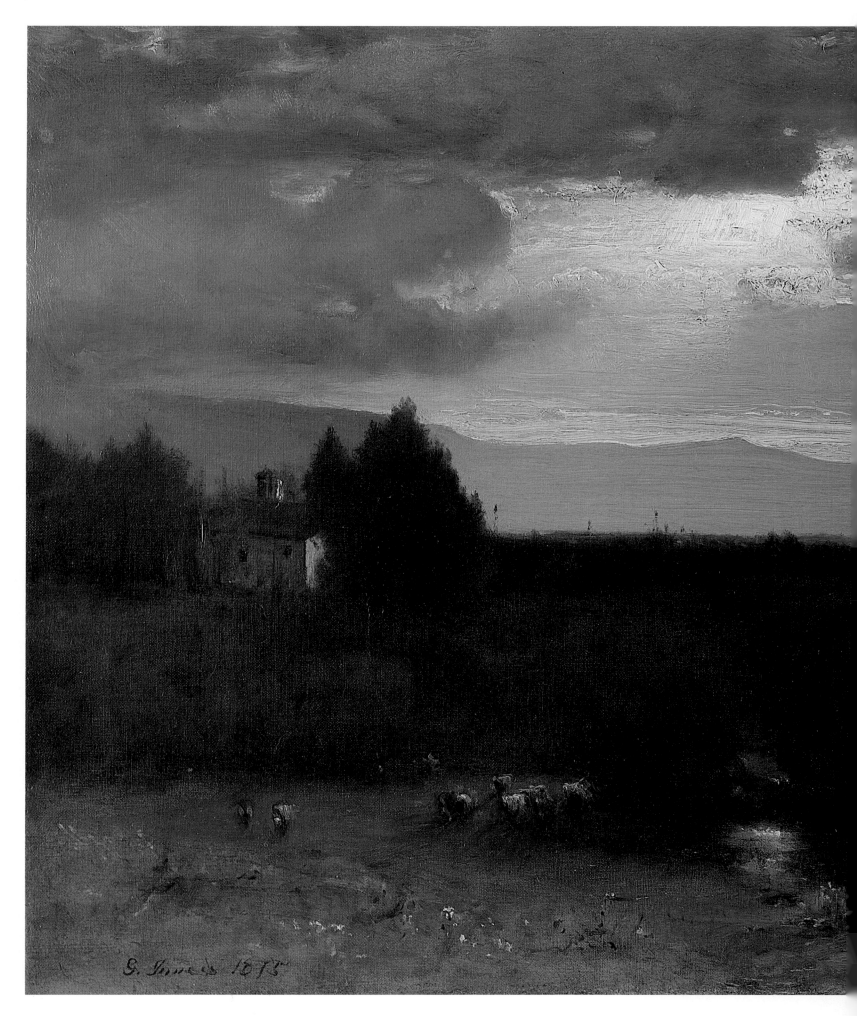

25. **George Inness** (1825–1894)
Hudson Valley, 1875, oil on canvas, 20¼ × 30½ inches
Signed and dated lower left: *G. Inness 1875*

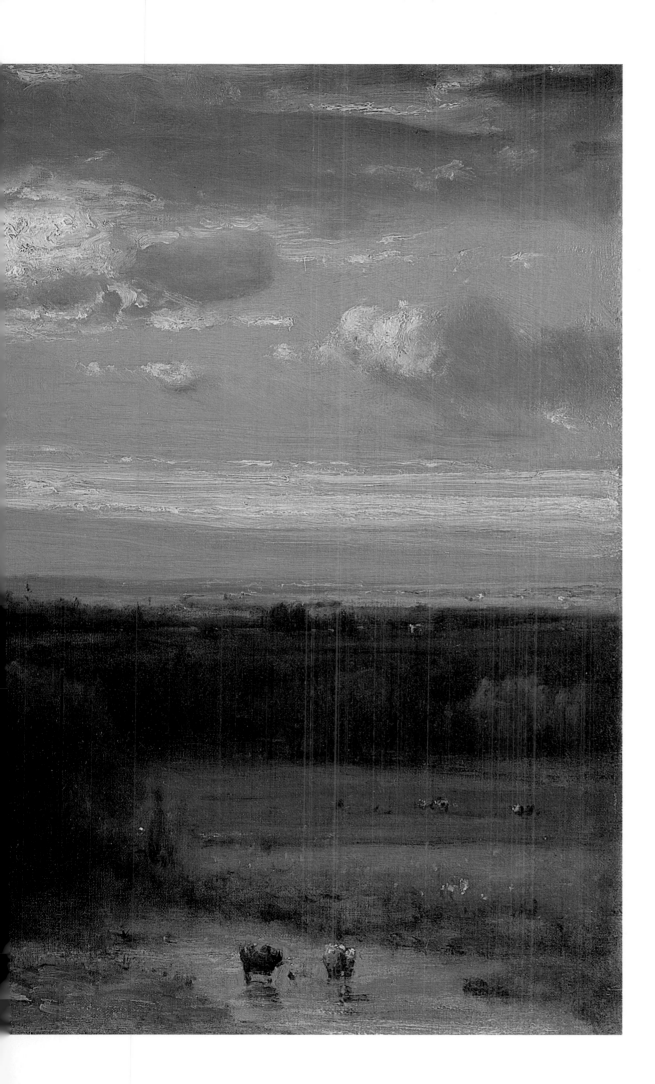

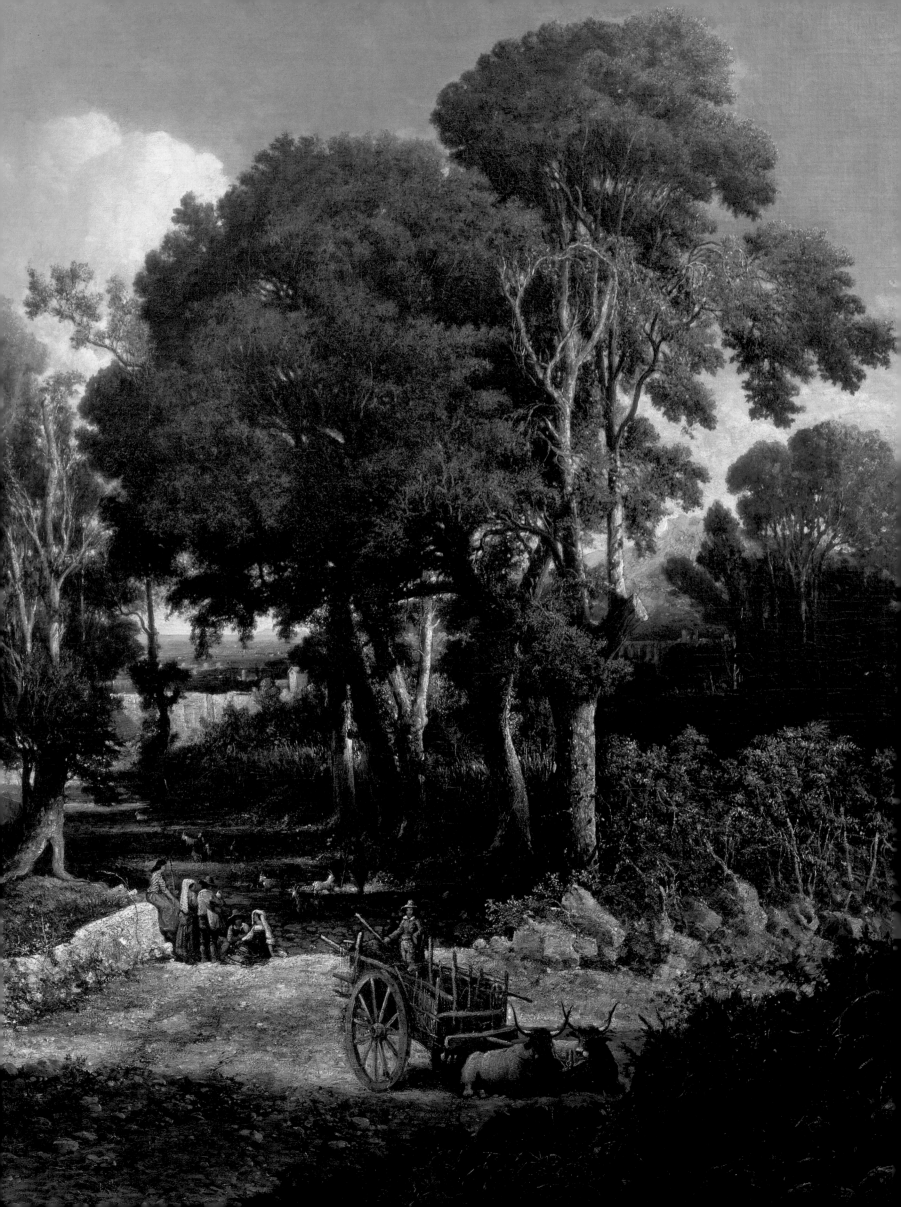

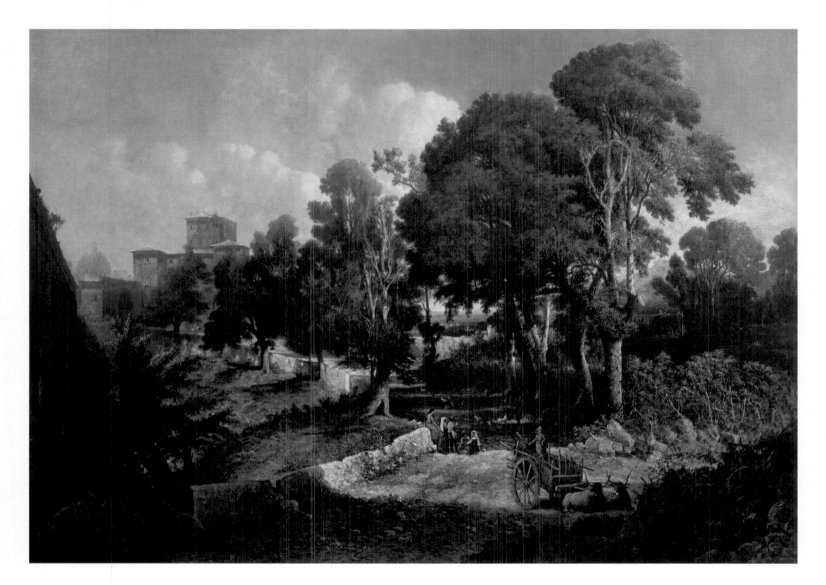

26. **George Loring Brown** (1814–1889)
Effect near Noon—Along the Appian Way, 1858, oil on canvas, 68½ × 95 inches
Signed, dated, and inscribed lower left: *G. L. Brown Rome 1858*

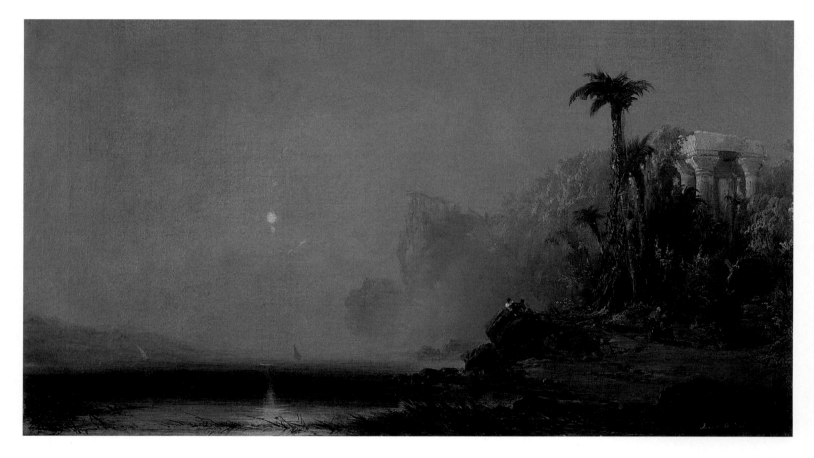

27. **Franklin D. Briscoe** (1844–1903)
Greek Ruins, 1870, oil on canvas, 15 × 27 inches
Signed lower right: *Frank D Briscoe*;
signed, dated, and inscribed on verso: *Greece / Painted for Mr. Samuel Grubo / Wilmington Del / 1870 / F. D. Briscoe*

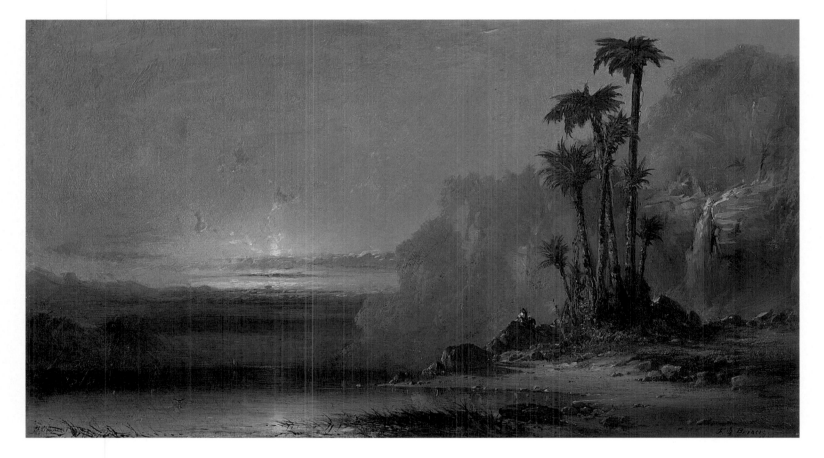

28. **Franklin D. Briscoe** (1844–1903)
Palms at Sundown, 1870, oil on canvas, 14¾ × 27 inches
Signed and dated lower right: *F. D. Briscoe 1870*;
signed lower left: *F. D. Briscoe*

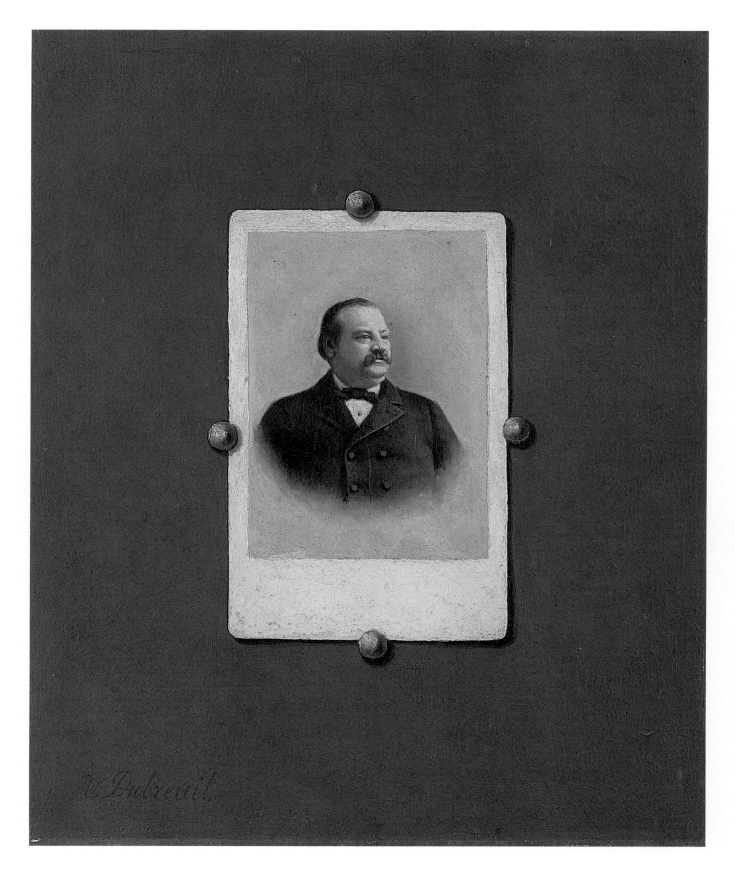

29. **Victor Dubreuil** (active 1880–1910)
Grover Cleveland, ca. 1890s, oil on canvas, 12 × 10 inches
Signed lower left: *V. Dubreuil*

30. **Alexander Pope** (1849–1924)
In Charge, ca. 1890s, oil on canvas, 26⅛ × 36⅛ inches
Signed and titled upper center: *In Charge painted by Alexander Pope*

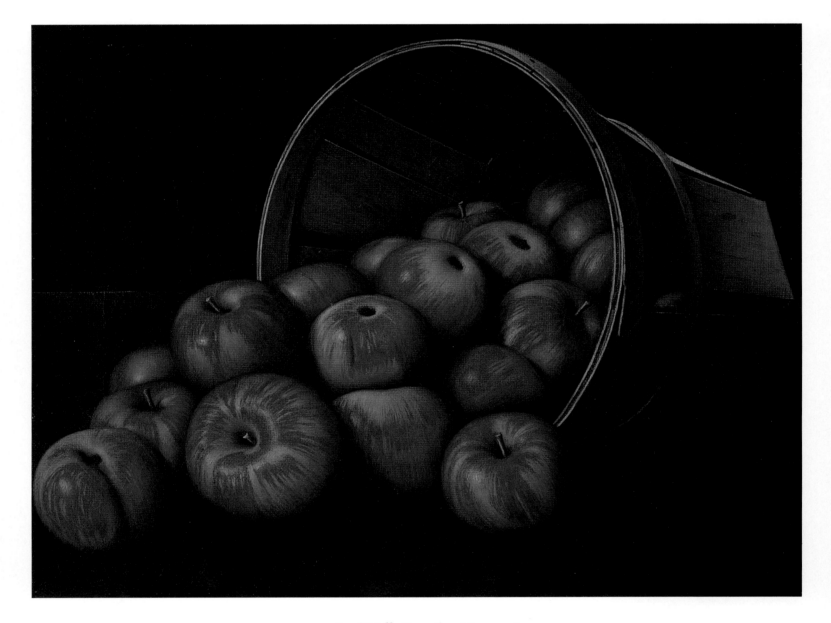

31. Levi Wells Prentice (1851–1935)
Basket of Apples, ca. 1890, oil on canvas, 12 × 16 inches
Signed lower right: *L. W. Prentice*

32. **Severin Roesen** (ca. 1815–ca. 1872)
Still Life, ca. 1860–65, oil on canvas, 30 × 25 inches
Signed lower right: *Roesen.*

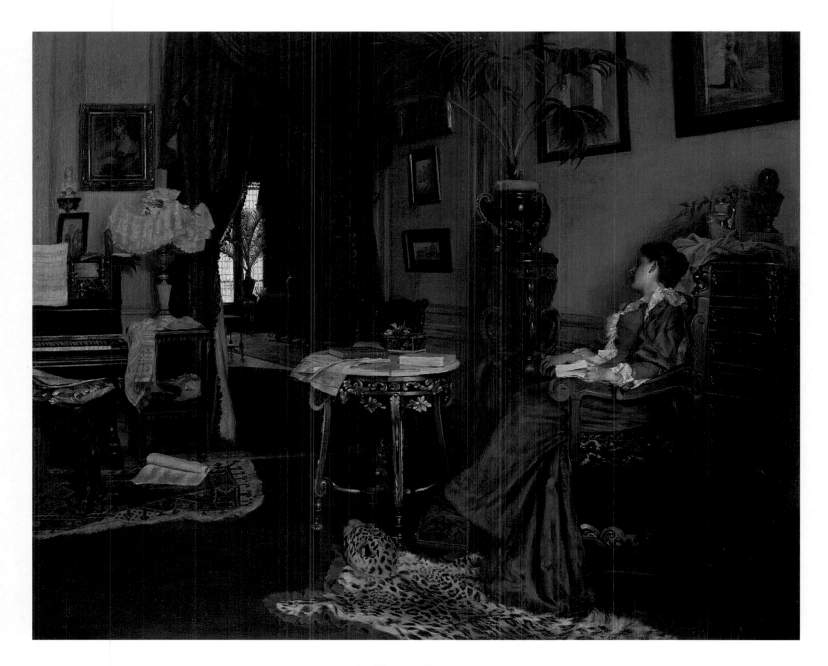

33. **Maximilien Colin** (1862–ca. 1893)
Woman Seated in an Interior, ca. 1880s, oil on canvas, 29 × 35 inches
Signed and inscribed lower right: *M. Colin / Paris*

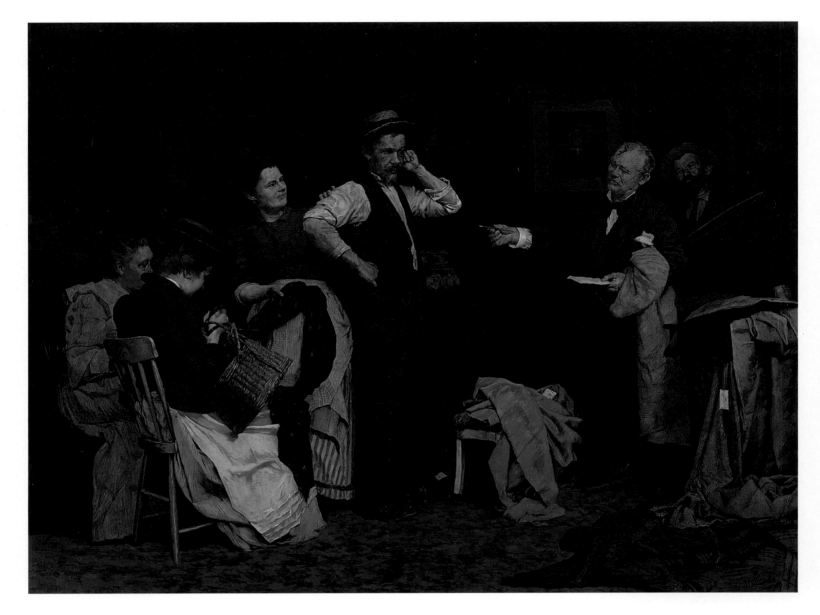

34. **Louis Charles Moeller** (1855–1930)
"Sign Here," ca. 1890s, oil on canvas, 30 × 40 inches
Signed lower right: *Louis Moeller N.A.*

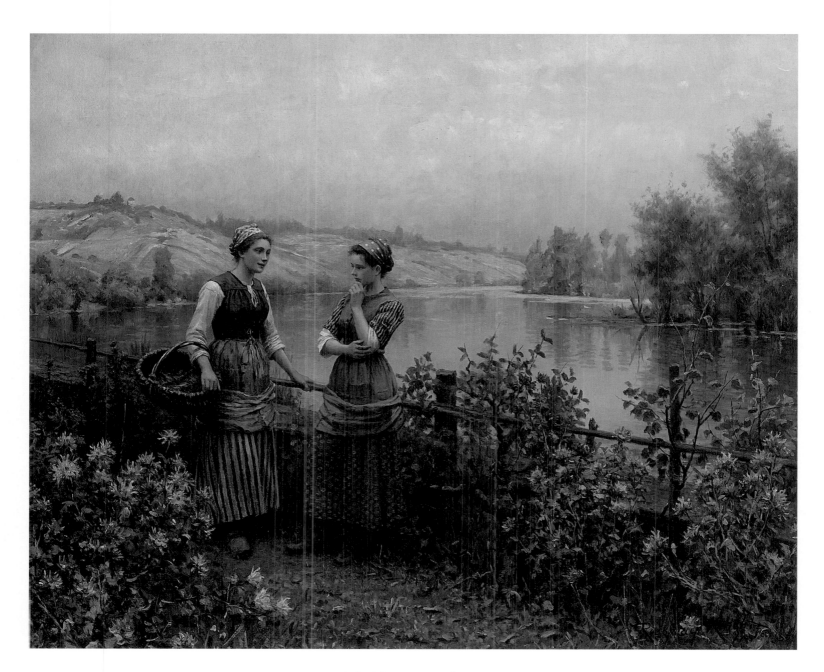

35. **Daniel Ridgway Knight** (1839–1924)
Stopping for Conversation, ca. 1880s, oil on canvas, 26 × 32 inches
Signed and inscribed lower right: *Ridgway Knight / Paris*

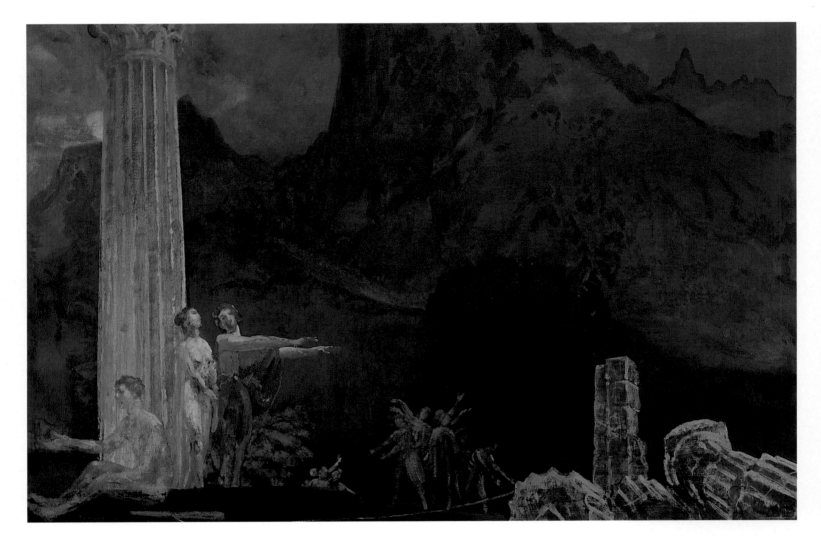

36. **Arthur Bowen Davies** (1862–1928)
Builders of the Temple, ca. 1890s, oil on canvas, 26½ × 40 inches
Signed lower left: *A. B. Davies*

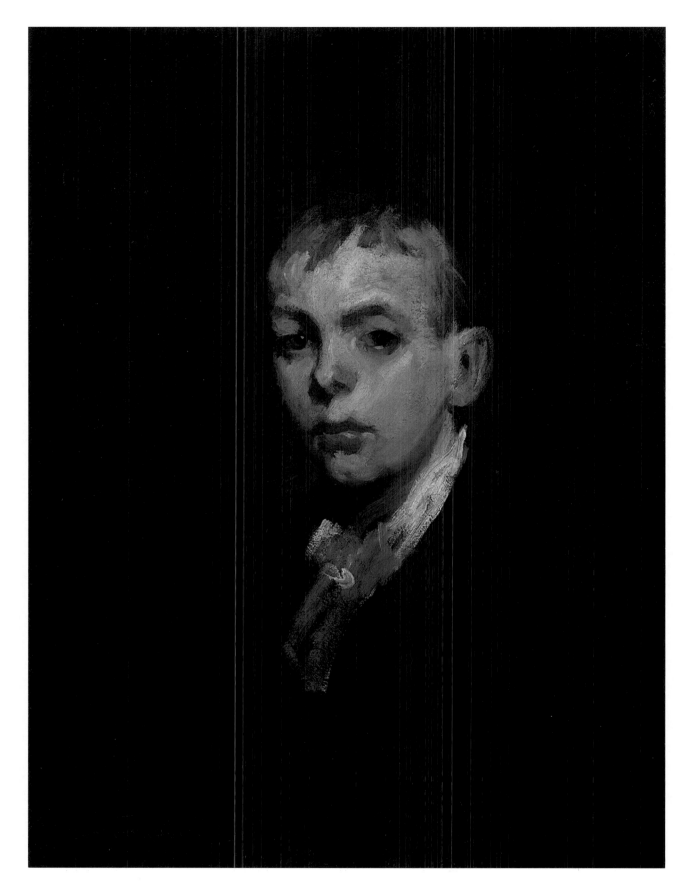

37. **George Bellows** (1882–1925)
Head of a Boy (Gray Boy), ca. 1905, oil on canvas, 26¼ × 20½ inches
Signed lower left: *Geo. Bellows.*

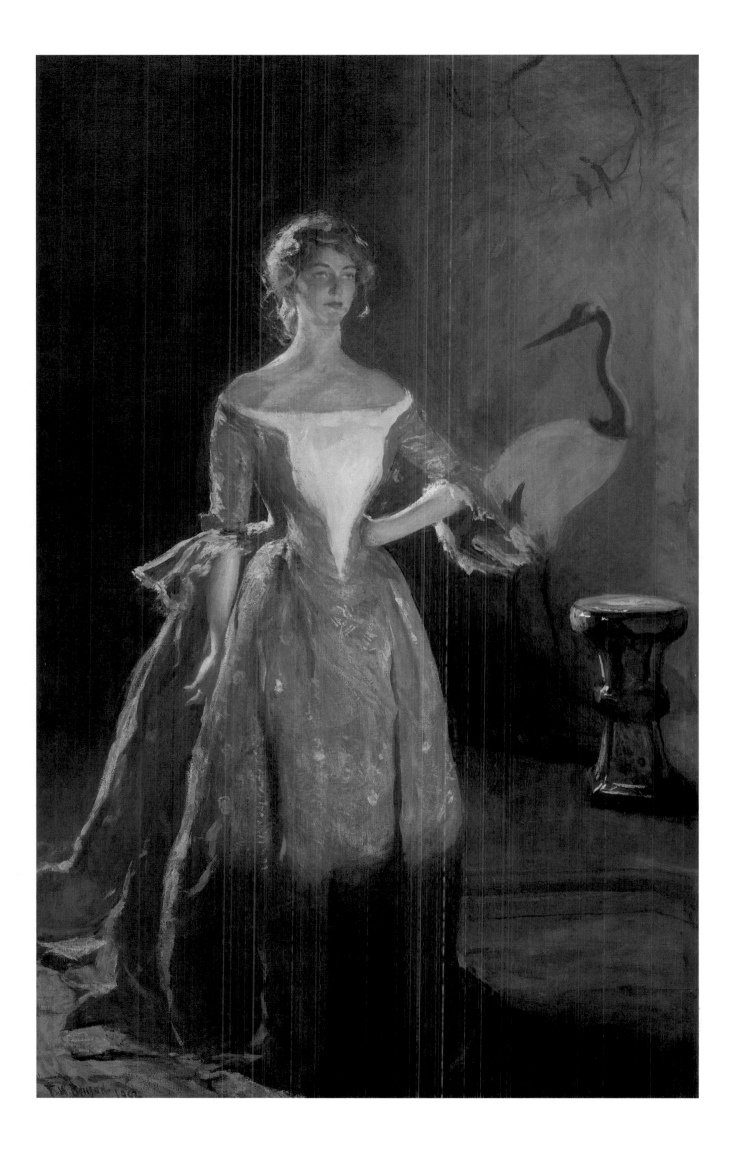

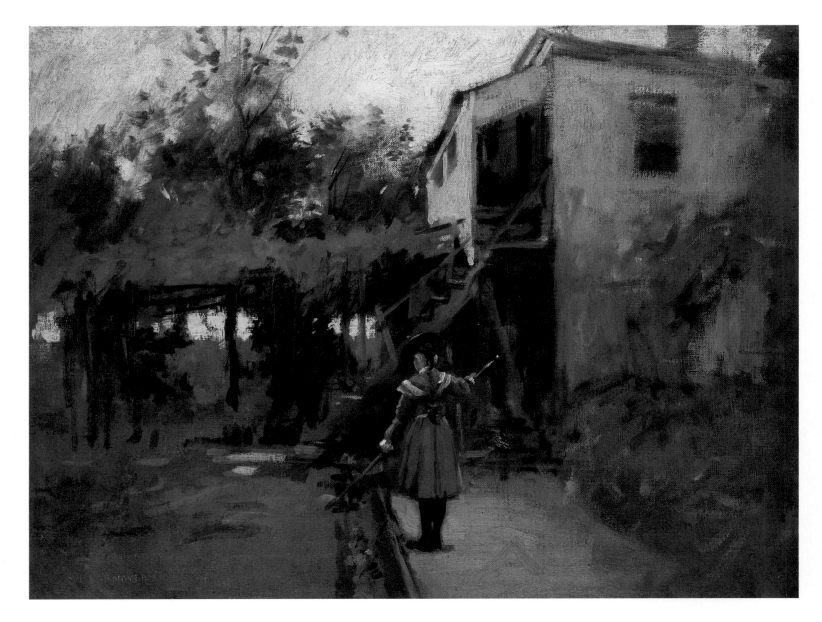

39. **Paul Cornoyer** (1864–1923)
Studio Garden, East Gloucester, ca. 1900, oil on canvas, 18½ × 24 inches
Signed lower left: *Paul Cornoyer*

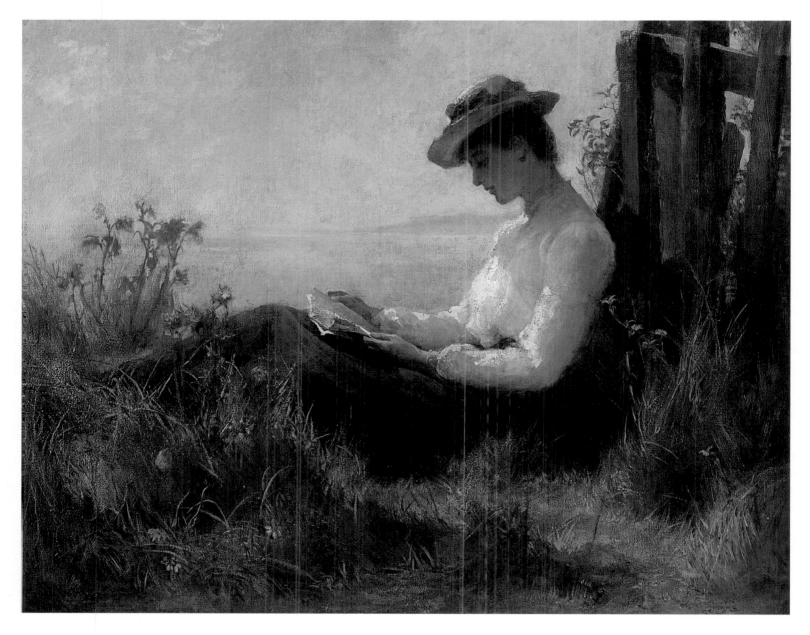

40. **Boston School**
Woman Reading, ca. 1890s–1910s, oil on canvas, 28 × 36 inches

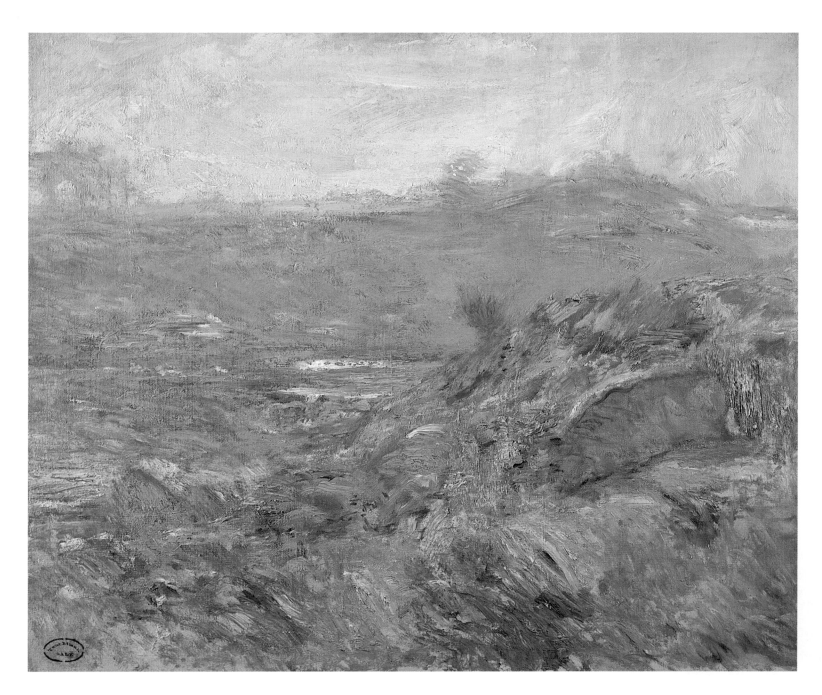

41. **John H. Twachtman** (1853–1902)
November Haze, ca. 1890s, oil on canvas, 25 × 30 inches
Estate stamped lower left: *Twachtman Sale*

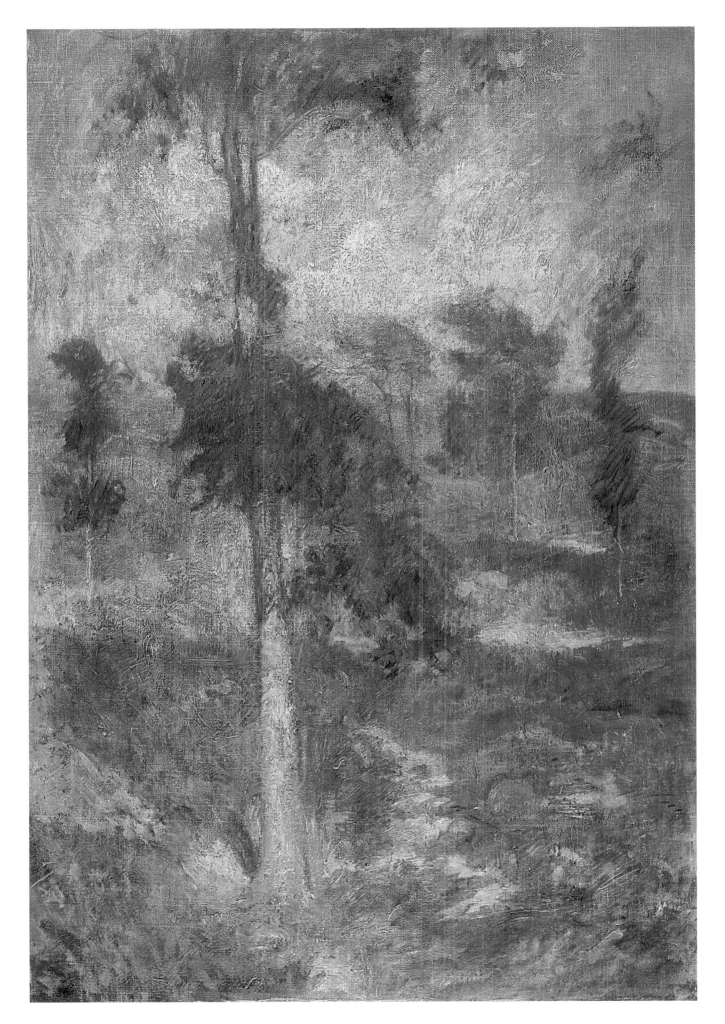

42. **John H. Twachtman** (1353–1902)
Tulip Tree, Greenwich, ca. 1890s, oil on canvas, 43¼ × 30¼ inches

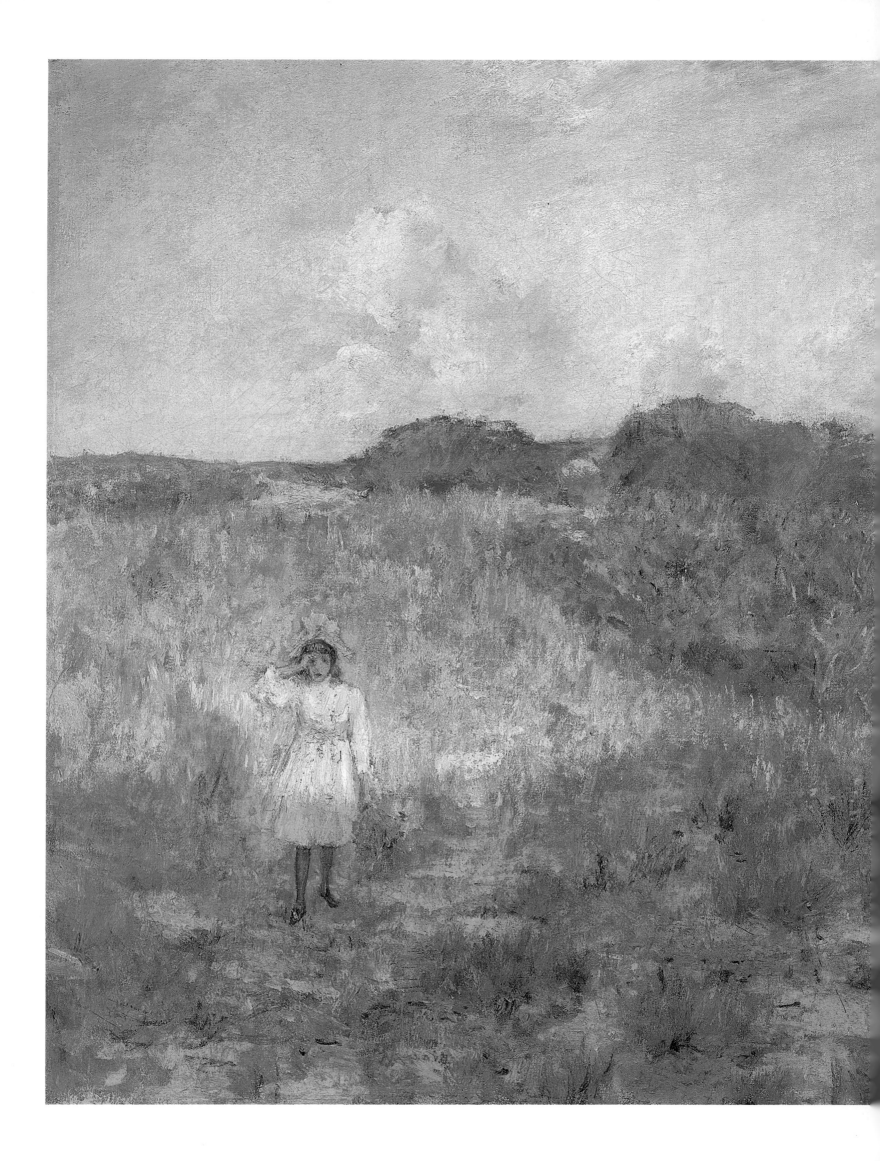

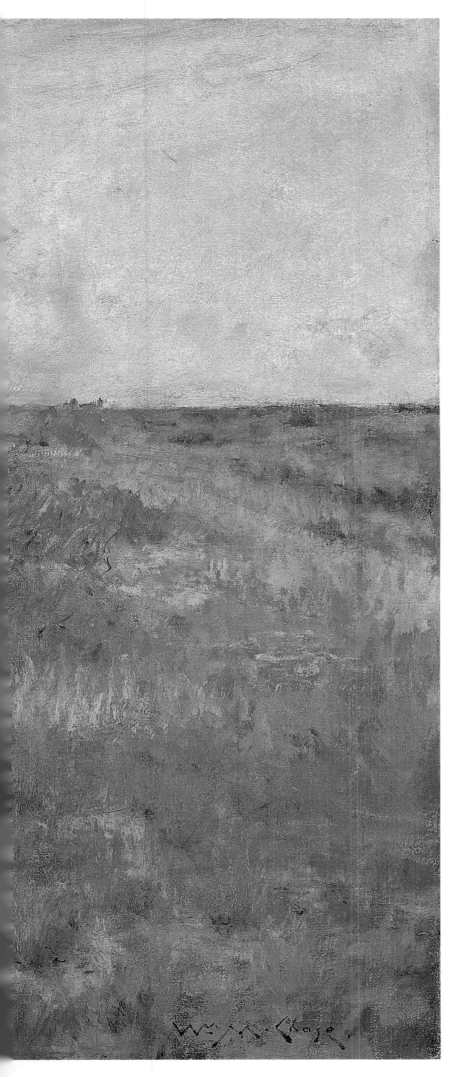

43. **William Merritt Chase** (1849–1916)
Sunset at Shinnecock Hills, ca. 1895, oil on canvas, 33 × 40 inches
Signed lower right: *Wm. M. Chase*

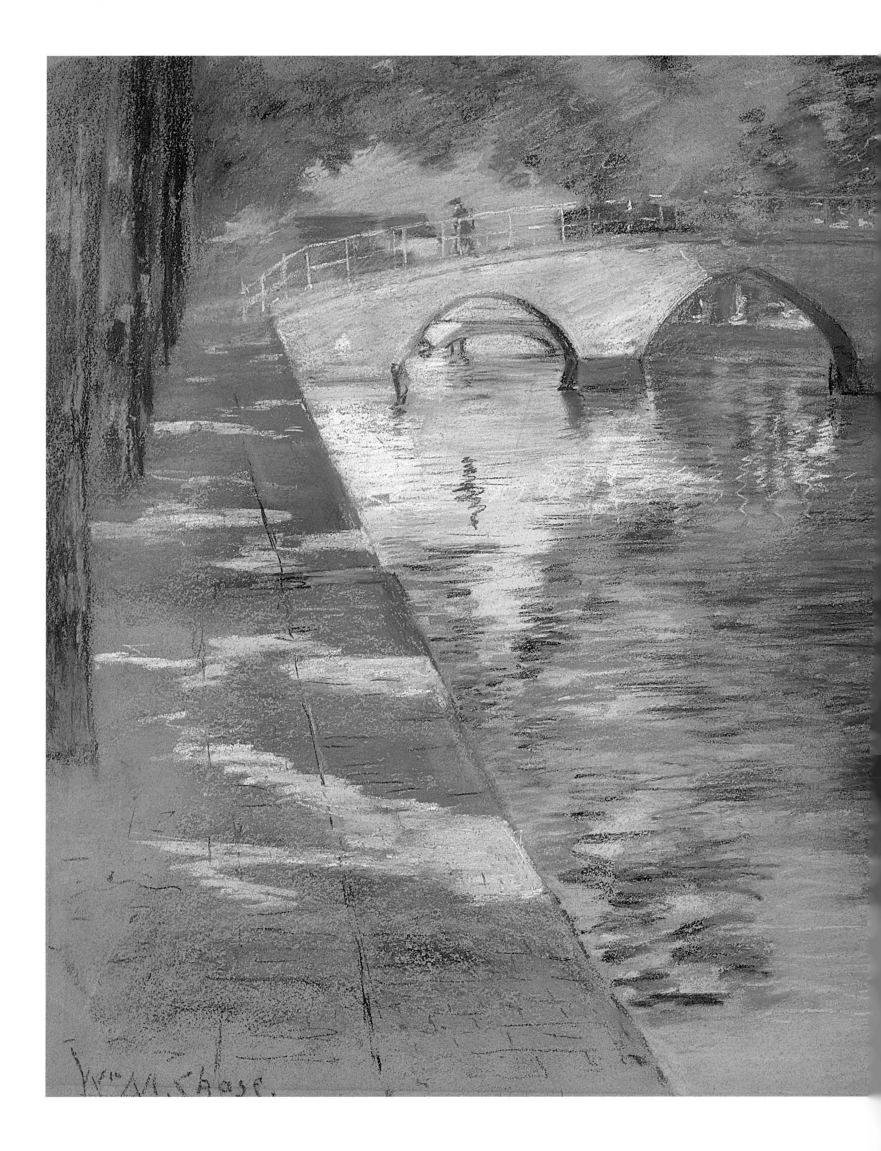

44. **William Merritt Chase** (1849–1916)
Reflections, Ho!land, 1883, pastel on paper, 24 × 30 inches
Signed lower left: *Wm. M. Chase*

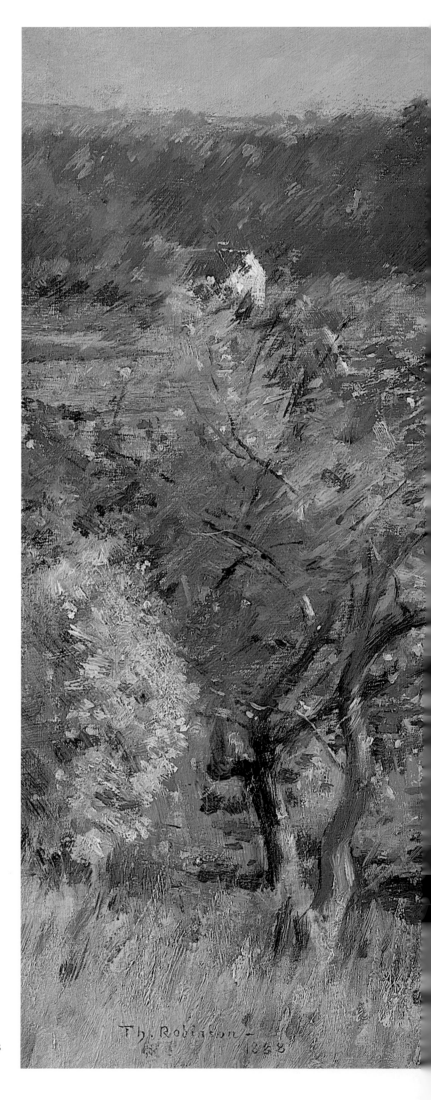

45. **Theodore Robinson** (1852–1896)
Saint Martin's (Summer), Giverny, 1888, oil on canvas, 18 × 22 inches
Signed and dated lower left: *Th. Robinson / 1888*

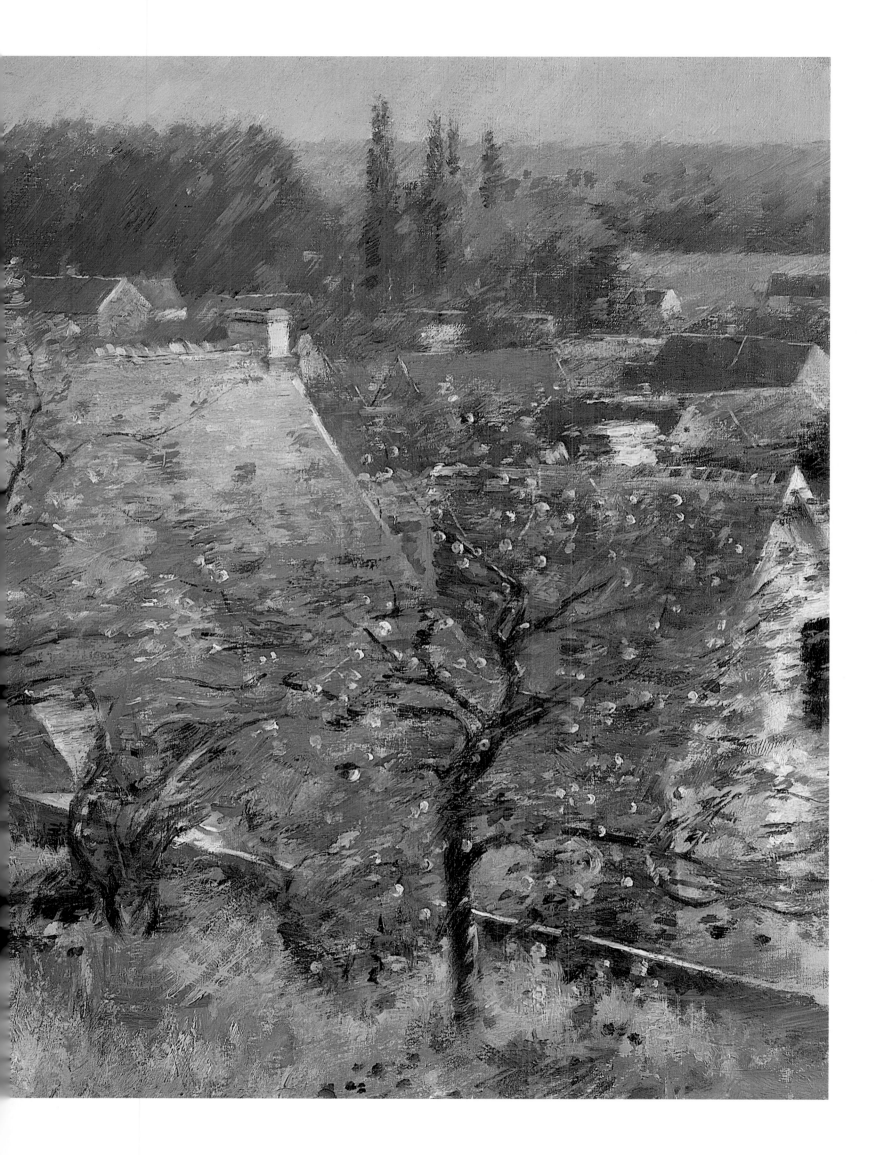

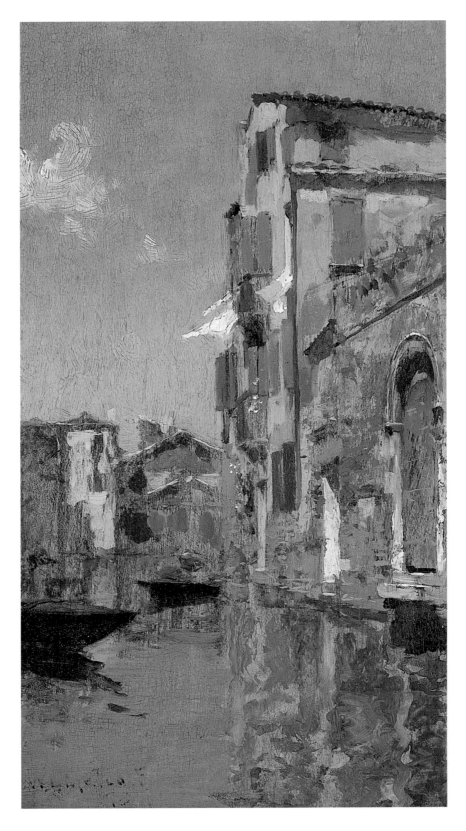

46. **Willard L. Metcalf** (1858–1925)
Venice, 1887, oil on panel, 11⅜ × 6¼ inches
Signed lower left: *W. L. Metcalf*

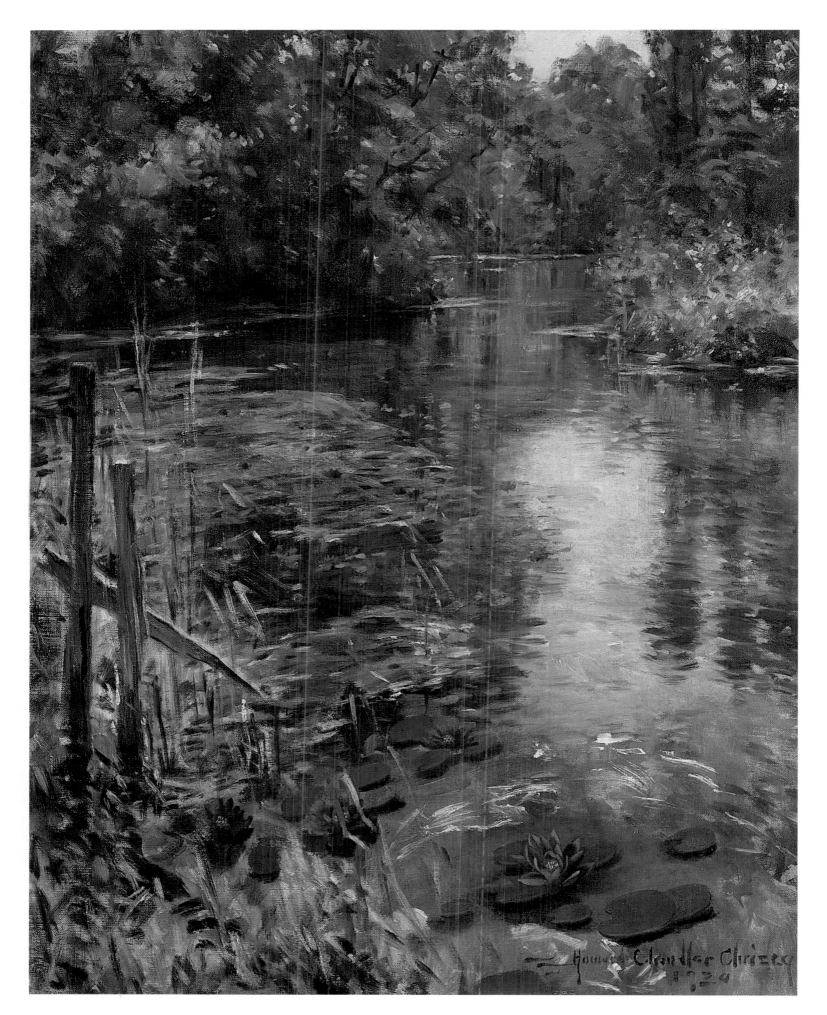

47. **Howard Chandler Christy** (1872–1952)
Lily Pond, 1924, oil on canvas, 30 × 24 inches
Signed and dated lower right: *Howard Chandler Christy / 1924*

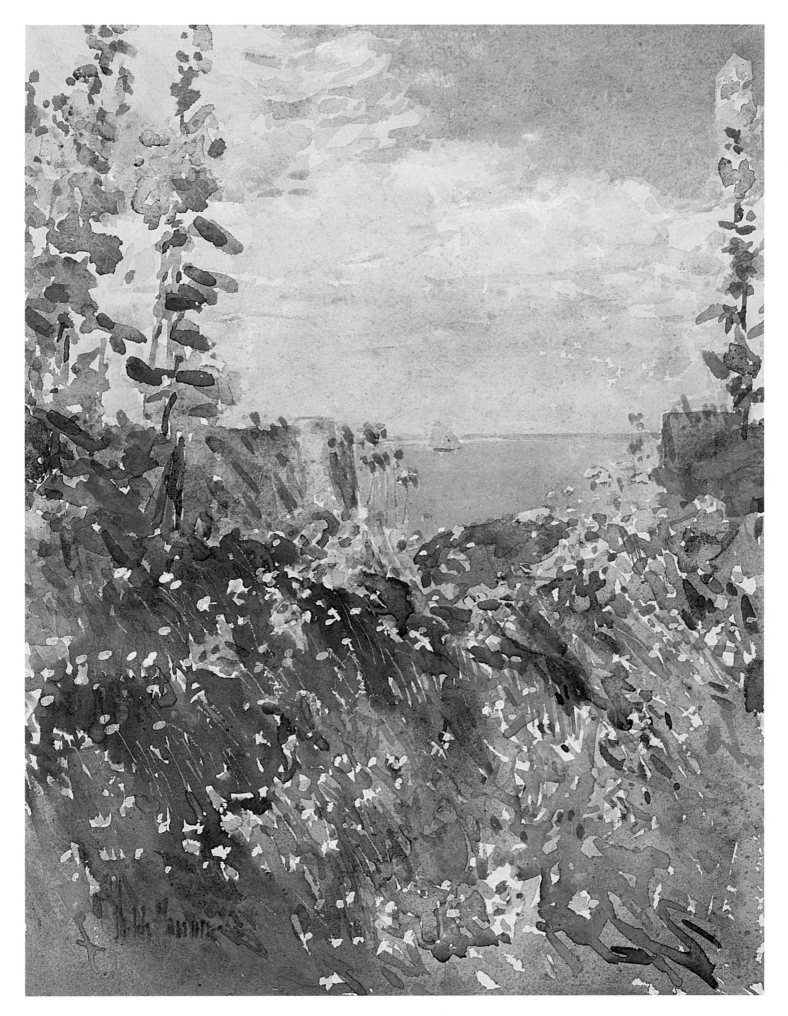

48. Childe Hassam (1859–1935)
Isles of Shoals Garden, ca. 1895, watercolor on paper, 10 × 7¾ inches
Signed lower left: *Childe Hassam*

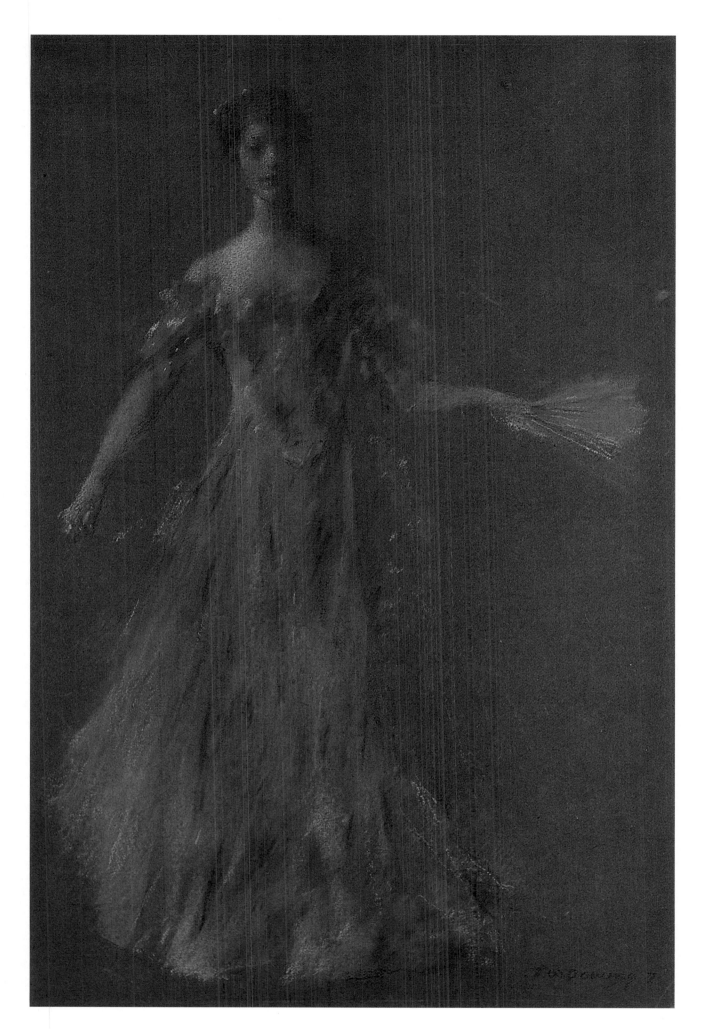

49. **Thomas W. Dewing** (1851–1938)
Lady in a Lavender Dress, ca. 1910, pastel on paper, 10¼ × 6½ inches
Signed and numbered lower right: *T. W. Dewing / 7*

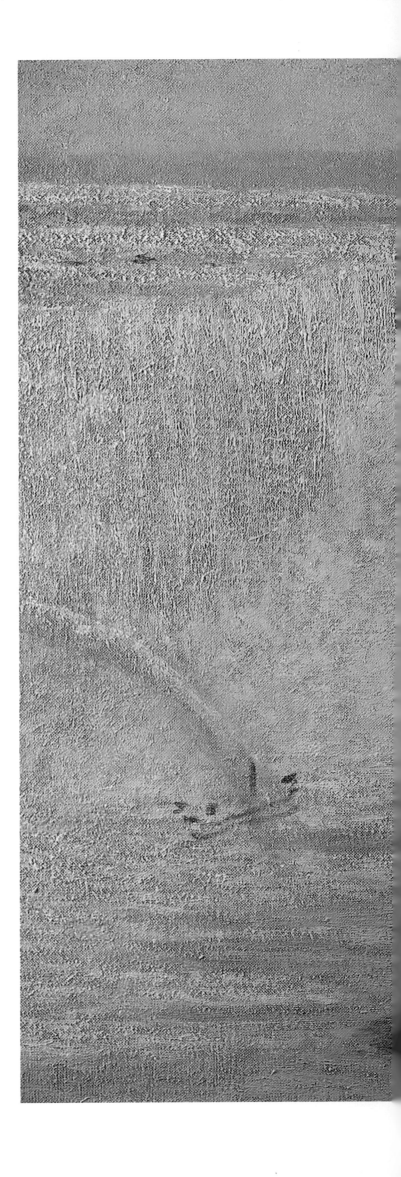

50. **Philip Leslie Hale** (1865–1931)
Niagara Falls, ca. 1902, oil on canvas, 35 × 41¼ inches

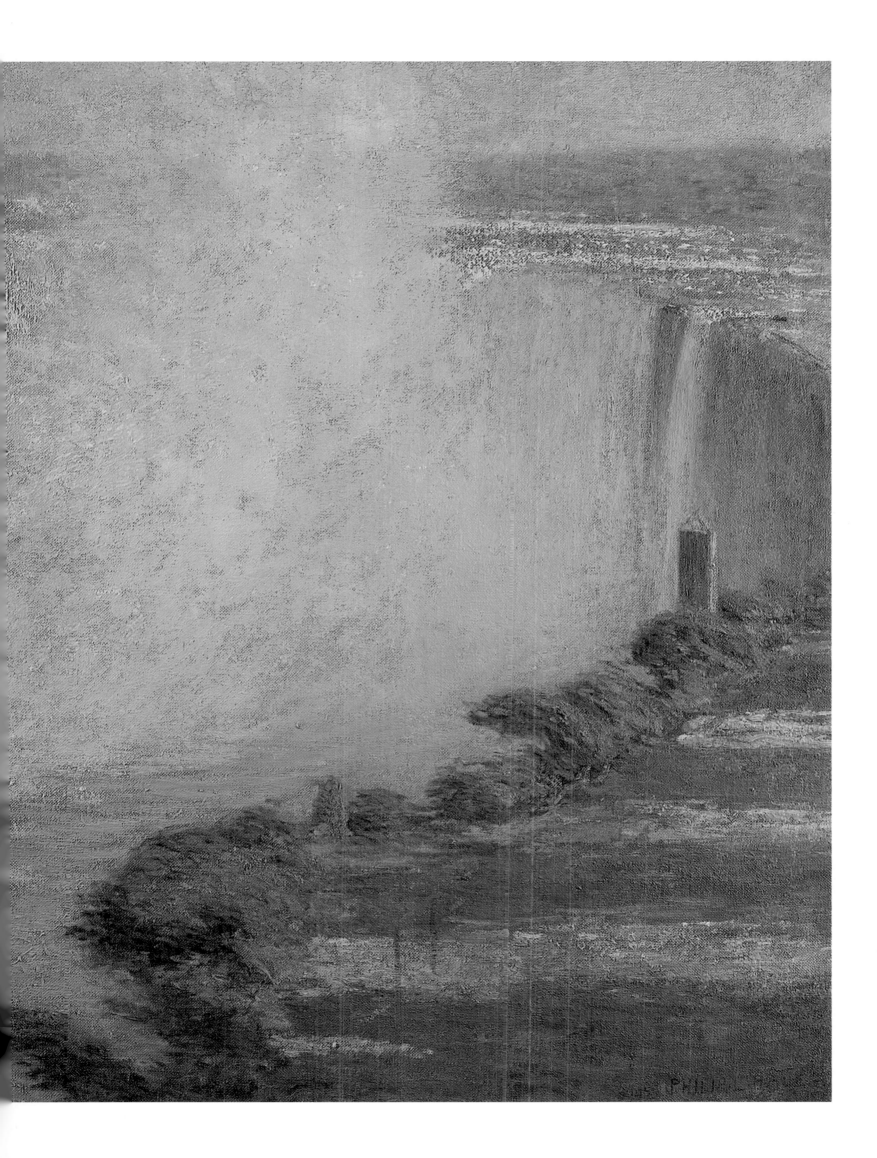

51. **Childe Hassam** (1859–1935)
Bridge in a Landscape—Mill Dam, Old Lyme, Connecticut, 1903
oil on canvas, 30 × 34 inches
Signed and dated lower right: *Childe Hassam 1903*

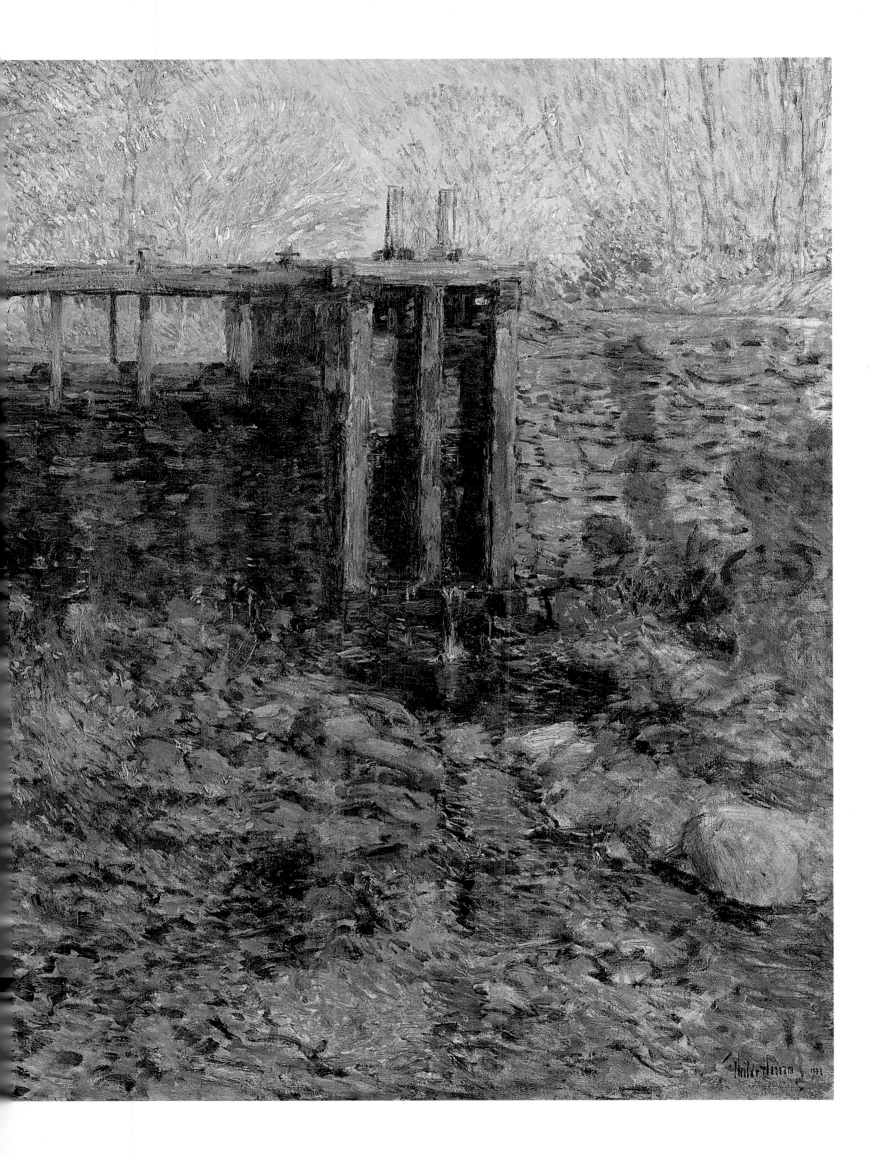

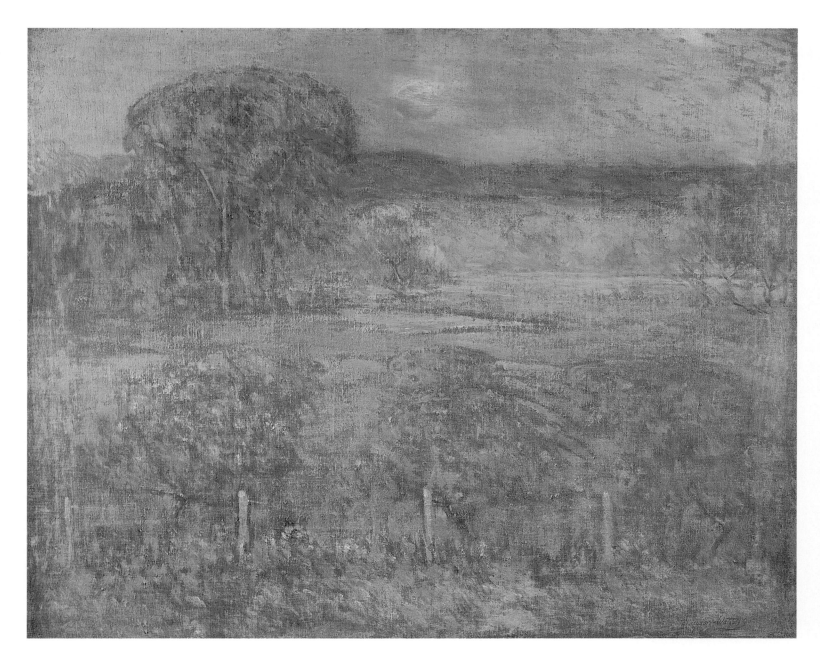

52. **Dawson Dawson-Watson** (1864–1939)
Setting Sun, ca. 1910s, oil on canvas, 23½ × 28½ inches
Signed lower right: *Dawson-Watson*

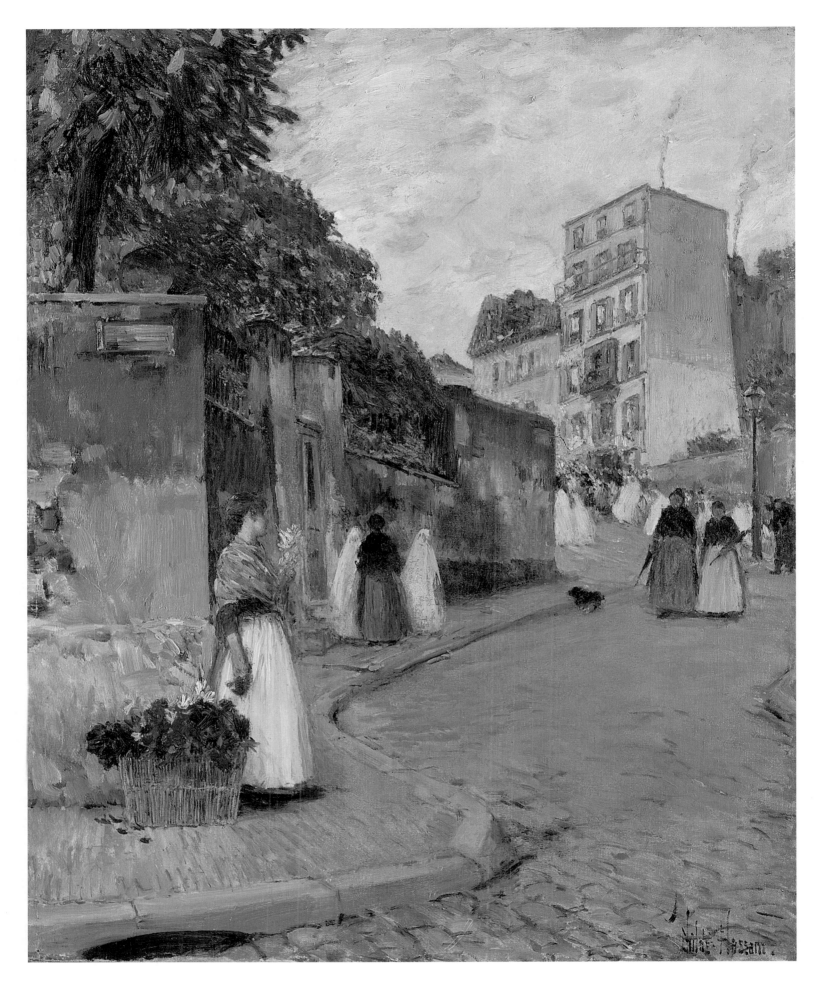

53. **Childe Hassam** (1859–1935)
Rue Montmartre, Paris, ca. 1888, oil on canvas, 18 × 15 inches
Signed lower right: *Childe Hassam.*

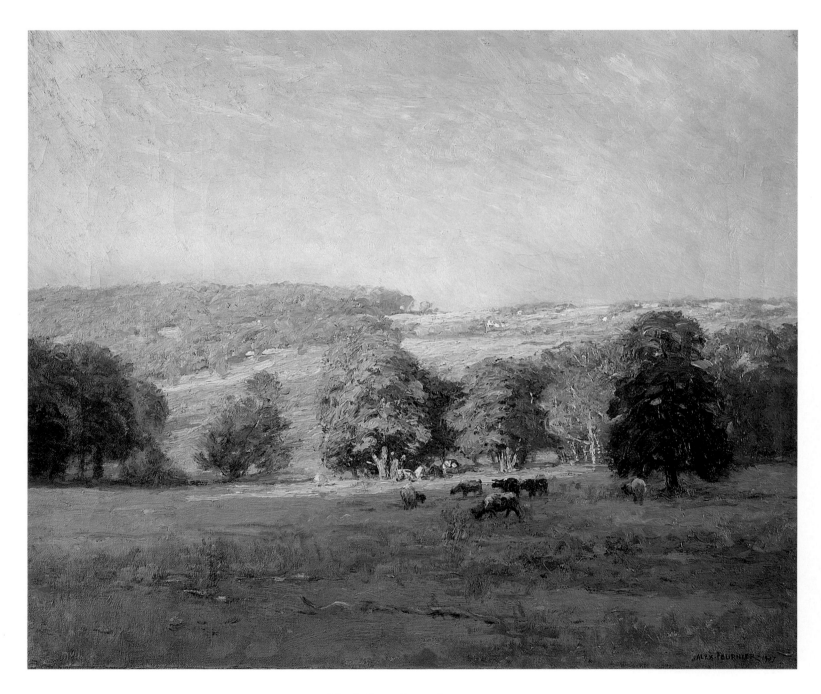

54. **Alexis Jean Fournier** (1865–1948)
Autumn Gold, 1907, oil on canvas, 19¾ × 23½ inches
Signed and dated lower right: *Alex Fournier 1907*

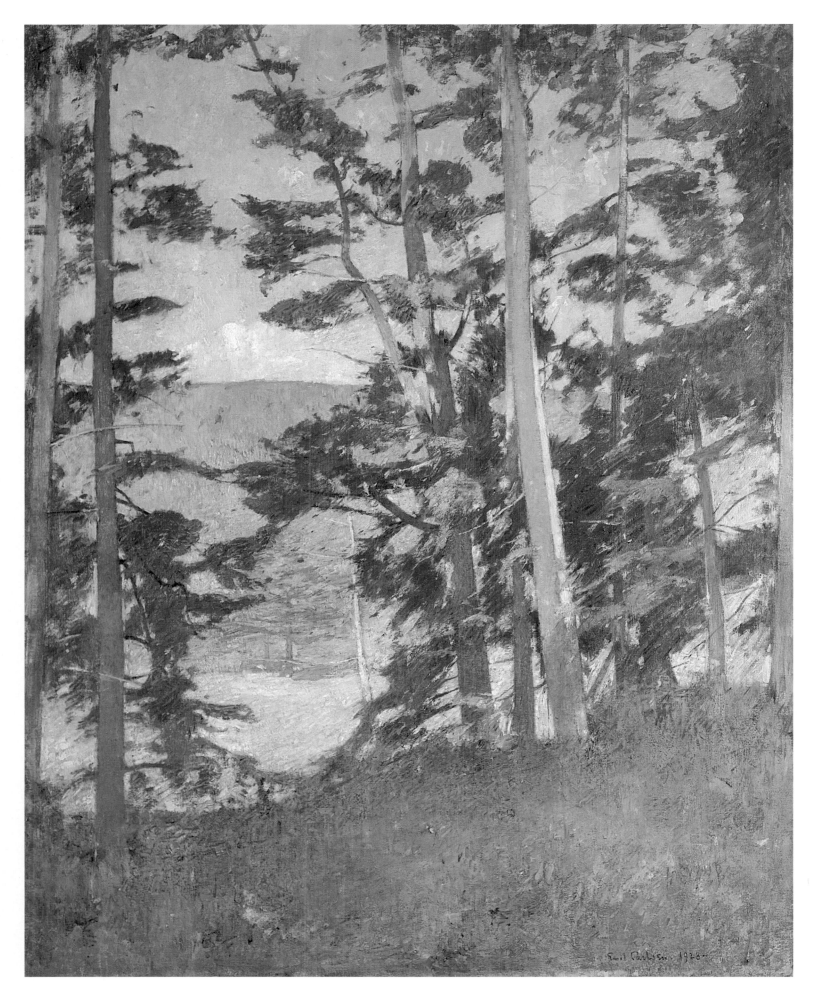

55. Emil Carlsen (1853–1932)
A Clearing beyond the Trees, 1928, oil on canvas, 50 × 40 inches
Signed and dated lower right: *Emil Carlsen. 1928.*

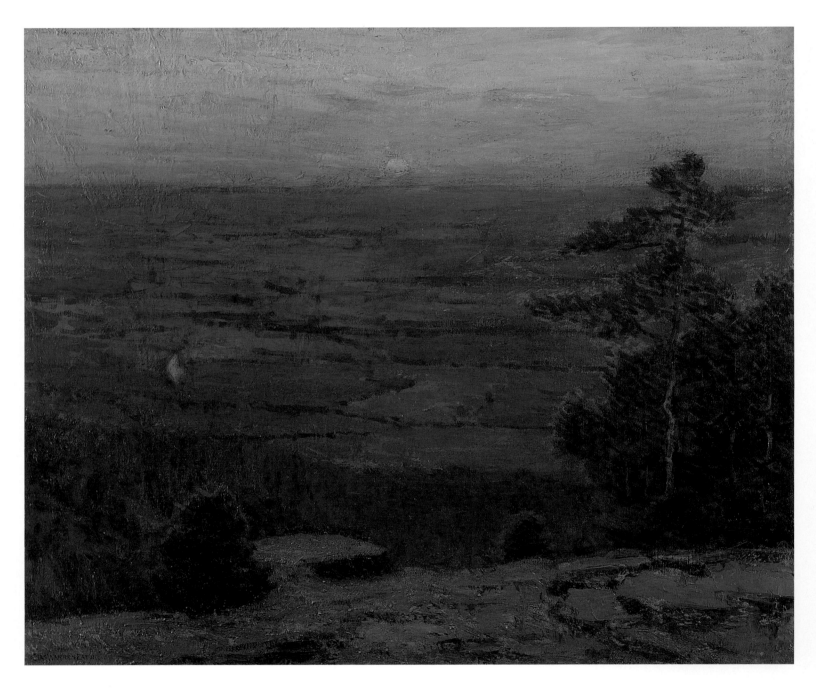

56. Charles Warren Eaton (1857–1937)
The Shawangunk Valley, ca. 1900, oil on canvas, 30 × 36¼ inches
Signed lower left: *Chas Warren Eaton*

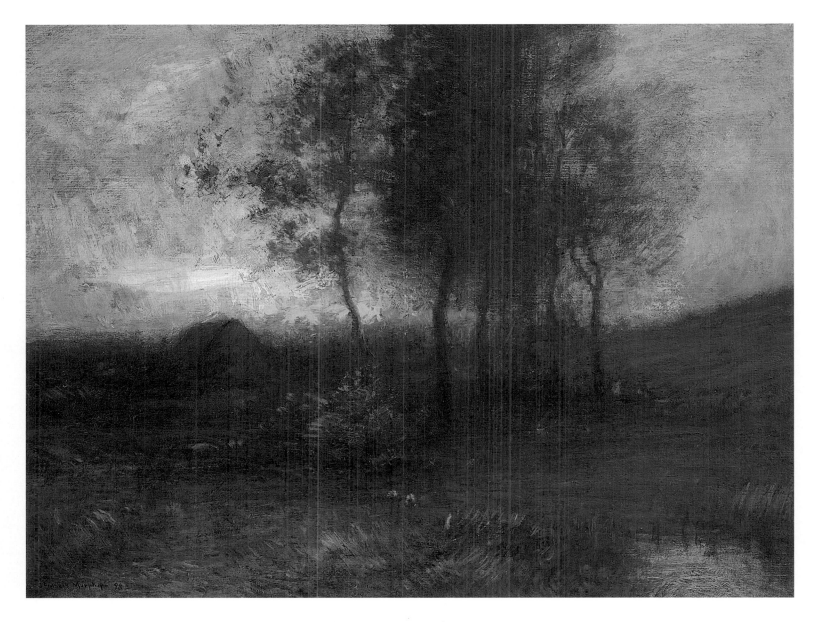

57. **John Francis Murphy** (1853–1921)
Autumnal Landscape, 1898, oil on canvas, 12 × 16 inches
Signed and dated lower left: *J. Francis Murphy. '98*

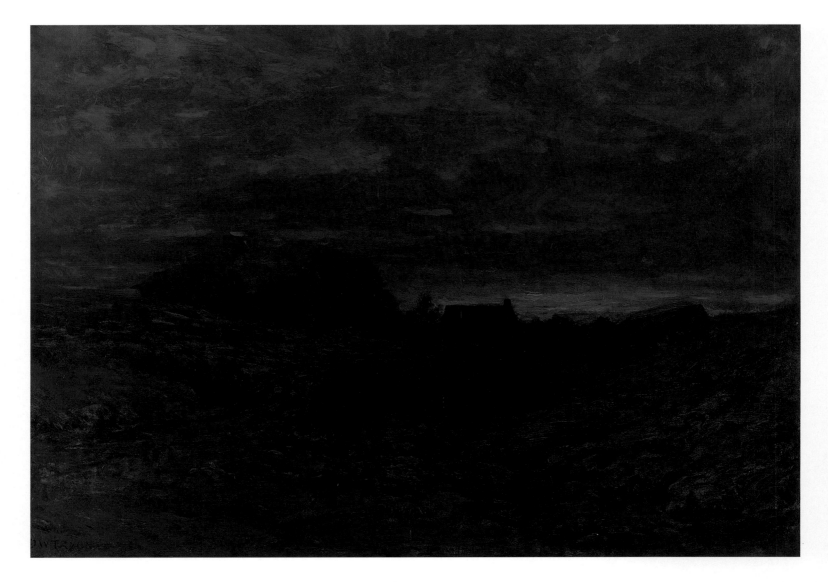

58. **Dwight William Tryon** (1849–1925)
End of Day, ca. 1890s, oil on canvas, 32 × 48 inches
Signed lower left: *D. W. Tryon*

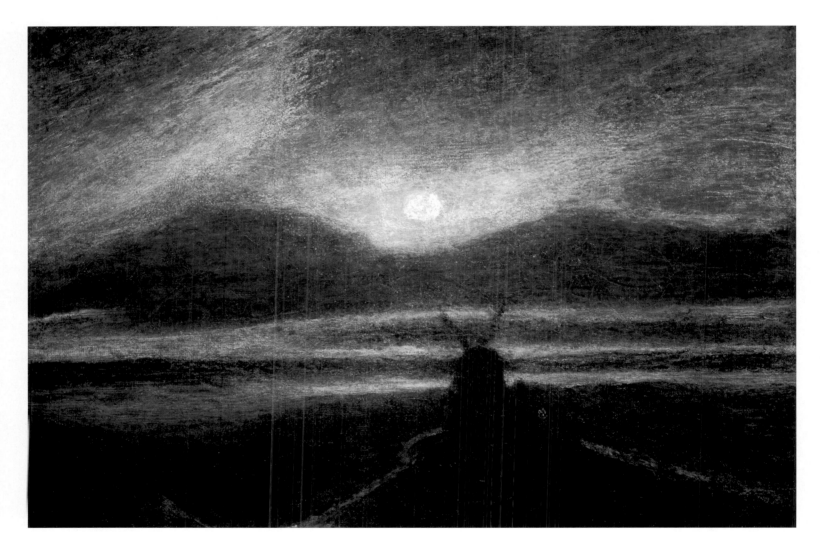

59. **Albert Pinkham Ryder** (1847–1917)
The Old Mill by Moonlight, ca. 1885, oil on canvas, 8⅛ × 11¼ inches

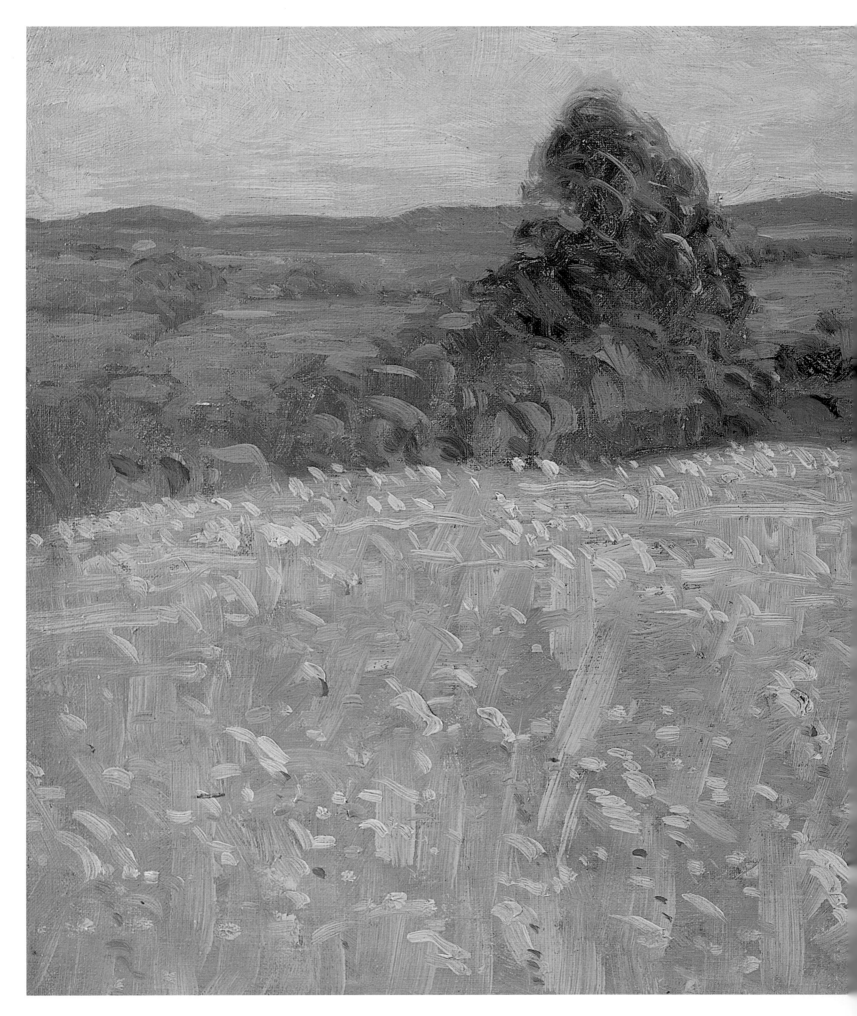

60. **Arthur Wesley Dow** (1857–1922)
Goldenrod and Asters, ca. 1910s, oil on canvasboard, 14 × 20 inches
Signed lower right: *Arthur W. Dow*

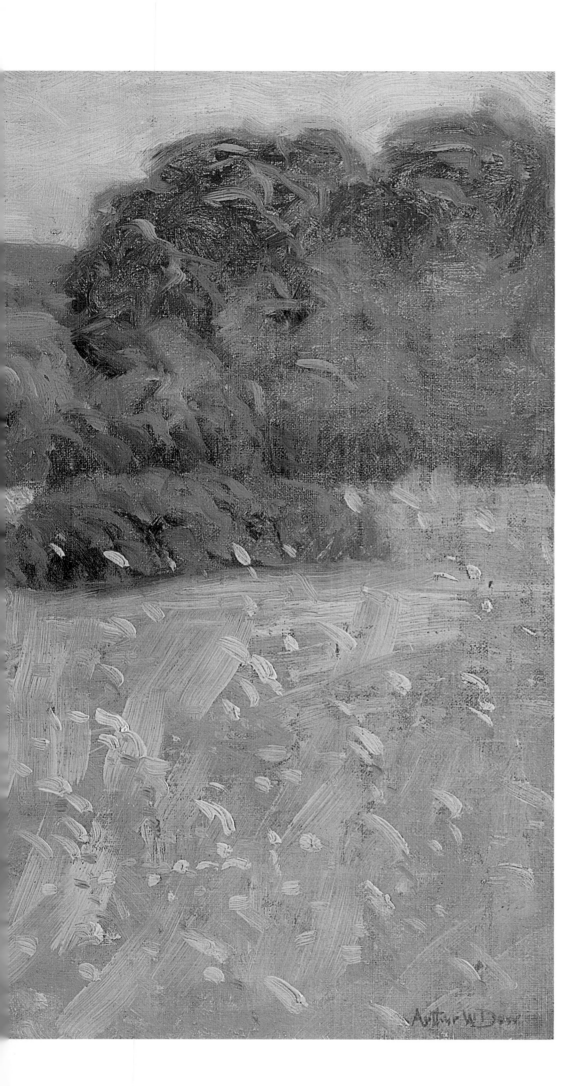

61. **Chauncey F. Ryder** (1868–1949)
Chestnut Hill, ca. 1910s, oil on canvas, 22 × 28 inches
Signed lower left: *Chauncey F. Ryder*

62. **Arthur Wesley Dow** (1857–1922)
Flood Tide, Ipswich Marshes, Massachusetts, ca. 1900, oil on canvas, 18 × 32 inches
Signed lower left: *Arthur W. Dow*

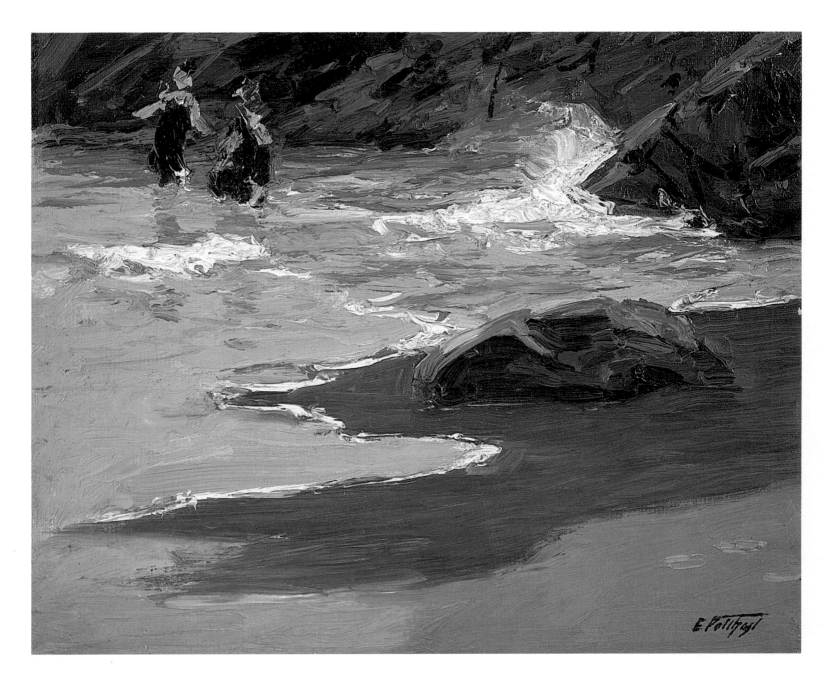

63. **Edward Henry Potthast** (1857–1927)
Bathers by a Rocky Coast, ca. 1915, oil on canvas mounted on board, 8 × 10 inches
Signed lower right: *E. Potthast*

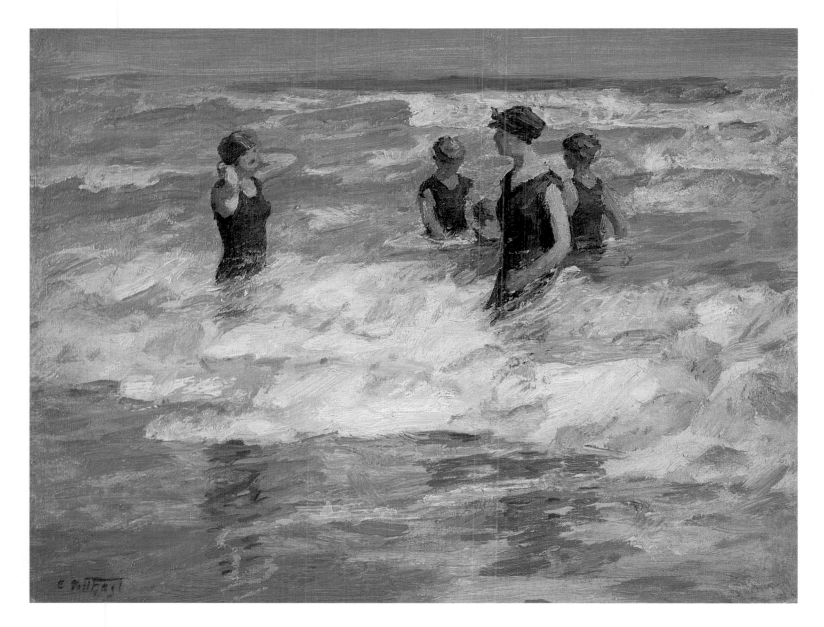

64. **Edward Henry Potthast** (1857–1927)
Bathers in the Surf, ca. 1910s–20s, oil on board, 12 × 15¾ inches
Signed lower left: *E. Potthast*

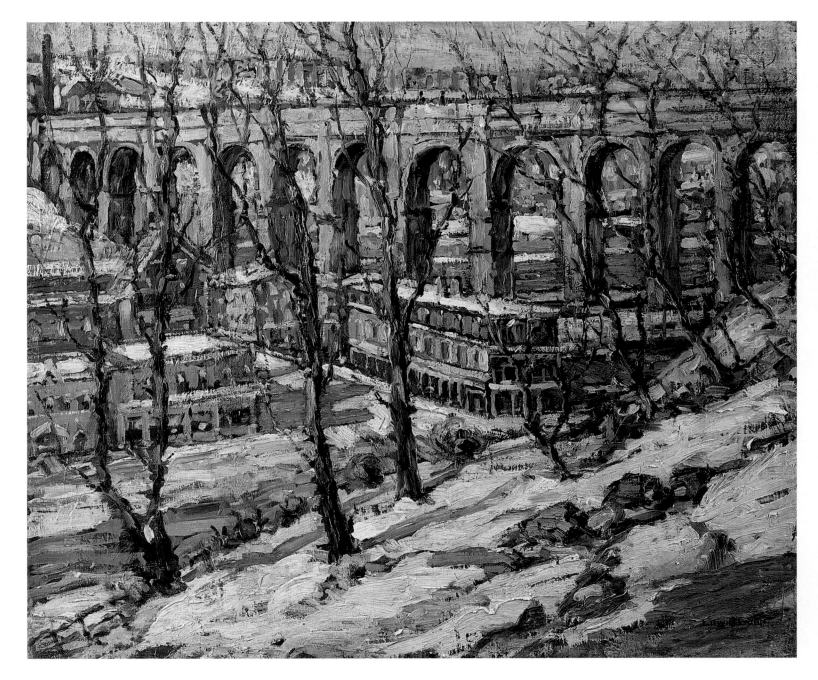

65. **Edwin H. Gunn** (1876–1940)
Highbridge, The Harlem River, ca. 1907, oil on canvas, 25 × 30 inches
Signed lower right: *Edwin Gunn.*

66. Joseph Raphael (1869–1950)
By the Stream, Papekasteel, ca. 1915, oil on canvas, 22 × 27⅛ inches
Signed lower right: *Jos Raphael*

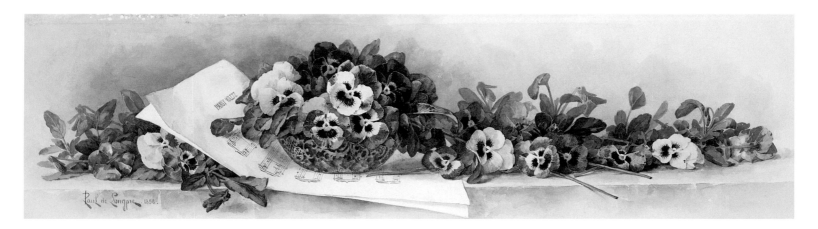

67. **Paul de Longpré** (1855–1911)
Pansy Waltz, 1896, watercolor on paper, 9½ × 35 inches
Signed and dated lower left: *Paul de Longpré 1896.*

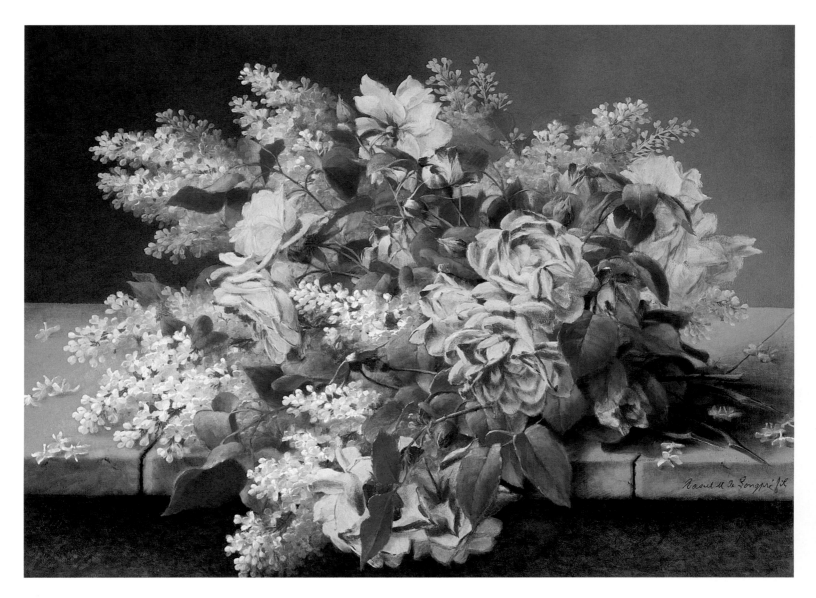

68. **Raoul de Longpré** (b. 1843)
Roses on a Marble Tabletop, ca. 1890s, gouache on paper, 21 × 28½ inches
Signed lower right: *Raoul M. de Longpré, fils*

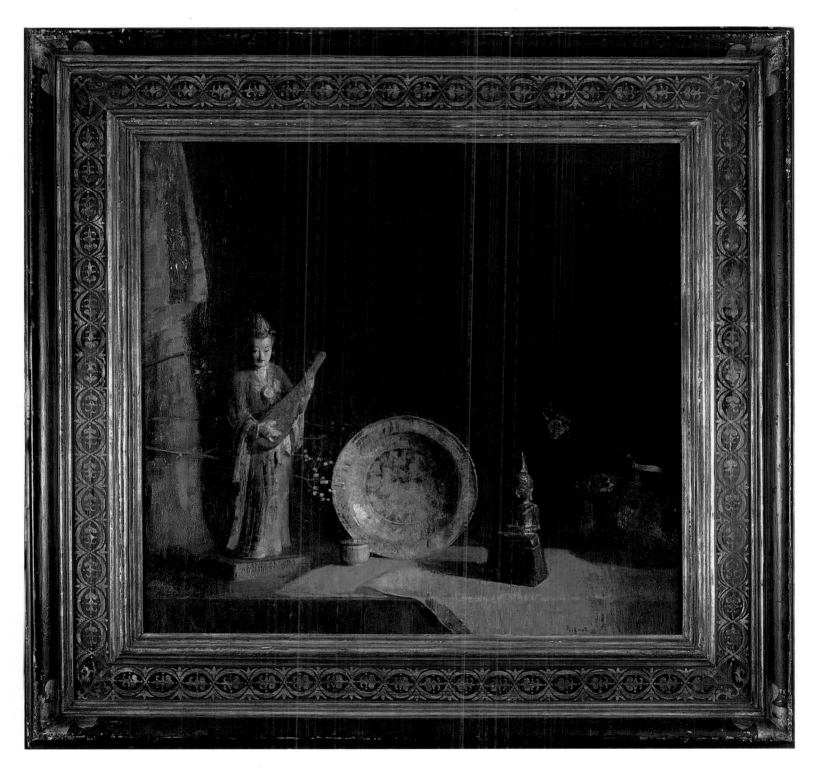

69. **Hovsep Pushman** (1877–1966)
Serenade to Silence, ca. 1930s, oil on board mounted on canvas, 25½ × 27½ inches
Signed lower right: *Pushman*

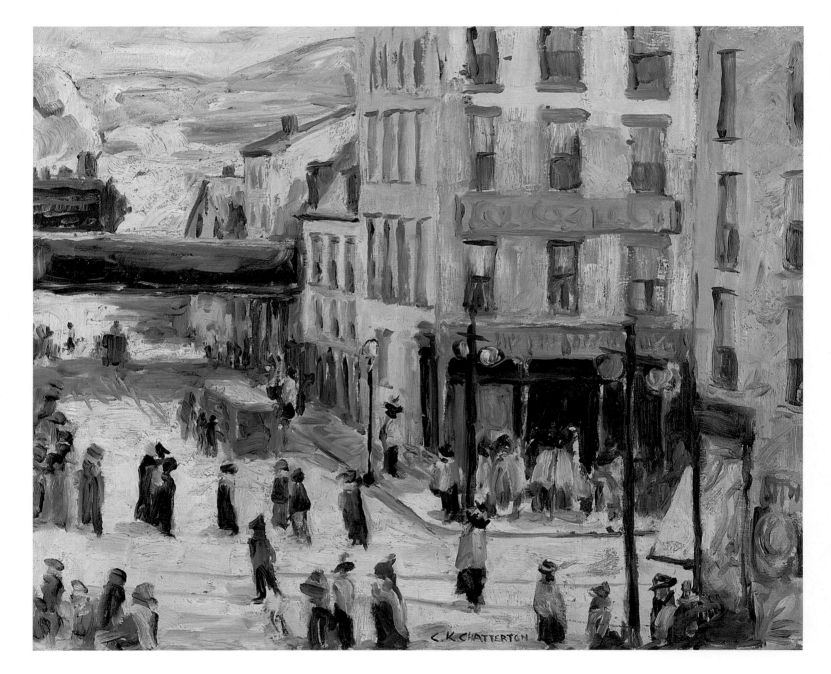

70. **Clarence K. Chatterton** (1880–1973)
Street Scene, Newburgh, New York, ca. 1910s, oil on canvas, 20 × 25 inches
Signed lower center: *C. K. Chatterton*

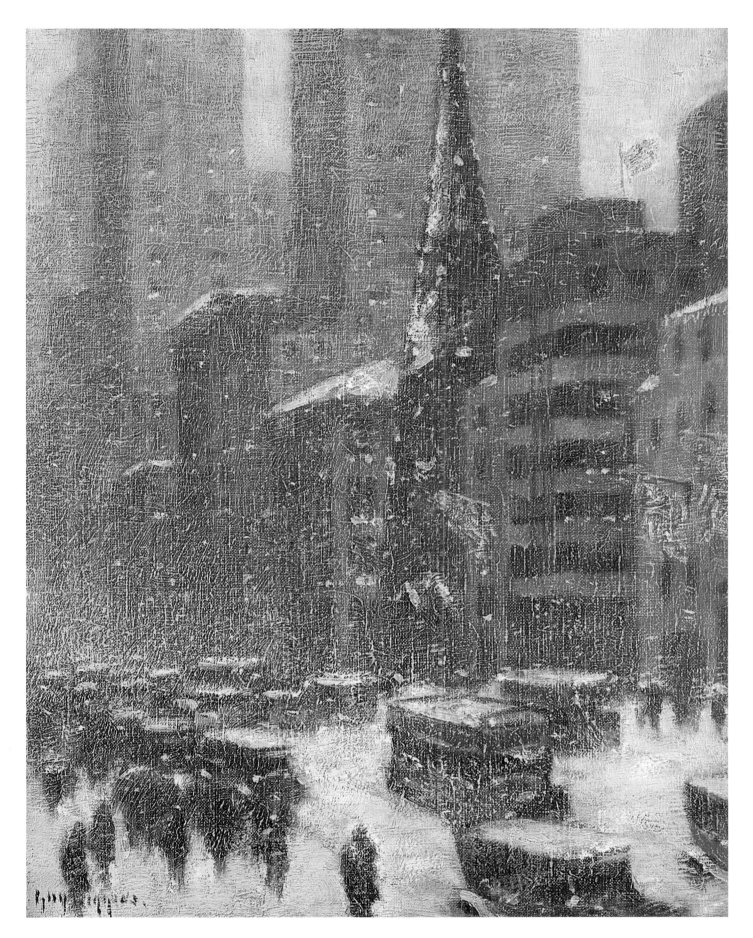

71. **Guy Carleton Wiggins** (1883–1962)
Manhattan Winter, 1934, oil on canvas, 20 × 16 inches
Signed lower left: *Guy Wiggins.*; signed, dated, and titled on verso: *Manhattan Winter / Guy Wiggins / 1934*

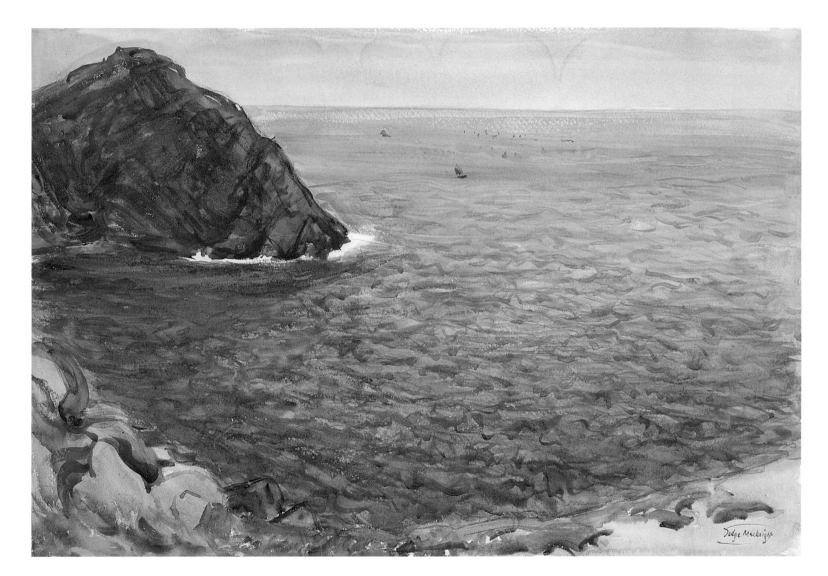

72. **Dodge MacKnight** (1860–1950)
Shoreline View, No. 1 (Grand Manan Island), ca. 1890s, watercolor on paper, 15½ × 22½ inches
Signed lower right: *Dodge MacKnight*

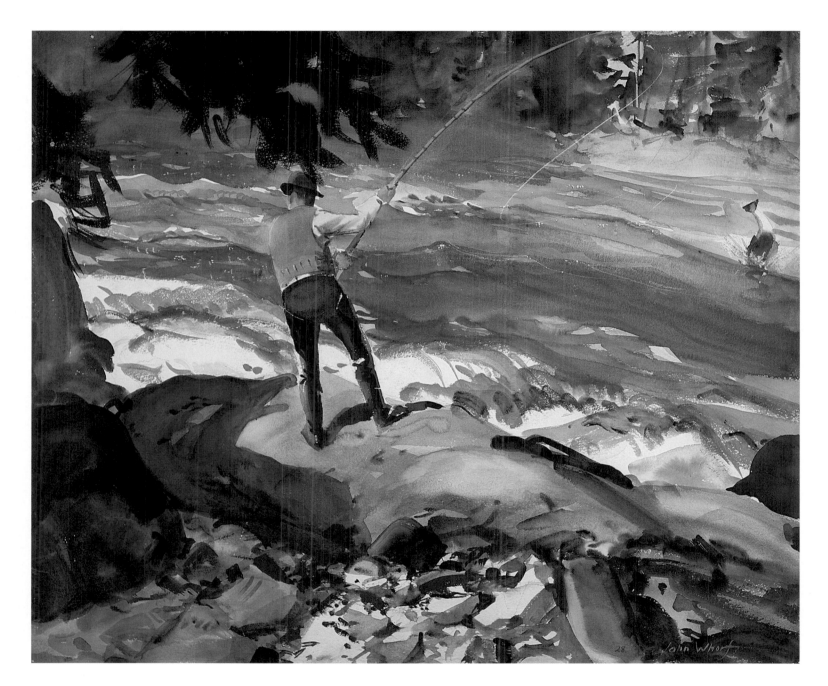

73. **John Whorf** (1903–1959)
Fisherman, ca. 1930s, watercolor and gouache on paper, 21⅝ × 26 inches
Signed lower right: *John Whorf*

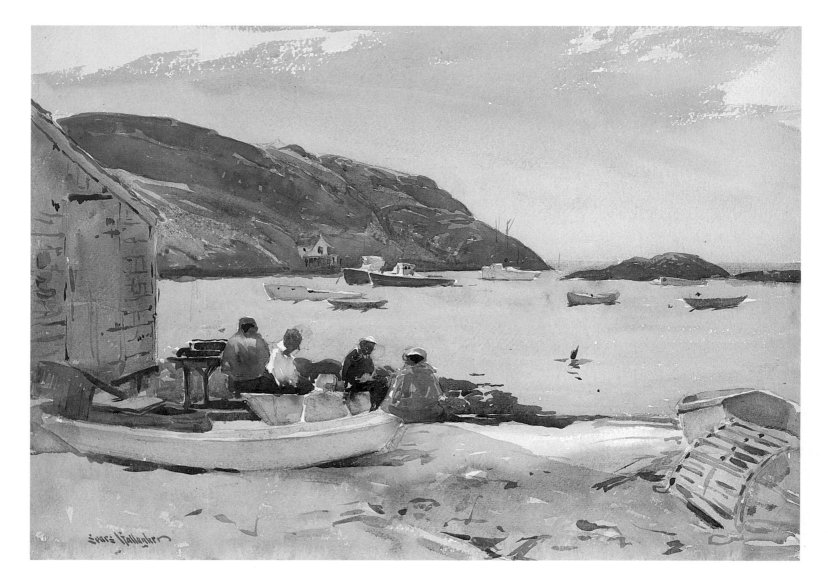

74. **Sears Gallagher** (1869–1955)
Fish Beach, Monhegan Island, Maine, ca. 1910s–30s, watercolor on paper, 14 × 20 inches
Signed lower left: *Sears Gallagher*

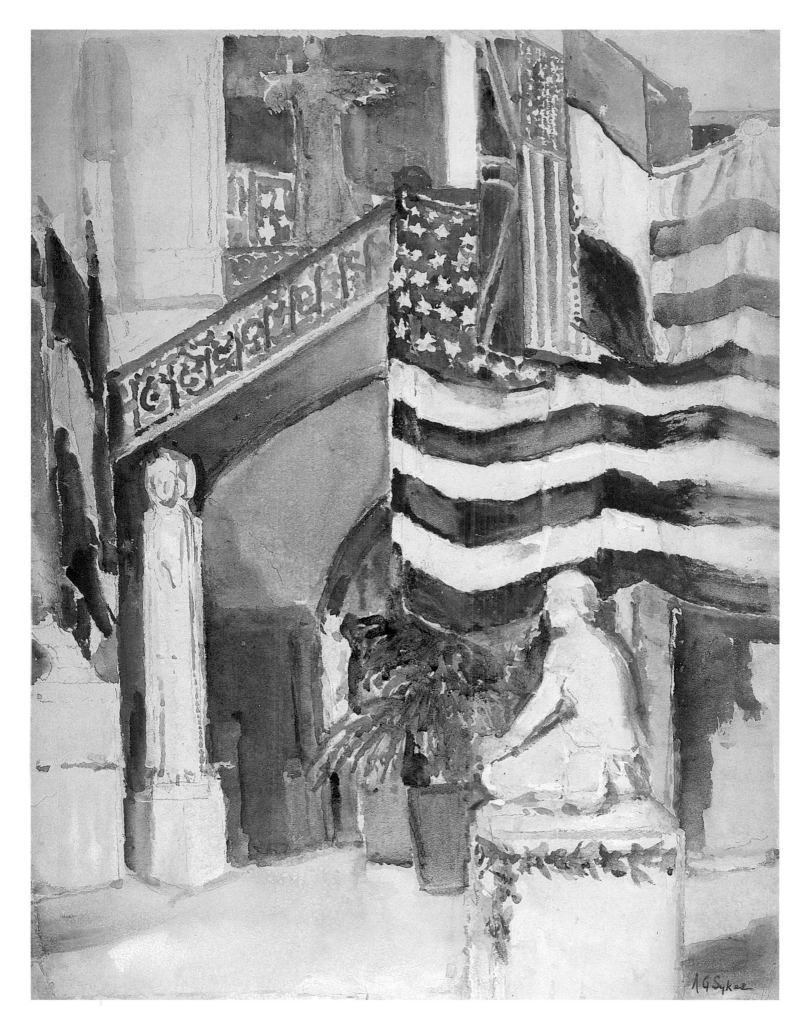

75. **Annie Gooding Sykes** (1855–1931)
Art Museum, Cincinnati, ca. 1918 and *Wash Day,* ca. 1910s: a double-sided watercolor
watercolor on paper, 22¼ × 17⅛ inches
Signed recto lower right: *AG Sykes*

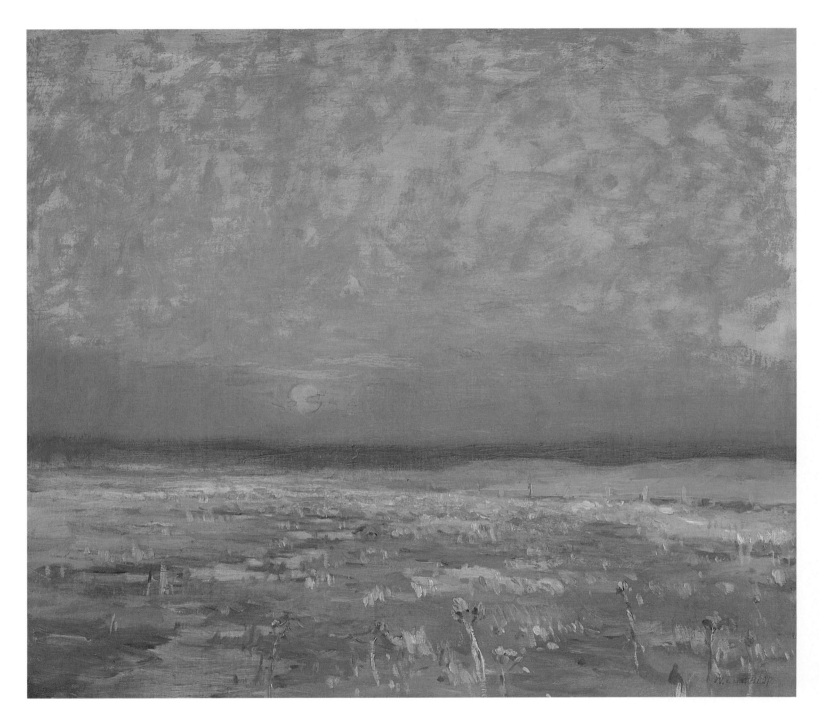

76. **William Langson Lathrop** (1859–1938)
Winter Marshes, ca. 1920, oil on canvas, 22 × 25 inches
Signed lower right: *W. Lathrop*

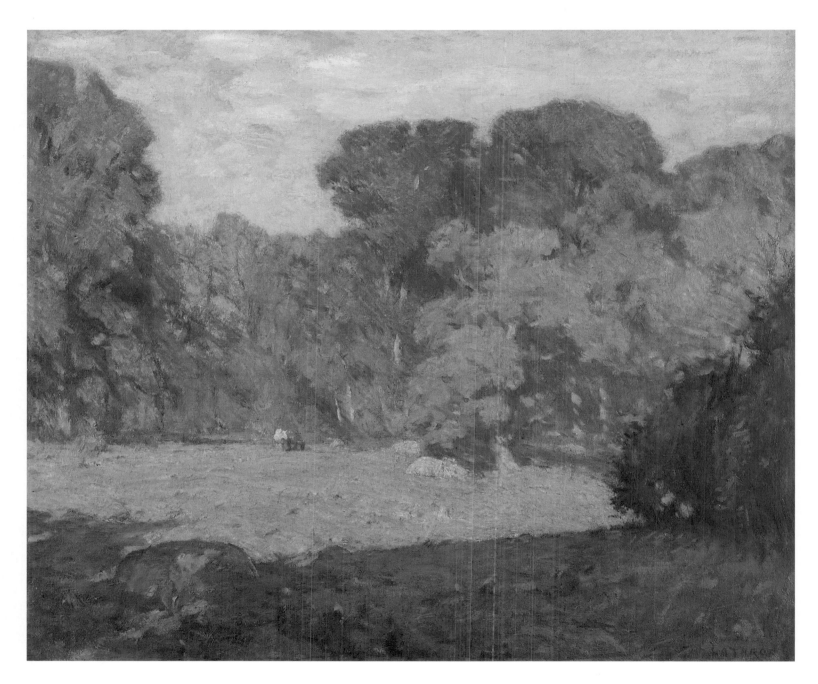

77. **William Langson Lathrop** (1859–1938)
Forest Glade, ca. 1938, oil on board, 24 × 29 inches
Signed lower right: *Lathrop*

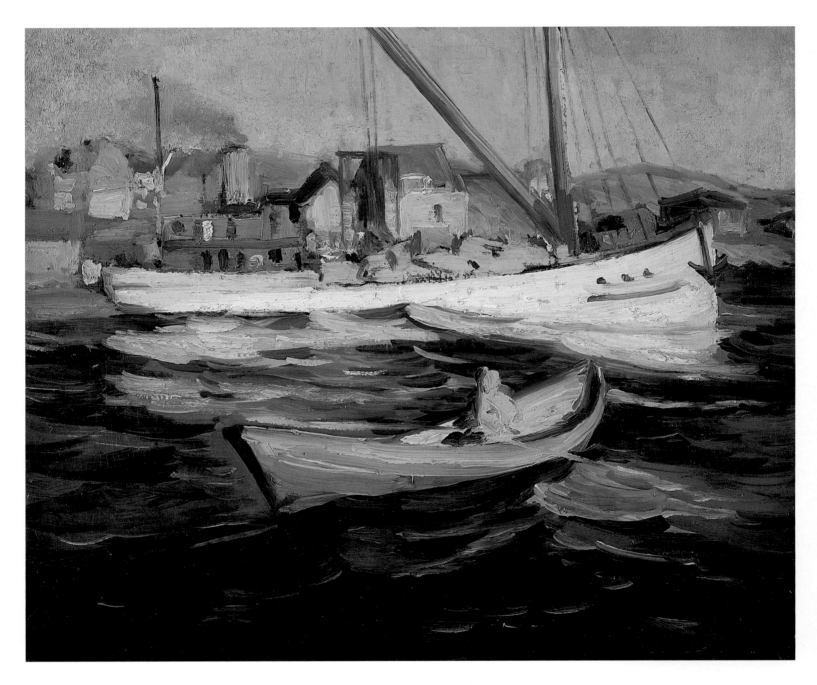

78. **Abraham J. Bogdanove** (1886–1946)
Eric's Hunting Ground—The Golden Dory, Monhegan Harbor, Maine, ca. 1920s–30s, oil on canvasboard, 20 × 24 inches
Signed lower right: *A. J. Bogdanove*

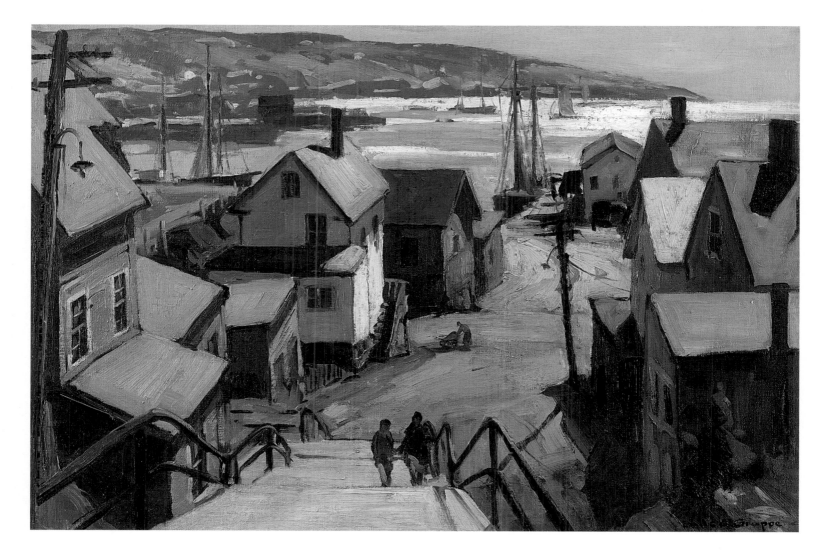

79. Emile A. Gruppe (1896–1978)
View from Portugee, Gloucester, Massachusetts, ca. 1920s, oil on canvas, 24 × 36 inches
Signed lower right: *Emile A. Gruppe*

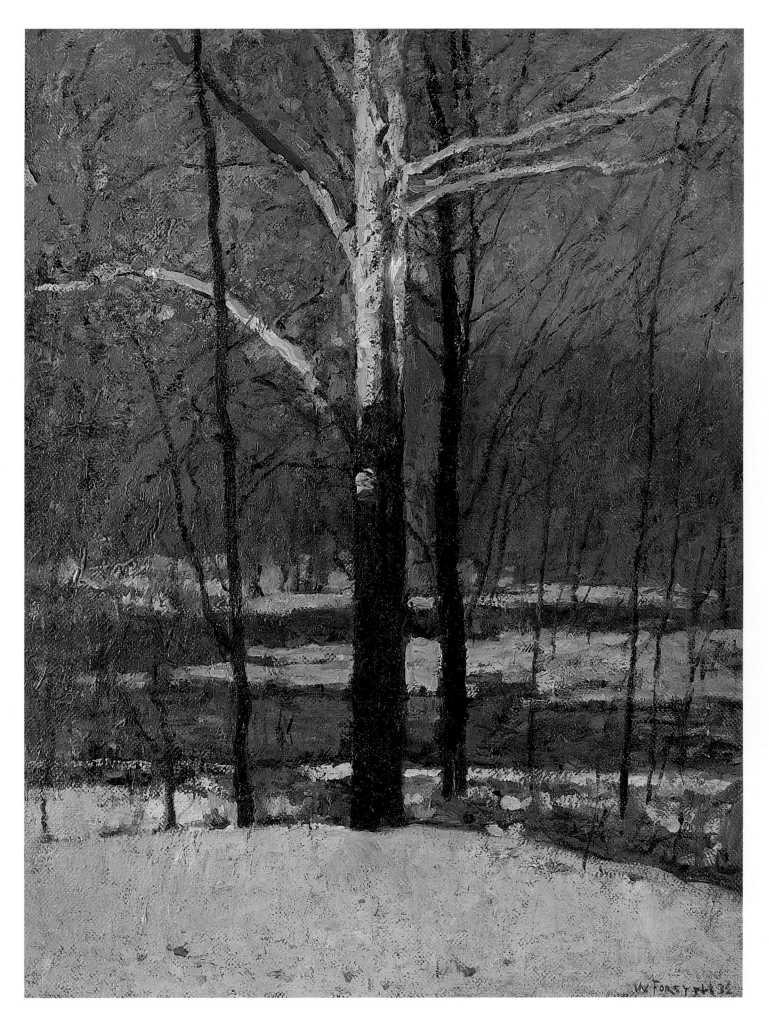

80. **William Forsyth** (1854–1935)
The Sunset Hour, 1932, oil on canvas, 32 × 24 inches
Signed and dated lower right: *W. Forsyth 32*

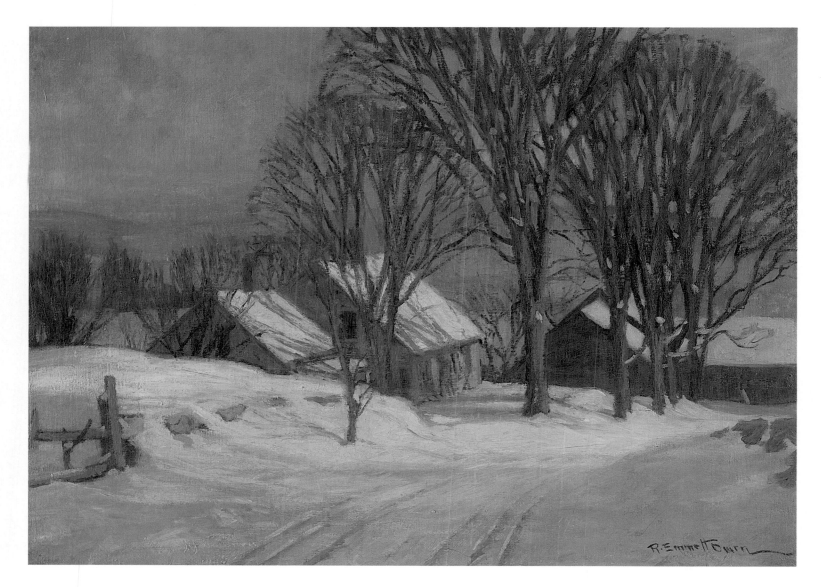

81. **Robert Emmett Owen** (1878–1957)
Farmhouse in Winter, ca. 1910s–30s, oil on canvas, 26 × 36½ inches
Signed lower right: *R. Emmett Owen*

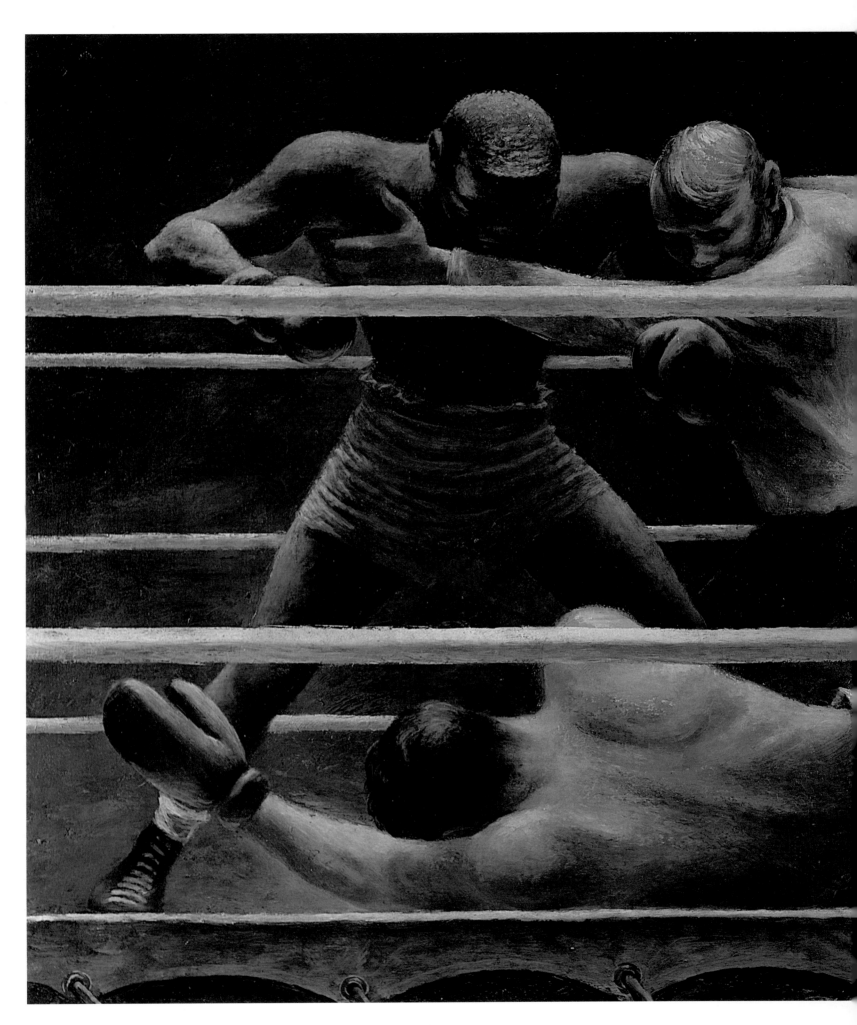

82. **Fletcher Martin** (1904–1979)
Lullaby, ca. 1942, oil on masonite, 31 × 48 inches
Signed lower right: *Fletcher Martin*

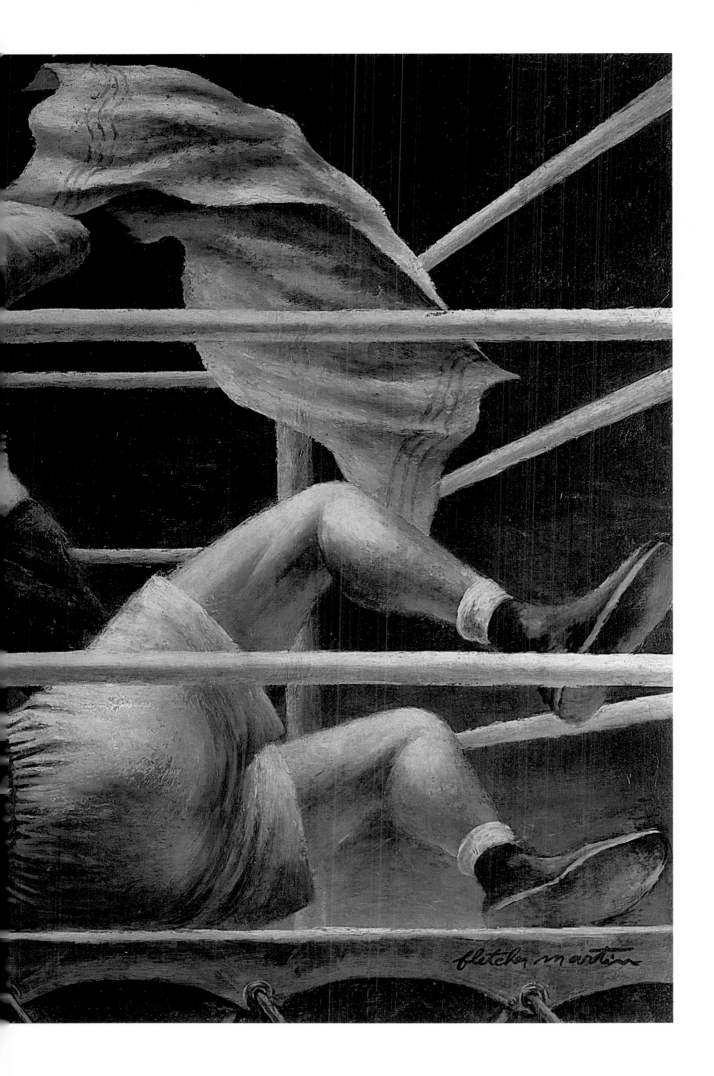

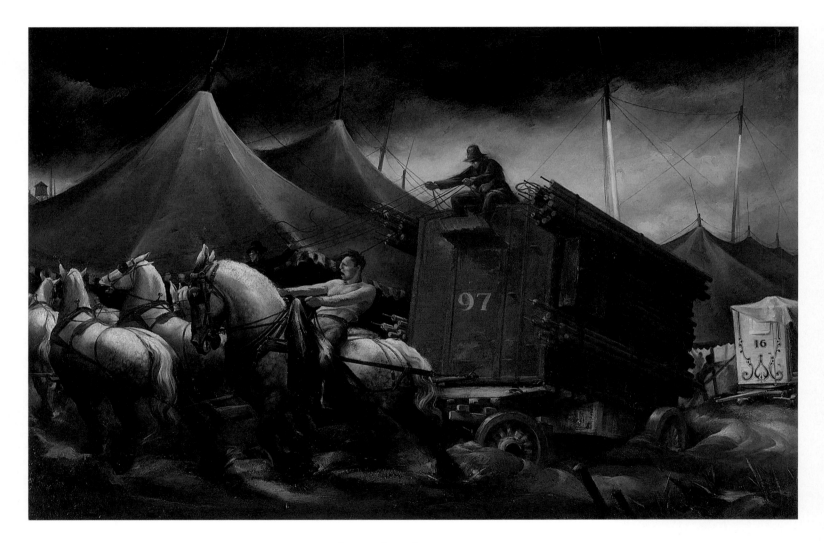

83. **Robert Edward Weaver** (1914–1991)
Wagon "97," 1937, oil on masonite, 31 × 48 inches
Signed and dated lower left: *R. E. Weaver / 1937*

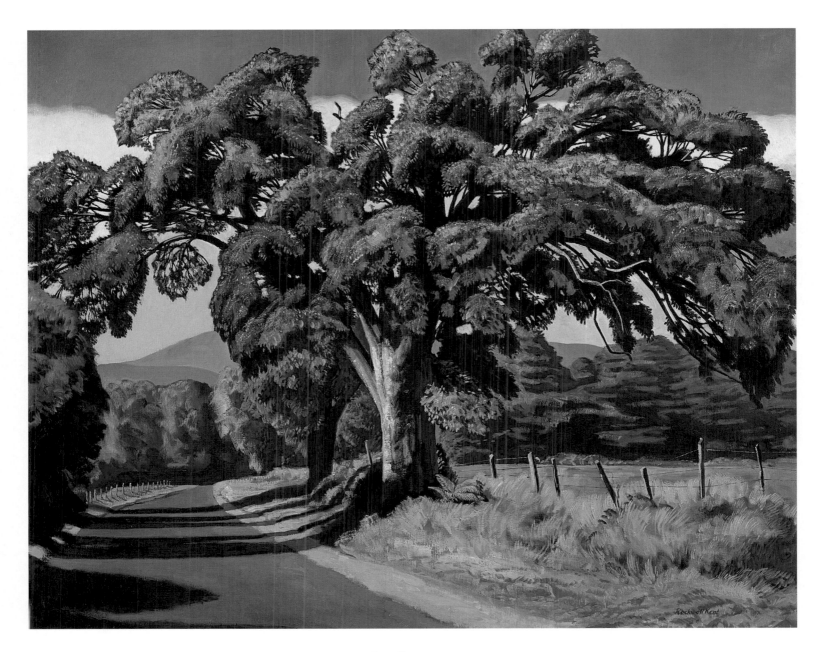

84. **Rockwell Kent** (1882–1971)
Ancient Elm, ca. 1961–62, oil on canvas, 38 × 44 inches
Signed lower right: *Rockwell Kent*

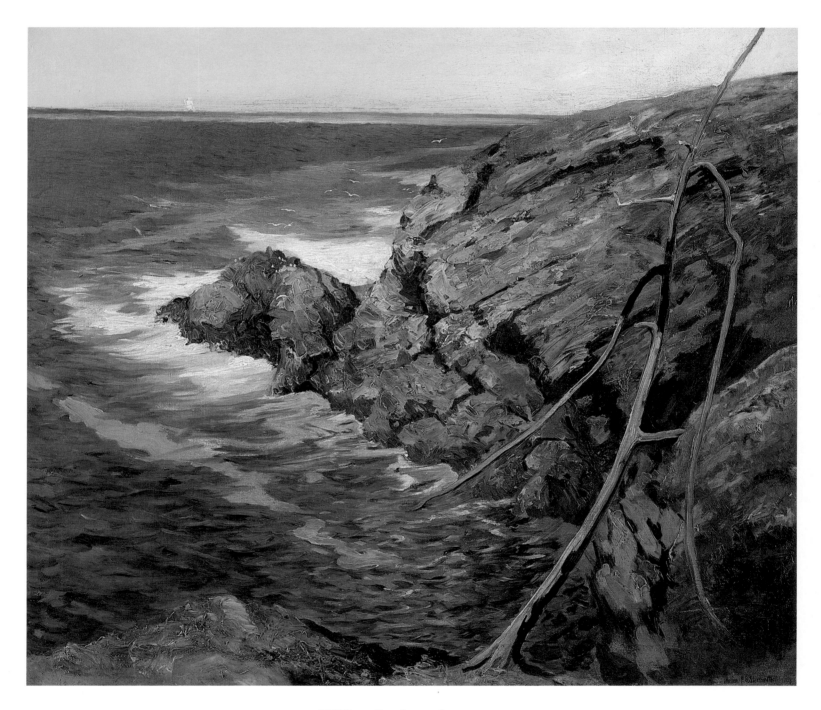

85. William Starkweather (1879–1969)
Cliff at Grand Manan, Canada, 1934, oil on canvas, 24 × 28 inches
Signed lower right: *William [illeg.] Starkweather*; signed, dated, and inscribed on verso:
Cliff at Grand Manan Island. N.B. Canada / Painted 1934 by William Starkweather

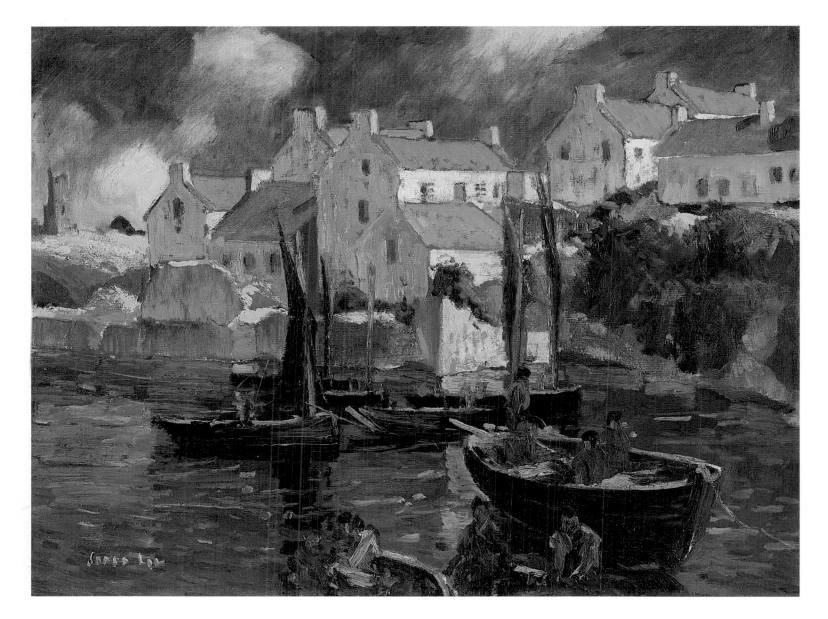

86. **Jonas Lie** (1880–1940)
Brittany Fisher Boats, ca. 1931, oil on canvas, 15 × 23½ inches
Signed lower left: *Jonas Lie*

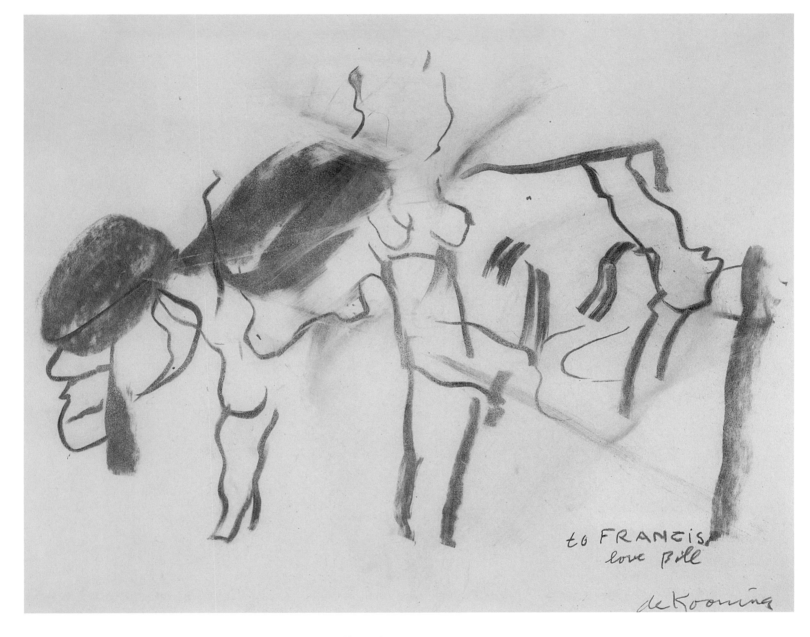

87. **Willem de Kooning** (1904–1997)
Untitled (Figures), ca. early 1970s, charcoal on paper, 18½ × 23½ inches
Signed lower right: *de Kooning*; dedicated lower right: *to Francis / love Bill*

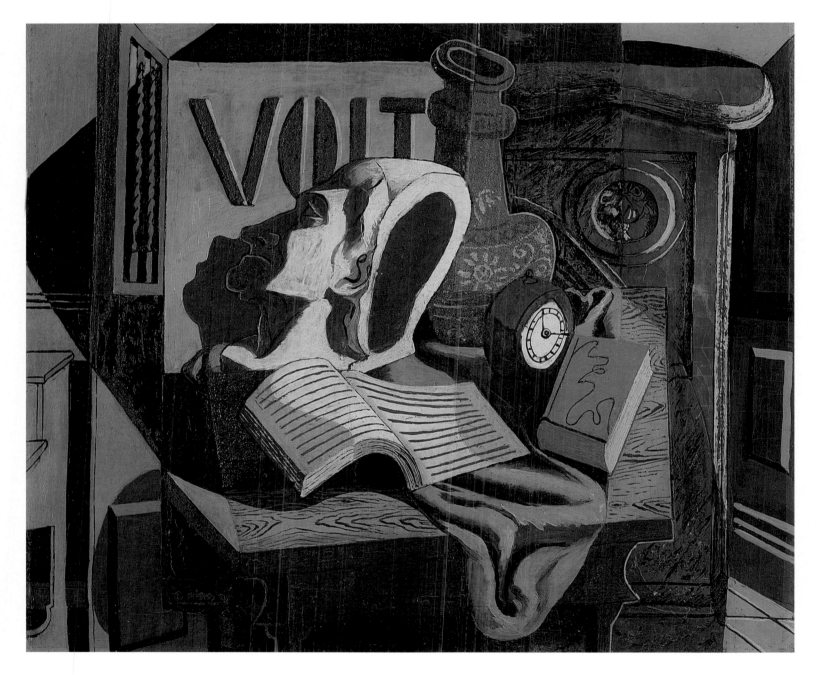

88. **Francis Hyman Criss** (1901–1973)
Still Life, 1930, oil on canvas, 20¼ × 24½ inches
Signed and dated lower left: *Criss 30*

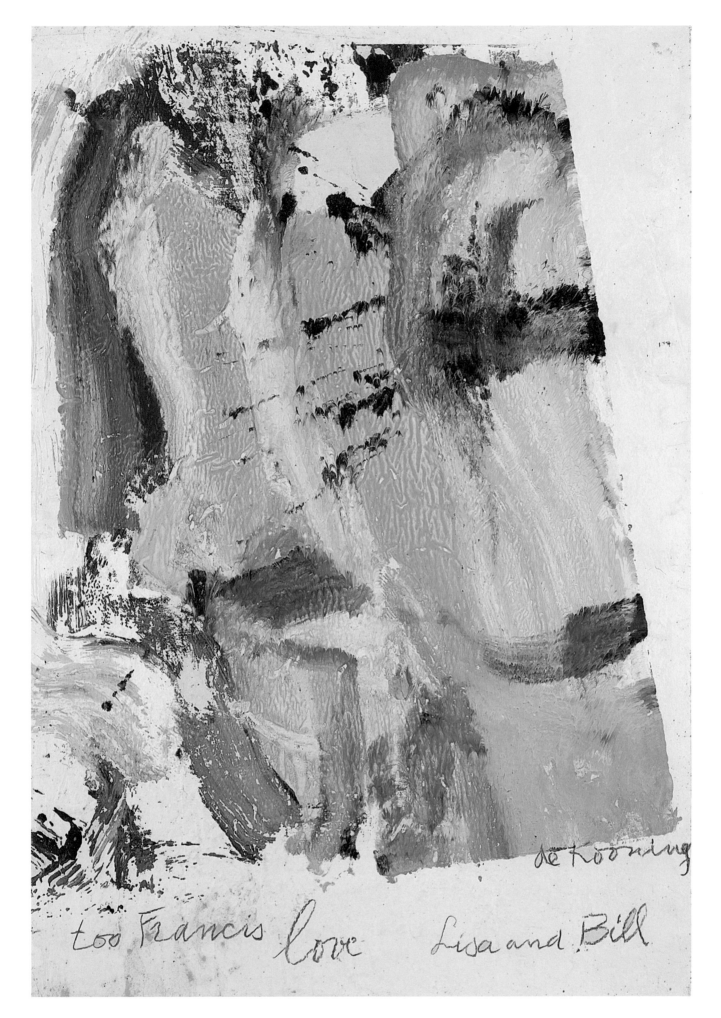

89. Willem de Kooning (1904–1997)

Abstraction, ca. mid-1970s, oil on paper mounted on canvas, 29½ × 18¾ inches

Signed lower right: *de Kooning*; dedicated bottom left: *too Francis / love Lisa and Bill*

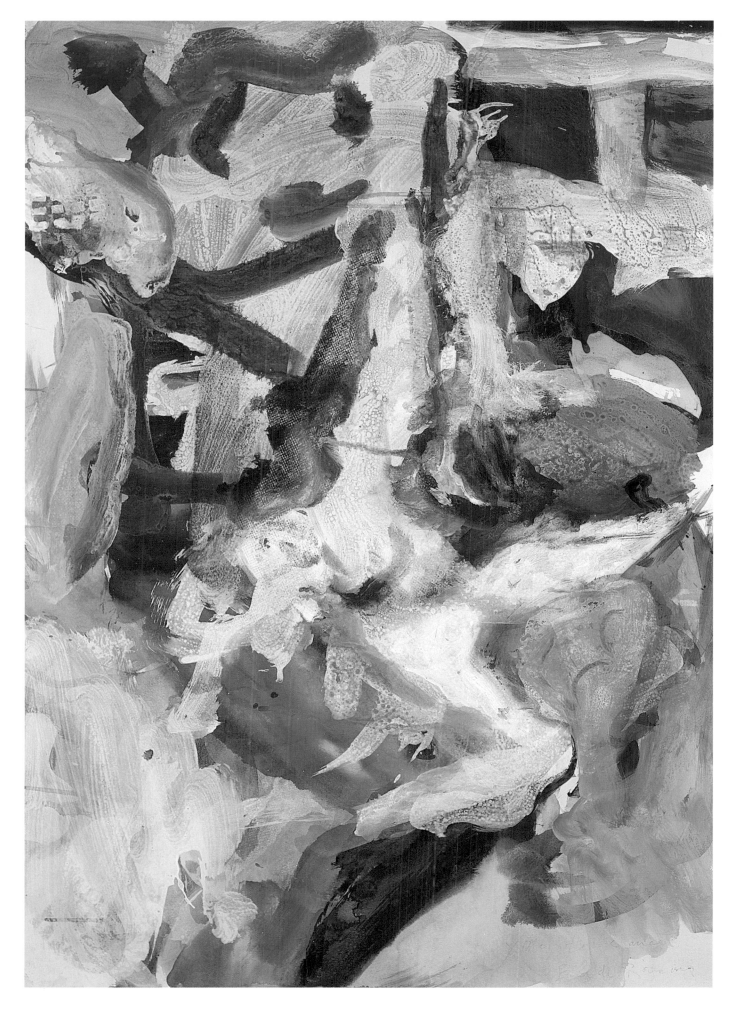

90. Willem de Kooning (1904–1997)
Xmas to Frances, ca. late 1960s – early 1970s, mixed media on paper mounted on canvas, 42 × 29½ inches
Signed and dedicated lower right: *Xmas to Frances / Bill de Kooning*

Biographies of the Artists

George Bellows (1882–1925)

George Bellows was an important early twentieth-century American realist painter, best known for his dynamic and spontaneous depictions of New York City as well as his landscapes and his lively images of prize fights. Born in Columbus, Ohio, Bellows attended Ohio State University and studied painting at the New York School of Art, where he was Robert Henri's star pupil. Bellows established his own studio in 1906 and was elected an associate member at the National Academy of Design in 1909. In the years that followed he taught at the Art Students League, helped to organize the Armory Show of 1913, and contributed his prints to books and magazines, including the journal, *The Masses*. He also explored art theory, drawing on the color principles of Denman Ross and Hardesty Maratta and the doctrine of "Dynamic Symmetry" espoused by Jay Hambidge. Bellows spent summers painting landscapes in New England and upstate New York. He especially favored the coast of Maine, which is featured in many works, and the town of Woodstock, New York, where he bought a home in 1921. He traveled as far west as Carmel, California, where he spent the summer of 1917. The artist died suddenly of appendicitis when he was forty-two years old and at the height of his fame. A memorial exhibition was held at the Metropolitan Museum of Art, New York.

Frank W. Benson (1862–1951)

A leading figure in the Boston School of painting, Frank W. Benson won acclaim in the early twentieth century for his images of women and children, shown outdoors in the sunlight or inside in elegant, discreetly lit interiors. He was born in Salem, Massachusetts, and received his art training at the School of the Museum of Fine Arts, Boston, and in Paris at the Académie Julian. Benson returned from Europe in 1885, and three years later moved to Boston, where he became an instructor at the School of the Museum of Fine Arts. Along with his close friend and fellow teacher Edmund C. Tarbell, Benson helped to establish the school as one of the outstanding art instruction facilities in the United States. In 1898 Benson joined a number of artists from New York and Boston to form the Ten American Painters, a group dedicated to participating in small exhibitions of high-quality work. Beginning in 1901, Benson spent summers on North Haven Island, Maine, located in Penobscot Bay. There he painted vivid Impressionist images featuring the island's open sunlit hills and his wife and children, clad in white, on hillsides and at the water's edge. In his studio during the winter, Benson maintained a more traditional approach, depicting quiet interiors inhabited by carefully wrought figures in works that evoke the art of the Dutch Little Masters, Jan Vermeer in particular. Always a passionate naturalist and outdoorsman, in the 1920s, Benson focused on wildlife, sporting, and hunting scenes. His depictions of these subjects in oil, watercolor, pen and ink, and etching were extremely popular.

Albert Bierstadt (1830–1902)

Albert Bierstadt was one of America's preeminent nineteenth-century landscape artists. His paintings of the American West, executed in a tight, naturalistic style with an emphasis on dramatic lighting and pictorial scale, celebrated the inherent beauty and majesty of the Western landscape. Although he was born in Solingen, Germany, Bierstadt grew up in New Bedford, Massachusetts. By 1853 he was in Düsseldorf, where he discovered the work of Carl Friedrich Lessing and Andreas Aachenbach, two painters widely admired for their heroic, highly finished landscape compositions. In 1859 Bierstadt joined Colonel Frederick W. Lander's Overland Trail expedition, a decisive event in his career. The large-scale, panoramic landscapes that he later completed from his sketches and stereoscopic photographs proved immensely popular and established him as the foremost painter of the American frontier. In 1860 the members of the National Academy of Design elected him a full academician. After several painting trips to New Hampshire's White Mountains and to the southern United States, Bierstadt made a second journey west in 1863, resulting in works such as his monumental *The Rocky Mountains, Lander's Peak* (1863; Metropolitan Museum of Art, New York). Over the next two decades the artist visited Europe, the Bahamas, Alaska, and British Columbia, producing paintings that were conspicuous for their naturalistic detail and dramatic, almost sublime, lighting effects. Although Bierstadt's popularity declined during the latter part of the century, he continued to paint until his death in 1902.

Abraham J. Bogdanove (1886–1946)

Abraham J. Bogdanove was a landscape painter, portraitist, muralist, and art teacher, who is best known for his dynamic images of Monhegan Island, Maine. Born in Minsk, Russia,

Bogdanove immigrated with his family to the United States in 1900. Settling in New York, he studied at the Cooper Union Institute of Art, the National Academy of Design, and the Columbia University School of Architecture, where he trained under the prominent mural painter, Francis Davis Millet. Bogdanove created a number of important murals between 1913 and 1930, but by the 1910s, he was devoting most of his time to landscape painting. He first visited the coast of Maine in 1915, and in 1918 he made his initial sojourn to Monhegan Island, seventeen miles off the state's midcoast. For the rest of his life, he returned annually to Monhegan, where he purchased a home on Horn Hill and spent his days painting at the water's edge, directly recording the rocks, surf, weather-beaten fish houses, and harbor scenery. Influenced by the work of color theorist and chemist Maximilian Toch, who advocated the use of natural pigments and a limited palette, Bogdanove produced works with harmonious color schemes and permanent colors. Their strong, abstract qualities reflect the artist's responsiveness to developments in twentieth-century modernism. During the mid-1930s, Bogdanove painted in Canada's Gaspé Peninsula and in Europe. From 1918 until 1942, he taught at Townsend Harris High School of the College of the City of New York (now City College of the City University of New York). Following his retirement from teaching, Bogdanove moved to Dunbarton, New Hampshire.

Franklin D. Briscoe (1844–1903)

A painter of seascapes, history subjects, and portraits, Franklin D. Briscoe was a respected figure in Philadelphia art circles during the last quarter of the nineteenth century. A native of Baltimore, he grew up in Philadelphia, where, at the age of sixteen, he studied under the noted marine painter Edward Moran. He later supplemented his formal studies through travel abroad, studying the art of past and present in the galleries of London, Paris, and Munich. Briscoe initially specialized in maritime themes inspired by his extended voyages to Europe and Great Britain. Indeed, his depictions of boats and the sea were vital in establishing his reputation, attracting the attention of critics and collectors for their masterful technique and sense of romantic drama. In 1885 the artist enhanced his standing in local and national art circles with *The Battle of Gettsyburg*, a major historical work (location unknown), comprised of ten separate panels, that was circulated to museums and galleries throughout the United States. Briscoe's paintings were also shown intermittently at the Pennsylvania Academy of the Fine Arts and the Brooklyn Art Association. His career was cut short by his untimely death in Philadelphia at the age of fifty-nine.

George Loring Brown (1814–1889)

Called "the most celebrated of American landscape painters abroad" by scholar Edgar P. Richardson, George Loring Brown was an extremely important figure in expatriate art circles in Italy. He was esteemed for his romantic and panoramic views of the Italian countryside, and he was often referred to as the American "Claude" due to his large and structured compositions, which capture the luminous qualities of moonlit and misty skies and express the grandeur of landscapes that resonated with evidence of the great civilizations of the past. Brown was born in Boston and began his career as an apprentice to the wood engraver Alonzo Hartwell. He later studied with the Boston portraitist George P. A. Healy. In the summer of 1862, he traveled to Europe, visiting Antwerp, London, and Paris. In Paris, Brown became a student of landscape painter Eugène Isabey and spent his time copying works at the Louvre. After returning to Boston in 1834, he spent five years traveling in New England, illustrating song sheets and painting portraits, miniatures, and landscapes. Traveling to Europe again in 1840, he established his home in Florence. Eight years later, he settled in Albano, Italy, which became his base for sketching trips in and around Rome. In the 1850s, he had a studio in Rome, where he entertained American painters Worthington Whittredge, George P. Healy, and American sculptors Thomas Crawford and Randolph Rogers. After returning to the United States in 1859, he settled initially in New York, and spent summers in Newport, Rhode Island, the White Mountains, and Medford, Massachusetts. In 1864 he moved to South Boston, where he produced several important Italian subjects, but he also concentrated on creating views of New England, focusing especially on the White Mountains. In 1879 Brown purchased a home in Malden, Massachusetts. Throughout his career, he was a frequent exhibitor at the Boston Athenaeum, the National Academy of Design, and the Pennsylvania Academy of the Fine Arts.

Emil Carlsen (1853–1932)

Emil Carlsen was a painter of elegant, classically influenced still lifes and Impressionist landscapes. He initially trained as an architect in his native Denmark, but after immigrating to the United States and settling in Chicago in 1872, he turned his attention to art, studying at a school that would become part of the city's Art Institute. His career was given direction in 1875, when, during a sojourn in Paris, he became enamored of the still lifes of the eighteenth-century French artist Jean-Baptiste Chardin. He was soon emulating Chardin in works through his use of tactile surfaces, tonal harmonies, and balanced compositions. After studying at the Académie Julian in Paris from 1884 to 1886, Carlsen moved to San Francisco, where, for five years, he shared a studio with prominent local painter Arthur Mathews and taught at the California School of Design (now the San Francisco Art Institute). On returning to New York in 1891, Carlsen began to teach at the National Academy of Design and at the Pennsylvania Academy of the Fine Arts in Philadelphia. In the early twentieth century, he bought a house in Falls Village, Connecticut, where he derived many of his landscape subjects from the nearby countryside.

William Merritt Chase (1849–1916)

William Merritt Chase was a dominant figure in nineteenth-century American painting and in the American Impressionist movement. Born in Williamsburg, Indiana, a small town near Indianapolis, he studied in New York and Munich. On his return to the United States in 1878, he settled in New York, where he became a leader of a generation of cosmopolitan artists who employed styles influenced by modern European art. He was one of the first and most important teachers at the Art Students League and was a prominent exhibitor at the newly formed Society of American Artists. In the late 1870s and early 1880s, Chase often depicted his ornately decorated studio in New York's famous Tenth Street Studio Building, creating images that summed up the experience of the worldly bachelor artist. After his marriage in 1886 to Alice Gerson, Chase lightened his palette and focused greater attention on American subject matter and domestic themes. In the mid- to late 1880s, he painted a series of sparkling views of leisurely life in New York City parks that anticipated his adoption of an Impressionist style in the next decade. From 1891 until 1902, Chase conducted outdoor summer classes in Shinnecock, Long Island, where he painted his wife and growing family and the spare beauty of the coastal dunes. There, Chase formulated his own vital Impressionist approach, using the style to capture both the sensuous qualities of his subject matter and to convey the joyful feeling of summer. After closing the school, Chase summered abroad, holding classes for art students in Madrid, Florence, Bruges, Venice, and Haarlem. In 1903 he was elected a member of the Ten American Painters, taking the place left open by the death in the previous year of John Henry Twachtman. In the last decade of his life, Chase received high accolades for his art and was given one-artist shows in nearly every major American city.

Clarence K. Chatterton (1880–1973)

A native of Newburgh, New York, Clarence K. Chatterton initiated his formal studies at the Newburgh Academy. In 1900 he moved to Manhattan, enrolling at the New York School of Art with the intention of becoming an illustrator. However, encouraged by Edward Hopper, a fellow student, he switched his major to painting, developing a vigorous realist style. Upon returning to Newburgh in 1904, he went on to paint views of local and regional scenery—establishing a reputation as an interpreter of small-town America. In addition to working in the Hudson River Valley, Chatterton was active in Ogunquit and Monhegan Island, Maine. He exhibited his work in the national annuals and had solo shows at the Wildenstein Gallery and the Macbeth Gallery in New York. Chatterton was also a noted educator, teaching art at Vassar College from 1915 until 1948, when he retired with the rank of Professor Emeritus. Prior to leaving Vassar, Chatterton organized a number of exhibitions devoted to the work of contemporary realists such as Robert Henri, George Bellows, Gifford Beal, and Rockwell Kent.

Howard Chandler Christy (1872–1952)

A noted illustrator and painter, Howard Chandler Christy was born in Muskingum County, Ohio. Intent on pursuing an artistic career, he moved to New York in 1892 to study at the National Academy of Design. He also received instruction from the Impressionist painter William Merritt Chase at the Art Students League and in Shinnecock, Long Island. By 1895, he had demonstrated considerable talent as a landscape and portrait painter, but to Chase's dismay, Christy decided to focus on book and magazine illustration instead. He went on to become one of the country's top illustrators, contributing to periodicals such as *Scribner's*, *Collier's*, and *Harper's Weekly*. Christy is best known for creating the beautiful and high-spirited "Christy Girl," a "type" of female figure that appeared frequently in his book and magazine work. From about 1920 until his death in New York in 1952, Christy did little illustration work, preferring to spend his time painting portraits of notables, such as presidents Harding and Coolidge and aviator Amelia Earhart. He also produced historical subjects and colorful landscapes that reflect the legacy of his earlier training with Chase.

Frederic Edwin Church (1826–1900)

For his spectacular and panoramic paintings of the wilderness of North and South America, Frederic Edwin Church was a dominant figure in the second generation of the Hudson River School. His canvases celebrated the drama of the American frontier and expressed the expansionist and optimistic outlook of the United States in the mid-nineteenth century. Born in Hartford, Connecticut, Church received his first art training from local painters Benjamin Hutchins Coe and Alexander Hamilton Emmons. In 1844, with the help of the art patron Daniel Wadsworth, he became the first pupil of Thomas Cole. After two years, Church moved to New York, where he was one of the youngest artists to be elected an academician at the National Academy of Design. Soon he was training pupils of his own, including Jervis McEntee and William James Cole. After exposure to the writings of Alexander von Humboldt, a German naturalist-explorer, Church gradually began to take a more scientific approach to nature, using sketches he had created in the outdoors in the preparation of his canvases. In 1853 he became the first American artist to visit South America, when he traveled along Humboldt's 1802 route from Colombia to Ecuador. When his works based on the expedition received high praise, Church was emboldened to return to South America, and he set off on a second expedition in 1857 with the landscape painter Louis Remy Mignot. This trip resulted in Church's celebrated *Heart of the Andes* (1859; Metropolitan Museum of Art, New York). During the next two decades, Church continued to travel, seeking subject matter for his paintings in the tropics, as well as in Europe and the Middle East. By 1880 Church's painting activity was curtailed due to ill health, and in 1883, rheumatism crippled his right arm and hand. In 1890, he settled at Olana, his grand villa near Hudson, New York,

which had been designed for him in the Persian and Moorish styles by the architect Calvert Vaux in 1870. The house, which is preserved as a museum today, reflected Church's eclectic interests and his travels, including exotic furnishings and decorative objects. Although he spent the winters of his last years in Mexico, Church spent most of the final phase of his life at Olana.

George Lafayette Clough (1824–1901)

George Lafayette Clough was a painter of landscapes and portraits, who combined the realism of the Hudson River School with the more poetic style that became popular in late nineteenth-century American art. He was born in Auburn, New York, and studied first with the local artist Randall Palmer and later with the well-known portraitist Charles Loring Elliot. Clough traveled to Europe in 1840, where he visited Holland, Germany, Italy, and France. On his return to the United States, he settled in New York, where he began to create pastoral landscapes. He found his sites in the Catskill Mountains as well as in the Adirondacks, where he captured the region's clear light and numerous lakes, streams, rivers, and fertile valleys. He specialized in images in which he brought out the human and recreational aspects of the Adirondacks, portraying scenes of camping and fishing as well as depicting sawmills. Clough was a member of the Brooklyn Brush and Palette Club and was president of the Brooklyn Art Association for seven years.

Maximilien Colin (1862–ca. 1893)

A painter of genre scenes and figural works, Maximilien Colin was known in New York and Parisian art circles in the late 1880s and early 1890s. He was born in New York and began his career as a newspaper illustrator. By 1884 he was living in Paris, where he studied with the American painter of peasant genre scenes Henry Mosler, as well as with the Parisian academic artists Benjamin Constant and Frederic Cormon. Between 1888 and 1893, Colin exhibited at the Paris Salon, the National Academy of Design in New York, the Boston Art Club, the Pennsylvania Academy of the Fine Arts, and the Art Institute of Chicago. By 1893 he had returned to New York; that year a sale of his oils and watercolors was held at the Holbein Company Art Galleries. Colin may have died shortly after the Holbein sale, because 1893 is the last year that he exhibited his work.

Paul Cornoyer (1864–1923)

Born in St. Louis, Paul Cornoyer studied at the St. Louis School of Art while working as a reporter for a local newspaper. In 1889, he went to Paris, where he attended the Académie Julian, exhibited his paintings at the Salon, and visited the art capitals of Europe. During this period he began rendering cityscapes, a theme that occupied him for the rest of his career. He returned to St. Louis in 1894 and remained there until 1898 when he moved to New York at the suggestion of the painter William Merritt Chase. Cornoyer subsequently turned his attention to the city's parks, streets, and squares, which he depicted in sunlight, moonlight, rain, and snow, often intermingling natural and artificial light. He exhibited his work at the national annuals and soon developed a reputation as one of the most significant interpreters of the American urban scene. Cornoyer was a popular teacher, attracting many students to his summer painting classes in Gloucester, Massachusetts. He moved permanently to East Gloucester in 1917 and died there six years later.

Francis Hyman Criss (1901–1973)

A painter identified with the American Precisionist movement, Francis Hyman Criss was renowned for his colorful, tightly rendered portrayals of the architectonic forms within the urban landscape, especially those of Manhattan. Criss was born in London but grew up in Philadelphia, where he studied at the Pennsylvania Academy of the Fine Arts. He also attended New York's Art Students League while supporting himself by designing screens for decorators. In the 1930s, Criss depicted New York's architecture—notably skyscrapers, subway kiosks, and the elevated subway trains—using a style inspired by the high-keyed, nondescript coloration and flat, two-dimensional planes of Synthetic Cubism. During the later 1930s, Criss helped to found An American Group, an organization of socially oriented artists such as Philip Evergood, William Gropper, and Jack Levine. His art of the time, which focused on humanistic themes and explored subjects related to fascism, was also imbued with Surrealist overtones. He returned to cityscapes in the 1950s, creating images closer to the Neo-Impressionist technique of Pointillism than with the hard-edged approach of his earlier period.

Jasper Francis Cropsey (1823–1900)

Jasper Francis Cropsey was a major figure in the Hudson River School and one of our finest mid-nineteenth-century landscape painters. He was born in Rossville, on Staten Island, and trained as an architect in the Manhattan office of Joseph Trench. His interest in watercolor renderings led him to try his hand at painting, and in 1843, the same year he opened a private architectural practice, he exhibited one of his first paintings at the National Academy of Design. By 1845 he had abandoned architecture to devote his energies entirely to landscape painting. During the 1850s he painted throughout New England, and between 1856 and 1863 he lived in London. When he exhibited *Autumn—On the Hudson River* (1860; National Gallery of Art, Washington, D.C.) at a London gallery, he gained renown

on both sides of the Atlantic. In 1867 Cropsey achieved a life-long ambition when he designed and built Aladdin, a Gothic-style mansion in Warwick, New York, equipped with a spectacular, skylit painting studio. Here he painted throughout the 1870s, studying his treasured sketchbooks and drawing on his memories to fuel his prolific brush. His work from the last fifteen years of his life, much of it in watercolor, reveals Cropsey's enthusiasm for an idealized, optimistic view of the United Sates as symbolized by its landscape.

Arthur B. Davies (1862–1928)

Recognized for his distinctive and highly personal mode of artistic expression, Arthur B. Davies played a vital role in the development of American modernism. A figure painter, he was renowned for his Symbolist-inspired renderings of female figures in ideal Arcadian landscapes, which carried on the tradition of American visionary painting established by such artists as Albert Pinkham Ryder and Ralph Blakelock. Davies exhibited his work with the group of artists known as the Eight, held at the Macbeth Gallery in New York in 1908. He later helped organize the 1913 Armory Show, a watershed event in the history of American art. Despite his enthusiastic support of the avant-garde, Davies eschewed Cubist fragmentation and the vivid coloration of Fauvism in favor of a realist style influenced by European Symbolism, German romanticism, and his own inner vision of nature. Throughout his career, Davies produced oils and pastels, crayon and pencil drawings, as well as lithographs, drypoints, and sculptures. Toward the end of his life, he executed many watercolors, taking advantage of the medium's fluidity, transparency, and easy portability.

Dawson Dawson-Watson (1854–1939)

An important landscape, portrait, and figure painter, Dawson Dawson-Watson was born in London, England. He received his first art lessons from his father, John, a painter and illustrator. Later he studied with the English painter Mark Fisher, who sparked his interest in Impressionism. In 1886 he went to Paris, continuing his training under Charles-Emile-Auguste Durand (Carolus-Duran), Léon Glaize, Raphael Collin, and others. From 1888 until 1893, Dawson-Watson lived and worked in Giverny, France, where he associated with American artists such as John Leslie Breck and Theodore Robinson and painted landscapes and scenes of rural life, conjoining academic precepts of form and structure with the bright colors of Impressionism. In 1893 he moved to Hartford, Connecticut, serving as director of the Hartford Art Society from 1897 to 1901. From 1893 until 1904, when he joined the faculty of the St. Louis School of Fine Arts at Washington University, he painted in the New England countryside and at various times in England, Québec, and Woodstock, New York. He founded the Dawson-Watson Summer School of Painting and Handicraft in Brandesville,

Missouri, in 1912. In 1927 Dawson-Watson settled permanently in San Antonio, Texas, where he established a reputation as a painter of Texas wildflowers.

Willem de Kooning (1904–1997)

One of the most important and influential members of the Abstract Expressionist movement, Willem de Kooning drew upon a variety of sources, such as Cubism, Surrealism, and Abstraction, to create his own original and highly complex visions. Throughout his career he focused on two themes—the human figure, especially women, and landscape—producing powerful and highly expressive images. Born in Rotterdam, de Kooning attended art schools in Holland before immigrating to America in 1926. While living in New York's Greenwich Village, he fraternized with forward-thinking artists such as Stuart Davis and Arshile Gorky and began experimenting with techniques of color abstraction. During the late 1930s, he became linked to a group of artists that included the painters Jackson Pollock and Franz Kline and the sculptor David Smith, all of whom became part of the so-called New York School. Along with Pollock, de Kooning became an unofficial spokesman for Abstract Expressionism, helping develop the style known as "gestural" or "Action" painting. The artist lived and worked in New York until 1963, when he moved to The Springs in East Hampton, Long Island.

Paul de Longpré (1855–1911)

A talented *fleuriste*, Paul de Longpré began his career in his native France, where he painted flower decorations on fans. Although he is said to have studied briefly under Léon Bonnat and Jean-Léon Gérôme while in Paris, he was basically a self-taught artist who drew inspiration directly from nature. He began exhibiting watercolors of flowers at the Paris Salon in 1876 and did so intermittently until 1890, when he lost his savings in a bank failure and immigrated to New York. De Longpré worked in relative obscurity until 1895, when, on the occasion of a major exhibition of his work at New York's American Art Galleries, he was hailed in *Art Interchange* as "America's foremost flower painter." Two years later, a writer for the *New York Times* lauded his ability to combine mood and poetic effect with "the knowledge of a botanist and a marvelous fidelity in the reproduction of both form and color." De Longpré became so successful that in 1898 he settled in California and built a lavish, Moorish-Mission-style villa in Hollywood. There he cultivated a three-acre flower garden that provided him with the fresh specimens he loved to paint. De Longpré depicted a variety of blossoms, favoring simple, harmonious arrangements shown against unadorned backgrounds. His firm draftsmanship, sensitive colorism, and awareness of the symbolic language of flowers contributed to his immense popularity at the turn of the last century.

Raoul de Longpré (b. 1843)

Raoul de Longpré came from a family of *fleuristes* associated with Lyons, France, an important center of flower painting during the nineteenth century. His father, Jean-Antoine, was a decorator of fans who exhibited floral still lifes in both Paris and Lyons, while his brother, Paul, was a professional flower painter, first in Paris and later in the United States. In contrast to Paul, who painted a wide range of flowers, Raoul was drawn to informal arrangements of lilacs and roses—depicted individually or together—which he portrayed in one of three ways: arranged on a stone ledge or plinth, newly cut and strewn on a floor or other surface, or as a bouquet floating mysteriously in the air. Like other flower painters of the nineteenth century, his choice of motifs was likely inspired by the language-of-flowers literature available in France and elsewhere in Europe. Working in watercolor or gouache, he combined surety of touch with a poetic and wistful interpretation of his subject. Although he never lived in America, his work found its way into many public and private collections in the United States, possibly through the efforts of Paul, who might have acted as his agent.

Thomas Wilmer Dewing (1851–1938)

Guided by his belief that "the purpose of the artist [is] to see beautifully," Thomas Wilmer Dewing became one of the best-known figure painters of his generation, renowned for his poetic depictions of attractive young women. Born in Newton Lower Falls, Massachusetts, he was apprenticed to a commercial lithographer as a teenager and is thought to have studied drawing under the physician-artist William Rimmer in Boston. He went on to refine his skills at the Académie Julian in Paris, before joining the faculty at the School of the Museum of Fine Arts, Boston and beginning to exhibit academic figure paintings at the national annuals. After moving to New York late in 1880, he married the painter Maria Oakey Dewing and taught at the Art Students League (1881–88). In 1885 he began spending summers in Cornish, New Hampshire; his presence helped establish Cornish as a major art colony. Dewing specialized in allegorical figure subjects until about 1890, when he turned his attention to elegantly dressed women posed in spare interiors or in idyllic landscapes, portraying his subjects with soft brushwork and a subtle tonal palette that gave his work an ethereal quality. His paintings were avidly collected by patrons such as Charles Lang Freer and John Gellatly. Toward the end of his career, Dewing produced pastel and silverpoint drawings that, like his paintings, underscore his exquisite draftsmanship. A landmark exhibition of his work—*The Art of Thomas Wilmer Dewing: Beauty Reconfigured*—was organized by the Brooklyn Museum of Art in 1996.

Arthur Wesley Dow (1857–1922)

As an artist, a teacher, and a leader of the American Arts and Crafts revival at the turn of the twentieth century, Arthur Wesley Dow was an important figure in many facets of the art scene of his time. Most significantly, he developed a new philosophical approach to art that synthesized Eastern and Western aesthetics. Exemplifying his brand of Synthetism, his own works were far ahead of their time, while his ideas influenced the modernist artists of the next generation, including his students Max Weber and Georgia O'Keeffe. Dow was born in Ipswich, Massachusetts, and studied in Worcester, Massachusetts, and Boston, before continuing his training in Paris in 1884. After he returned to America from Europe in 1887, he became interested in Egyptian and Aztec artifacts, which he saw in Boston at the Public Library and the Museum of Fine Arts. He also studied the prints of the Japanese artist, Hokusai and began making woodcut prints of Massachusetts's North Shore that were inspired by a Japanese appreciation of nature. In 1893, Dow was appointed assistant curator of the Japanese collection at the Museum of Fine Arts, and in 1899 he published his book *Composition*, which disseminated his ideas to art students in the public schools. Dow later wrote additional books on design including *Theory and Practice of Teaching Art* (1908) and *Constructive Art Teaching* (1913). He also had an active career as an art instructor, teaching at the Pratt Institute in Brooklyn, the Art Students League in New York, and Columbia University's Teachers College. After 1900 Dow maintained a studio in his native Ipswich and conducted summer classes there. The nearby marshes and the area of Bayberry Hill were frequent subjects of his landscapes. His work in print mediums took up most of his time during the first decade of the century but, when he returned to oils in 1907, he began to experiment with a brighter palette and more expressive brushwork. Trips he made to the Grand Canyon in 1911 and 1912 resulted in original works filled with vivid color harmonies. In the last phase of his career, Dow painted often at Gay Head, on Martha's Vineyard; he also visited the West Coast, painting in Oregon and California.

Victor Dubreuil (active 1880–1910)

Very little information has emerged about the life of Victor Dubreuil. A creator of humorous trompe l'oeil works, the artist was probably based for much of his career in New York. Due to its imagery and stylistic approach, his art appears to have been shaped by an awareness of the works of Philadelphia trompe l'oeil painter, William Harnett; Dubreuil painted a number of the illusionistic depictions that Harnett had popularized including tabletop pictures and other still-life subjects. However, the subject with which Dubreuil is most closely associated is that of money. The majority of his works depict this motif, portraying meticulous reproductions of individual dollar bills, wads of currency, even barrels overflowing with cash. His works often depict money and other motifs defined by dark outlines and set within a heavy grid patterns that serve as the basis for his compositions. The artist occasionally used clever gimmicks intended to suggest the accessibility of currency to viewers. Indeed, the realism of one of Dubreuil's images of money barrels led to its being confiscated by the Secret

Service and kept at the Treasury in Washington until it was eventually destroyed. Dubreuil also became known for fastidious pictures of photographs of George Washington and Grover Cleveland and reproductions of well-known proclamations.

Charles Warren Eaton (1857–1937)

A major figure in the American Tonalist movement, Charles Warren Eaton painted evocative landscapes in New Jersey, New England, and Europe. Guided by his desire to convey the underlying moods of nature, he eschewed grandiose vistas in favor of quieter, more intimate views, which he depicted at dawn or dusk. Born in Albany, New York, Eaton studied in New York at the National Academy of Design and the Art Students League. A trip to Europe in 1886 provided him with the opportunity to study contemporary art. However, the most important influence on his aesthetic was George Inness, a painter of poetic landscapes in the Barbizon mode, whom he met in 1889. Eaton established a summer residence in Bloomfield, New Jersey, in 1887 and spent the next decade depicting the local countryside during the late autumn and winter. After 1900, he made seasonal visits to Thompson and Colebrook, Connecticut, where he developed his signature theme—a grove of pine trees silhouetted against sunset or moonlit skies. Eaton was also active in Belgium, Italy, and Glacier Park, Montana.

William Forsyth (1854–1935)

An important figure in the artistic life of Indiana during the early twentieth century, William Forsyth was affiliated with the Hoosier School of American Impressionism. Along with fellow artists J. Ottis Adams and Theodore Steele, he focused his attention on depicting regional scenery, painting pictures "with a vigor and virility that show a love for nature in her moods and a love for the tools of her art." Born in California, Ohio, Forsyth studied under John Love at the Indiana School of Art (1877–79), and went on to attend the Royal Academy of Art in Munich (1882–86), where he fraternized with fellow students Steele and Adams. While in Munich, Forsyth honed his landscape skills outside the academy, receiving informal critiques from the American painter J. Frank Currier in the nearby village of Schleissheim. Forsyth returned to Indiana in 1888. By the early 1890s he was painting colorful, Impressionist-inspired depictions of southern Indiana, working along the Muscatatuck River, and at Old Vernon, and later in and around Corydon and Hanover. Forsyth held various teaching positions until 1906, when he became chief instructor of drawing and painting at the John Herron Art Institute, remaining there until 1933. Through his painting, teaching, and writings, he did much to promote artistic activity in the Midwest. In one of his many articles, Forsyth set forth the aesthetic mandate for the Hoosier School, stating: "To live out-of-doors in intimate touch with nature, to feel the sun, to watch the ever-changing face of the landscapethis is the heaven of the Hoosier painter."

Alexis Jean Fournier (1865–1948)

Alexis Jean Fournier was a talented landscape painter who drew his subject matter from a variety of locales, ranging from western New York to the Ile-de-France. Born in St. Paul, Minnesota, he received his earliest art lessons from a scene painter in Milwaukee where, as a youth, he sold newspapers and worked as an office boy. In 1879 he moved to Minneapolis, painting signs and stage scenery and studying with the academic painter Douglas Volk. In 1893 he went to Paris, attending classes at the Académie Julian. He returned to Minneapolis two years later, but in the ensuing years made additional trips to France, where his work was greatly influenced by the example of the French Barbizon School. In 1903 he became artist-in-residence at the Roycroft Arts and Crafts Colony in East Aurora, New York, his summer home until 1937, when he settled there permanently. Fournier painted landscapes in and around East Aurora and in popular art colonies such as Woodstock, New York; Provincetown, Massachusetts; and Brown County, Indiana. During the 1920s, he moved away from his Barbizon approach and began incorporating the bright colors and broken brushwork of Impressionism into his work.

Sears Gallagher (1869–1955)

Recognized as one of America's leading watercolorists and etchers during the early twentieth century, Sears Gallagher depicted a variety of themes, ranging from European subjects to New England scenery. A native of Boston, he studied drawing with the Italian artist Tomasso Juglaris and watercolor techniques with the British painter, Samuel P. R. Triscott. After further study at the Académie Julian in Paris (1894–96), he returned to Boston, working as an artist-reporter for a local newspaper and illustrating textbooks for the firm of Ginn and Company. By the early 1900s he had established himself as a professional artist specializing in works on paper. He was active in Italy and England and in the northeastern United States, including Cape Cod, Massachusetts, and Jackson, New Hampshire. Fond of "things coastal," he also made numerous visits to Monhegan Island, Maine, where he painted sparkling watercolors of rugged cliffs and local fisherfolk, working in a broad, fluid style. Admirers of his work included Loring Dodd Holmes, who noted in *A Generation of Illustrators and Etchers* (1960): Gallagher's "signature [was] inscribed all over his paper, in his selection of subject, in his manner of drawing, in his choice of color and his way of applying it."

Samuel Lancaster Gerry (1813–1891)

Considered to be the leader of New Hampshire's White Mountain School in the 1840s, Samuel Lancaster Gerry was a painter of landscapes, portraits, and miniatures that were characterized by their painterly qualities and strong color. The artist was born in Boston. Although he is not known to have received formal instruction, he may have been influenced by Asher

B. Durand and Thomas Cole in the United States and by Constant Troyon and Lambinet in Paris. He also studied art and became acquainted with American expatriates during three years that he spent abroad, in England, France, Switzerland, and Italy. At times Gerry copied other artists' works, including that of George Harvey and W. H. Bartlett. His landscape style was not derivative, however, demonstrating serene compositions and soft tonal effects. In 1854 he was one of the founders of the Boston Art Club. He became the organization's president four years later. Gerry exhibited his work at the American Art Union, the Boston Athenaeum, the National Academy of Design, and the Pennsylvania Academy of the Fine Arts, Philadelphia. He also participated in the Centennial Exposition in Philadelphia, in 1876.

Sanford Robinson Gifford (1823–1880)

One of the leading American landscape painters of the nineteenth century, Sanford Gifford was a second-generation Hudson River School artist whose extraordinary sensitivity to light and atmospheric effects links him to Luminist painting. Nature was the primary source of his art, but Gifford tended to value poetic expression over topographical exactitude. He was born in Greenfield, Saratoga County, New York, and grew up in Hudson, New York, across the river from the Catskill home of his idol, Thomas Cole. After attending Brown University for two years, he decided to devote his full attention to art. He studied in New York City with John Rubens Smith and at the National Academy of Design. His early instruction focused on drawing the human figure, but he soon elected to concentrate on landscape art. During two trips to Europe (1855–57 and 1868–69) he was exposed to a variety of artists and styles and was particularly impressed by the work of Turner, Constable, and the Barbizon painters. His fear that exposure to these different styles and schools of painting might unduly influence his direct engagement with nature never materialized, and the paintings he completed from his varied travels maintain a careful balance between style and content. Displaying a sensitive treatment of light, atmosphere, and the physical landscape, these images capture both the mood and poetry of the natural world.

Emile A. Gruppe (1896–1978)

An important figure in the artistic community of Cape Ann, Massachusetts, Emile Gruppe garnered acclaim for his vigorously rendered depictions of the waterfronts of Gloucester and Rockport. Born in Rochester, New York, he was the son of the landscape and marine painter Charles Gruppe, who gave him his earliest art lessons. He received his formal training in New York at the National Academy of Design and the Art Students League and in Paris at the Grande Chaumière. He later received instruction from John F. Carlson in Woodstock, New York, and Charles W. Hawthorne in Provincetown, Massachusetts, evolving a style in which he combined Impressionist strategies of light and color with a realistic portrayal of nature. He made his first visit to Gloucester in 1925, and four years later he began conducting outdoor painting classes there. He went on to open the Gruppe Summer School in Gloucester in 1942, which he operated until his death.

Edwin H. Gunn (1876–1940)

A respected engraver and painter, Edwin Gunn was born in New York City. As a boy, he and his four siblings attended plays, concerts, and art exhibitions under the guidance of culturally minded parents. After deciding on an artistic career, Gunn studied at the Cooper Union and at the National Academy of Design. He subsequently became an engraver of bank notes for the American Bank Note Company, where he was employed for forty-eight years. Gunn was also a painter in oil and watercolor, producing landscapes and rural subjects in an Impressionist style during summer trips to the family cottage in Port Clyde, Maine. He also painted views of Manhattan, exhibiting his work at the annuals of the National Academy of Design, the New York Water Color Club, the American Water Color Society, the Salmagundi Club, and elsewhere.

Philip Leslie Hale (1865–1931)

Philip Leslie Hale was an important member of the Boston School of figure painters and one of the most innovative of the American Impressionists. An influential and prolific critic, he is also recognized for his insightful writing on Impressionism and other aspects of turn-of-the-century art. A member of one of Boston's most distinguished families, Hale studied at the School of the Museum of Fine Art, Boston and the Art Students League of New York before continuing his studies in Paris during the late 1880s. He was among the first generation of American painters to work in the village of Giverny, and it was there that he abandoned his academic approach in favor of the bright hues and loose brushwork of Impressionism. During the 1890s, he evolved an advanced aesthetic, characterized by divisionist brushwork and a palette dominated by chrome yellow, that set him apart from his contemporaries and earned him a reputation as one of the boldest of the American Impressionists. After writing a book on the seventeenth-century Dutch painter Jan Vermeer in 1904, he adopted a more conservative style of figure painting, putting a greater emphasis on drawing and composition. A teacher at the Boston Museum School for over thirty years, Hale exhibited regularly at the national annuals and served on many award juries. He painted landscapes, garden subjects, and portraits, but images of attractive women in indoor and outdoor settings remained his forte. The artist resided in Boston until 1908, when he and his wife, the painter Lilian Westcott Hale, settled in the nearby suburb of Dedham.

Childe Hassam (1859–1935)

A preeminent American Impressionist, Childe Hassam painted a broad range of subjects, including landscapes of New England and Long Island, interior genre subjects, and still lifes. He was also the finest American Impressionist to focus on the urban scene, and his images of New York in all seasons encapsulate the beauty and vitality of the emerging metropolis. Hassam was born in Dorchester, Massachusetts, the descendant of sea captains and Revolutionary War patriots. He began his career as a wood engraver and illustrator and developed his skills as a painter through studies at the Boston Art Club (1877–78) and through private training with William Rimmer and Ignaz M. Gaugengigl. Hassam made his first trip to Europe in 1883, visiting England, France, Spain, Italy, and the Netherlands. Returning to Boston, he painted the city's streets and parks, often depicting them under rainy or overcast skies. He resided in Paris from 1886 to 1889, attending classes at the Académie Julian and assimilating Impressionist tenets. He returned to the United States in the fall of 1889 and settled in New York City, where he began to depict urban scenes with vibrant color and shimmering brushwork. He also painted landscapes, and from 1890 through 1920 one of his favorite summer painting locales was Appledore, one of the small islands off the New Hampshire coast. As a patriotic gesture, during World War I, Hassam created his famed "flag day" paintings, featuring the American flags that hung from the tall buildings along New York's Fifth Avenue. In 1904, 1908, and 1914, he made trips to the American West, painting in California and Oregon, where he was deeply inspired by the clear blue skies and rolling landscape. After 1915 he became involved in printmaking, becoming an accomplished practitioner, especially in etching. Four years later, he moved permanently to East Hampton, Long Island. Many of his later works in oil were characterized by his new willingness to experiment with pure color, simplified compositions, and elongated brushwork, reflecting his awareness of Post-Impressionist design principles.

Martin Johnson Heade (1819–1904)

A significant figure in the history of American Luminism and American still-life painting, Martin Johnson Heade was born in the Bucks County, Pennsylvania, town of Lumberville. His earliest works—portraits rendered in a flat, primitive style—were influenced by his first teacher, the folk painter Edward Hicks. After a second trip to Europe in 1848, Heade developed a more sophisticated handling and widened his range of subjects to include genre painting and figures rendered in a neoclassical style. During the 1850s Heade lived in New York's Tenth Street Studio building, where he came into contact with leading artists of the day. In particular, he was inspired by fellow resident Frederic Church, who encouraged him to focus on landscape painting. Heade's quiet, light-filled, and minutely detailed views of Lake George, rendered in the next decade, are characteristic of the American Luminist style and are akin to contemporaneous paintings by John Kensett of the same locale. During the 1860s Heade began to specialize in images of salt marshes in New Jersey and Massachusetts, among others, for which he is well known. While living in Boston from 1861 to 1863, he focused on marine scenes, depicting deserted coastlines with occasional sailboats in the distance and abandoned boats on the foreground shore. Heade's imagery as well as the feeling of stillness and melancholy expressed in these pictures suggests an affinity with the works of Fitz Hugh Lane. It was not until 1863 that Heade created his first still life. At the end of that year, he traveled to Brazil, where he furthered the still-life theme in a series of small pictures featuring various species of native hummingbirds. A trip to London to have these images reproduced in book form met with failure, and Heade returned to South and Central America in 1866 and 1870. These trips yielded a number of tropical landscapes, but their most significant result was the series of orchid and hummingbird images that he worked on until his death. From 1866 to 1881 Heade was based in New York City and produced the majority of his work in the studio. In 1883 he moved to St. Augustine, Florida, and, after his marriage at age sixty-four, he produced several new floral still-life series as well as a number of his most ambitious landscapes.

George Inness (1825–1894)

One of the most prominent figures in nineteenth-century American art, George Inness took a poetic and highly expressive approach to landscape painting. Born in Newburgh, New York, he studied with Regis Gignoux in New York City about 1843. His earliest landscapes were painted in the detailed manner of the Hudson River School. He traveled to Italy from 1851 to 1852 and to France from 1853 to 1854, where he was deeply impressed by the broadly painted rural landscapes of the French Barbizon School. So inspired, he changed his style, using rich colors and fluent brushwork to create mood and feeling. He also abandoned wilderness scenery and instead focused on the civilized landscape. In 1864 Inness moved to Eagleswood, near Perth Amboy, New Jersey. After periods of activity in Europe, Boston, and New York during the early-to-mid-1870s, he settled in Montclair, New Jersey, in 1878. In the ensuing years, he painted more dramatic subjects and explored the emotive possibilities of color. A spiritualist influenced by the teachings of the eighteenth-century religious thinker Emanuel Swedenborg, Inness sought to reconcile the real with the ideal, and in so doing, he produced some of his most imaginative canvases. These lyrical paintings of the 1890s—often woodland interiors at dawn or dusk—set the example for Henry Ward Ranger, Charles Warren Eaton, and other American Tonalists. As well as painting in New York, New Jersey and Connecticut, Inness was active in California and Florida.

David Johnson (1827–1908)

A landscape painter associated with the second-generation Hudson River School, David Johnson was born in New York

City. After studying at the National Academy of Design during 1845–46, he began making summer sketching trips to upstate New York, including the Catskill Mountains and the Genesee region. By 1849 he was exhibiting his work at both the National Academy and the American Art Union. Like most artists of his milieu, Johnson was also active in New England, including the White Mountains of New Hampshire. Many of his sketching trips were made in the company of fellow artists John F. Kensett and James W. Casilear. Johnson worked in the transcriptive style popularized by the mid-century Hudson River School until the late 1870s, when he modernized his approach, adopting a broader, more poetic manner indebted to the French Barbizon tradition. He was a resident of New York until 1904, when he settled in Walden, New York. Towards the end of his life, as critics and patrons alike began to focus their attention on the adherents of Impressionism and academic realism, Johnson's career slipped into relative obscurity. However, since about 1980, marked by the pioneering scholarship of the late John I. H. Baur, Johnson's oeuvre has attracted new attention and appreciation. Recent exhibitions have been organized by the Hudson River Museum in Yonkers and the Herbert F. Johnson Museum of Art at Cornell University.

Hugh Bolton Jones (1848–1927)

Hugh Bolton Jones was a painter of plein-air landscapes, who was associated with the Berkshires and Annisquam, Massachusetts. He was born in Baltimore and trained there at the Maryland Institute as well as in New York under Horace W. Robbins and Carey Smith. He traveled to Europe in 1876. During his four-year sojourn abroad, he trained briefly at the Académie Julian and spent time in the artists' colony in Pont-Aven, Brittany, where he fraternized with fellow Americans Thomas Hovenden, William Lamb Picknell, and Robert Wylie. Jones also took side trips to Tangiers, Italy, Belgium, Switzerland, and Spain. He settled in New York in 1881, and in the years that followed, he summered in South Egremont, where he painted his surroundings in the Berkshire Mountains. He also spent time in Annisquam on Cape Ann, often portraying the flat, marshy landscape stretching to the horizon. Jones's landscapes are noted for their sparkling light and crisp detail.

John Frederick Kensett (1816–1872)

John Frederick Kensett is renowned today as one of this country's preeminent nineteenth-century landscape artists. He produced a large body of work that is exceptional for its formal clarity and nuanced treatment of light and atmosphere, qualities that position him firmly within the American Luminist tradition. Born in Connecticut, Kensett initially worked as an engraver in his father's New Haven engraving firm before turning to landscape painting in the 1830s. In 1840 he sailed to Europe and spent the following seven years traveling and painting landscapes in England, France, Germany, Switzerland, and Italy. He was often accompanied by friends, including Asher B. Durand and John Casilear. While Kensett's early palette was rather dark and displayed rich impasto effects, he gradually adopted lighter, more luminous colors and tighter brushwork. His canvases quickly found a ready market, and after returning to New York in 1847, he was elected to the National Academy of Design. During the following years Kensett traveled extensively throughout New York and New England as well as to the West and returned to Europe several times. His work of the 1850s generally paralleled the topographically detailed landscape style common to the first-generation Hudson River School painters. It was during the 1860s that Kensett developed the extraordinary quality of light and atmosphere that characterizes his finest work. The landscapes and seascapes of that decade are equally remarkable for their spare, highly structured compositions, rich surface textures, and wonderful sense of tranquility.

Rockwell Kent (1882–1971)

Rockwell Kent achieved fame as a printmaker, muralist, illustrator, and writer. He was also renowned for his paintings of remote northern landscapes, executed in a powerful realist style. Born in Tarrytown, New York, Kent studied with the Impressionist painter William Merritt Chase at Shinnecock Hills, Long Island, during the early 1900s. In 1904 he enrolled at the New York School of Art, working under Chase and the realist painters Robert Henri and Kenneth Hayes Miller. One year later he began visiting Monhegan Island, Maine, where he painted seascapes and images of local fisherfolk that reflected his growing interest in the relationship between man and nature, a theme that would preoccupy him for the rest of his career. Drawn to isolated settings, Kent went on to spend periods of time in Newfoundland and Alaska. He settled in Vermont in 1920, the year he wrote and illustrated his first book, *Wilderness: A Journal of Quiet Adventure in Alaska,* which established his reputation on a national level. The artist continued to travel, visiting distant locales such as Tierra del Fuego, Greenland, France, and Ireland, all of which inspired his paintings and engravings as well as his writings, which included books such as *Voyaging* (1924), *N By E* (1930), *Rockwellkentia* (1933, with C. Zigrosser), *Greenland Journal* (1962), and his autobiography, *It's Me O Lord* (1955). In 1927 Kent settled on a farm near Ausable Forks in New York's Adirondack Mountains. A radical socialist and activist, he won the Lenin Peace Prize in 1967.

Daniel Ridgway Knight (1839–1924)

A leading member of the American expatriate art community in France during the late nineteenth century, Daniel Ridgway Knight was renowned for his bucolic depictions of French rural life. Indeed, the artist achieved popular and critical success in both France and the United States. He was born in Philadelphia and studied at the Pennsylvania Academy of the Fine Arts as well as in Paris, in the atelier of the Swiss-born painter Charles-Gabriel Gleyre and at the Ecole des Beaux-

Arts, where he worked under the history painter Alexandre Cabanel. Knight served in the Civil War and spent time in Philadelphia in the late 1860s. After traveling to France for his honeymoon in 1871, he decided to remain abroad permanently. The following year, he settled in Poissy, fifteen miles south of Paris, where he depicted his neighbors and friends, and focused particularly on peasant women seen washing clothes, tending sheep, or carrying water. Unlike Jean-François Millet, whom Knight met in 1874, his attitude toward his subjects was optimistic, and he showed them enjoying their lives in the outdoors. Knight's imagery and style share an affinity with the art of the French painter Jules Bastien-Lepage, who similarly included female peasants, rendered in crisp detail, in hazy, atmospheric settings. In about 1895 Knight moved to the town of Rolleboise. After his wife's death in 1911, he spent time in Paris, where he was recognized as the dean of American painters in France.

John La Farge (1835–1910)

One of the most creative artists of his day, John La Farge enjoyed a rich and varied career; he was active as a painter, stained-glass designer, muralist, and illustrator. Born to affluent parents in New York City, he attended Mount St. Mary's College in Maryland and then studied law. In 1856, while visiting Paris, he associated with leading French artists, copied Old Masters in the Louvre, and familiarized himself with modern color theories. He also studied briefly with the painter Thomas Couture, before traveling to England, where he saw examples of Romantic and Pre-Raphaelite painting. In 1858 he gave up law to pursue an artistic career. He subsequently went to Newport, Rhode Island, where he received instruction from the American Barbizon painter William Morris Hunt, a former Couture student. He also began drawing and painting directly from nature, focusing on landscapes and floral still lifes that in their fluent handling and simplicity of form had a distinctly modern look. During the 1870s and 1880s, he produced oils, watercolors, and book illustrations and executed murals and stained-glass designs for religious institutions such as Trinity Church in Boston, as well as for residences belonging to William H. and Cornelius Vanderbilt. On extended trips to the Orient and the South Seas during the 1880s and 1890s, he painted exquisite watercolors. La Farge's *Considerations on Painting*, based on a series of talks given at the Metropolitan Museum of Art in New York, was published in 1895.

William Langson Lathrop (1859–1938)

A noted figure in the American Tonalist movement and the "dean" of the New Hope Art Colony, William Langson Lathrop was born in Warren, Illinois. He grew up on a farm in Painesville, Ohio, spending his days painting and sketching the local countryside and making detailed drawings of farm machinery. During the 1880s, he moved to New York, working as an illustrator for leading magazines and studying briefly at the Art Students League (1887). After traveling and painting in England, France, and Holland during 1888–89, Lathrop returned to America and began exhibiting delicately rendered Tonalist landscapes at the Society of American Artists and elsewhere. In 1899 he settled in New Hope, Pennsylvania, where he continued to paint landscapes and ran a successful art school from his home, which also served as a gathering place for local artists. In 1916 he helped found the New Hope Group, an organization of painters, among them Daniel Garber and Robert Spencer, who specialized in depicting the regional landscape. About 1910, Lathrop brightened his palette in response to Impressionism, although he continued to adhere to a subtle interpretation of nature.

Jonas Lie (1880–1940)

A painter best known for views of New York City and the New England coast, Jonas Lie worked in a vigorous, colorful style reflecting the influence of French Impressionism and the realism of the Ashcan School. He was born in Moss, Norway, into a family that included a number of prominent figures in the art and literary world. In 1892, after his father's death, Lie moved to Paris. There he resided with his uncle and namesake, a noted writer, and focused his attention on becoming a painter, studying at a small private art school and visiting the Louvre. In the following year, Lie was reunited with his mother and sisters in New York. He subsequently studied art at the Ethical Culture School, and in 1896, he went with Dewing Woodward, one of his teachers, to Providence, Rhode Island, where he painted outdoors for the first time. After graduating from school, Lie took a job as a designer of textile patterns at Manchester Mills in New York and spent evenings attending classes at the National Academy of Design, Cooper Union, and the Art Students League. He left his job to concentrate full-time on art in 1906. Influenced by the Eight, he painted in a realist fashion with dark tonalities and vigorous brushwork. In the years that followed, he focused on painting coastal views in New England. He also portrayed scenes in the Adirondacks, in his native Norway, in Paris, where he concentrated on the river Seine, and in 1913, he created a series of important images of the Panama Canal. A popular and outspoken figure in the New York art scene, Lie helped to change outmoded policies at the National Academy of Design; he served as president of the academy from 1934 until 1939.

Dodge MacKnight (1860–1950)

The watercolorist Dodge MacKnight established a notable reputation in Boston art circles at the turn of the last century. A native of Providence, Rhode Island, he served an apprenticeship with a theatrical scene and sign painter before joining the Taber Art Company in New Bedford, Massachusetts, in 1878. In 1883 he went to Paris, studying under Fernand Cormon from 1884 to 1886 and exhibiting his work at the Salons. In 1886 he met the Post-Impressionist painter Vincent van Gogh, whom

he later visited in Arles and who influenced his penchant for bold colors. Between 1886 and 1897 MacKnight traveled and painted throughout Europe and the Mediterranean. Returning to the United States in 1897, he lived in Mystic, Connecticut, before settling in East Sandwich, on Cape Cod, in 1900. Thereafter he spent his summers in locales that provided him with interesting scenery and strong sunlight, such as the Grand Canyon, Spain, Jamaica, and Morocco. With their intense hues, his watercolors shocked many contemporary reviewers but were admired by such progressive-minded critics and artists as Philip Leslie Hale and Denman Ross. MacKnight's patrons included the important Boston collector Isabella Stewart Gardner, who displayed his striking watercolors in a specially created MacKnight Room in her mansion at Fenway Court.

Fletcher Martin (1904–1979)

Associated with Social Realism in the 1930s and 1940s, Fletcher Martin was a painter, muralist, and illustrator who worked in a realist style while incorporating principles of abstraction. He is known for his Western subjects as well as his images of boxers. He was born in Palisade, Colorado. After serving in the U.S. Navy from 1922 until 1926, the essentially self-taught artist worked on his own, often producing caricatures of his friends and supporting himself with lumberjacking and boxing. In the late 1920s, he moved to Los Angeles, where he worked at the Earl Hays Printers and began to fraternize with local artists. During the early 1930s, he assisted the noted Mexican muralist David Siquieros on a large fresco for Santa Monica and soon thereafter was receiving assignments for murals from the Works Progress Administration. During the second half of the 1930s, he painted frescoes for such buildings as the North Hollywood High School, the Federal Building, San Pedro, and post offices in La Mesa, Texas, and Kellogg, Idaho. In 1938 he began teaching at the Art Center School in Los Angeles. For the next thirty years he served as artist-in-residence or visiting professor at many prestigious institutions, including the Otis Art Institute, the Kansas City Art Institute, and the University of Iowa, to name only a few. At the same time, he continued to produce murals as well as to illustrate a number of books.

Mary Blood Mellen (1817–1882)

A painter of landscapes, seascapes, and still lifes, Mary Blood Mellen was the only known pupil of the leading American mid-century marine painter Fitz Hugh Lane. She was born in Sterling, Massachusetts, and attended the Fryville Seminary in Bolton, in her home state. In the 1840s, after settling with her husband, the Reverend Charles W. Mellen in Gloucester, Massachusetts, Mellen studied with Lane privately and eventually collaborated with him on a number of works. She also replicated a number of Lane's works, probably due to commissions. Mellen mastered her teacher's precise painting technique and his carefully designed compositions, while her glowing atmospheres and crisp details reveal her adherence to the Luminist aesthetic with which Lane is also associated. While Mellen adhered to Lane's brand of transcriptive realism, she tempered his crisp, meticulous brushwork and his emphasis on linear detail by interpreting forms with a more expressionistic technique, often blurring the edges of waves and clouds. She also described forms with softer volumes.

Willard Leroy Metcalf (1858–1925)

Willard Leroy Metcalf, a leading American Impressionist, was best known for scenes of the hills and rural countryside of New England. Born in Lowell, Massachusetts, Metcalf began his career as a wood engraver and figure painter in Boston. In 1883, after studying at the School of the Museum of Fine Arts, Metcalf used the income from illustrations published in *Century Magazine* to travel to Europe. In Paris, he continued his training at the Académie Julian under Gustave Boulanger and Jules-Joseph Lefebvre. He spent his summers abroad in artists' colonies in the French countryside, where he painted images of peasants and soft tonal landscapes that reflected the influence of the French pleinairist Jules Bastien-Lepage. Metcalf might have visited Giverny, the home of Claude Monet, as early as 1885, and he was part of the group of American artists that spent the summer there in 1887. He returned to the Boston area in 1888 and settled in New York in 1891. In 1897 he became a member of the Ten American Painters, the group of Impressionist artists from New York and Boston who exhibited together for twenty years. In the early twentieth century, Metcalf formed his mature style, merging a realist and an Impressionist approach. He worked frequently at popular artists' colonies in Old Lyme, Connecticut, and Cornish, New Hampshire, as well as at more remote locales, such as Chester and Springfield, Vermont, and Casco Bay and the Damariscotta peninsula in Maine.

Louis Charles Moeller (1855–1930)

A leading figure painter in the late nineteenth century, Louis Moeller specialized in interior genre scenes populated by elderly gentlemen such as lawyers, businessmen, booksellers, and other venerable types. Painted in a meticulous realist style, his work attracted the patronage of such eminent collectors as Thomas B. Clarke, among others. Born in New York City, Moeller learned the rudiments of his craft from his father, Charles, a painter of decorative interiors. He went on to attend the Cooper Union Art School and the National Academy of Design. In the fall of 1873 he traveled to Munich, where he studied under Wilhelm von Diez and Ludwig Loefftz at the Royal Academy and joined the circle of young American art students who worked informally under the painter Frank Duveneck. Returning to the United States, Moeller turned his attention to intimate, cabinet-size paintings depicting older men playing cards, reading, or conversing in clubs, libraries, and meeting rooms; his subject matter and meticulous style prompted many critics to compare him to the celebrated French genre painter,

Jean-Louis Meisonner. After 1890, he produced more complex, multi-figured compositions, often placing his subjects in richly decorated Victorian interiors.

Thomas Moran (1837–1926)

Thomas Moran is remembered today for his sweeping, dramatic landscapes of the American West and his luminous, Turneresque views of Venice. A versatile artist of lithographs, etchings, watercolors, and oils, Moran was largely responsible, along with Albert Bierstadt, for introducing eastern audiences to the spectacular scenery of the western frontier. He was born in England but accompanied his family to Philadelphia in 1844, where he was later apprenticed to a wood engraver. Moran was largely self-taught but received guidance from the marine painter, James Hamilton, who introduced him to engravings by J. M. W. Turner. Returning to England in 1861, he studied Turner's paintings firsthand at the National Gallery, an experience that proved seminal in his career. In 1871 he accompanied Ferdinand Hayden's expedition to the Yellowstone region, the first of several geological surveys that he would join during the next decade. Working in his studio from his drawings, Moran painted the large-scale landscape scenes that established his reputation. One of the resulting paintings, *The Grand Canyon of the Yellowstone* was purchased by the United States Congress in 1872 and now belongs to the United States Department of the Interior. Other important western scenes by Thomas Moran today belong to the Smithsonian American Art Museum in Washington, D.C. Although his luminous colors and brilliant effects of light emulated Turner's style, a characteristic linear quality and regard for form kept Moran's work firmly rooted in a realistic painting mode.

John Francis Murphy (1853–1921)

Called "the American Corot," John Francis Murphy was a painter of Tonalist landscapes who was renowned especially for his small, intimate views of nature. He was born in Oswego, New York, and moved at the age of fifteen with his family to Chicago. Largely self-taught, he began his career as a stage and scene painter. After settling in New York in 1875, he worked as an illustrator and made sketching forays to the Adirondacks and to the area around Orange, New Jersey. His first works—crisp, descriptive images in the style of the Hudson River School—were based on a direct observation of nature. Later his style became more poetic. Reflecting the influence of Alexander Wyant and George Inness, he recorded his own emotional responses to landscape through an expressive use of tone and surface texture.

Robert Emmett Owen (1878–1957)

The Impressionist Robert Emmett Owen captured the varied moods of rural New England with a vernacular truthfulness that has been likened to the poetry of Robert Frost. Painting old houses and churches, country roads curving through hills and farmland, covered bridges, peaceful waterways, and wooded glades, he created images that epitomized the widespread appreciation in the early twentieth century of New England as the wellspring of American culture and of the nation's identity. Owen was born in North Adams, Massachusetts. He studied there at the Drury Academy, in Boston at the Eric Pape School. On settling in New York in 1901, Owen became a leading illustrator for prominent magazines, including *Harper's New Monthly* and *Scribner's* and began to create works that reflected the influence of the American Impressionists Willard Leroy Metcalf, J. Alden Weir, and Childe Hassam. From 1910 until 1920 he lived in Bangall, Connecticut, now part of Stamford, and painted in the open air. After moving back to New York, Owen opened a gallery on Madison Avenue, where he exhibited and sold his own work exclusively. The gallery remained open until 1941, when Owen moved to New Rochelle, New York, and became the artist in residence at the Thomas Paine Memorial Museum. Until the end of his life he continued to paint and to sell his works directly to a large and devoted group of collectors.

James Peale (1749–1831)

The youngest brother of Charles Willson Peale, James Peale was a noted miniaturist and still-life painter. He was born in Chestertown, Maryland, and grew up in Annapolis, where he began his first career as a cabinetmaker. He used his carpentry skills to design frames for his brother's paintings. Eventually he followed his brother's example and became a painter. During the Revolutionary War, James rose quickly in military ranks, becoming a captain during his three years of service. After the Battle of Monmouth, he resigned from the army, but returned to the service in order to participate in the siege of Yorktown. His war-time experience led to two full-length portraits of George Washington. Peale created a number of historical scenes based on his military experiences including *The Battle of Princeton* (1781; Princeton University Art Museum, New Jersey). After the war, Peale settled in Philadelphia, and devoted his time to portraiture, creating watercolor miniatures on ivory and helping his brother with the family museum. He began his own professional painting career in 1782 and married the daughter of the genre artist James Claypoole. In 1786 James and his brother Charles decided to adopt different specialties. Charles strengthened his career as a portraitist while James focused on miniatures. In the early 1800s, Peale began painting still lifes. His interest in this subject matter gathered force around the time his nephew, Raphaelle Peale, who was the most prominent still-life painter of his day, became ill. After Raphaelle's death in 1825, James's prominence as a still-life painter was solidified, largely because he took over the role that Raphaelle had previously held. The styles of Raphaelle and James were similar, although James used a more painterly technique and was more attentive to local tones. Whereas

Raphaelle preferred perfectly formed fruits and vegetables, James favored objects that showed signs of age, reflecting a concern with the passage of time. James Peale first showed his work at the Peale Museum in Baltimore in 1823. Later in his career, he was a frequent participant in exhibitions at the Pennsylvania Academy of the Fine Arts. Both his miniatures and his still lifes were avidly sought after by the art buyers of his day.

Alexander Pope (1849–1924)

Alexander Pope was a painter of animals as well as of trompe l'oeil still lifes, including many game and hunting subjects. He also painted portraits and military images. His works were generally dark in tone and featured precise handling. He lived in Boston, where his works were popular with local society. Along with the Philadelphia painter William Harnett, Pope helped to elevate the genre of still-life painting, bringing it from a minor art form to one of significant popularity. Pope was born in Dorchester, Massachusetts, near Boston. He worked during his youth for his father's lumber business, where he learned to carve animals from wood. He honed his skills in sculptural rendering during classes with William Rimmer in Boston. He supplemented his training by visiting stables, aviaries, kennels, and zoos. In the mid-1880s, Pope turned to painting. He became known especially for his renderings of dogs and the theme of "after the hunt." His large trompe l'oeil still lifes often included military paraphernalia. After 1912 he focused on portraiture. Pope was a member of the Copley Society and the Boston Art Club and exhibited at the Art Institute of Chicago and the Pennsylvania Academy of the Fine Arts.

Edward Potthast (1857–1927)

One of a number of important American Impressionists to emerge from the burgeoning art milieu of Cincinnati at the turn of the last century, Edward Potthast began his career as a lithographer for the Strobridge Lithography Company while studying art at the McMicken School of Design. Beginning in 1881, he spent three years in Europe, continuing his training at Munich's Royal Academy and adopting the fluent handling and subdued hues associated with Munich realism. On a second trip abroad in 1887, he went to France, where he brightened his palette in response to Impressionism. He settled in New York in 1895, initially working as a freelance illustrator before pursuing painting full-time. About 1910, Potthast began creating sparkling oils and watercolors of children frolicking in the surf at Coney Island, Far Rockaway, Ogunquit, Maine, and other local beaches. His oeuvre also includes land- and seascapes painted during summer trips to New England, and views of Central Park.

Levi Wells Prentice (1851–1935)

Levi Wells Prentice played a significant role in the tradition of American still-life painting in the late nineteenth century. One of the finest of a group of Brooklyn-based artists who specialized in renderings of fruit, Prentice is acclaimed for his superior draftsmanship, his skills as a colorist, and his precise technique, which made him a master of the hard-edge still life that was so popular at the turn of the last century. Born on a farm in Harrisburgh, New York, Prentice opened a studio in Syracuse, New York by 1872, painting views of the Adirondack Mountains, as well as portraits and ceiling decorations for private homes. He lived in Buffalo in 1879, 1880, and 1884 and then settled in Brooklyn, home to trompe l'oeil still-life painters such as Joseph Decker and William Mason Brown, who likely inspired his adoption of the venerable still-life theme. Prentice favored simple designs, portraying fruit either spilling out of a basket or container onto grass, or growing *in situ* on the tree. He lived in Brooklyn until 1903, when he moved to Manhattan, and then to Connecticut, and New Jersey, before settling in Philadelphia about 1907.

Hovsep Pushman (1877–1966)

A notable figure in the American still-life tradition, Hovsep Pushman achieved critical and popular acclaim for his poetic still lifes featuring antique objects of Asian origin. He was born in Armenia and received his training at the Constantinople Academy of Art, the Art Institute of Chicago, and the Académie Julian in Paris. While living in Chicago and Paris in the early twentieth century, Pushman painted brilliantly colored portraits of romantic subjects such as Nubian princesses, Kurdistanian hillsmen, and Spanish gypsies. From 1917 to 1919 he lived in Riverside, California, but by the mid-1920s he had settled in New York. There he continued to create portraits and figural studies, but his interest gradually shifted to still lifes, particularly those of the antique objects from the Near and Far East that he had begun to collect: rare old tapestries and textiles; Syrian glass bowls; lacquered chests; small medieval carved figures of saints; Chinese Tang and Ming figurines; statues of Buddha and Genghis Khan; Kano-style screens; and bronze statuettes. Pushman's impeccable technique captured the iridescent qualities of their glazes and well-worn surfaces of his antique subjects. His ability to summon the mystery and spiritual force of the objects has led to comparisons to the eighteenth-century French still-life painter Jean-Baptiste-Siméon Chardin.

William Tylee Ranney (1813–1857)

William Tylee Ranney rendered portraits and history paintings, but he is best known for genre scenes depicting western and hunting subjects that convey the experience of the advancing frontier and the drama of American life in the West in the second quarter of the nineteenth century. Ranney is

also significant as a foremost painter of the "historical genre" scene, a mode between history and genre painting in which the experience of an earlier era is brought to life in an image of ordinary daily life, thereby making an understanding of the past both accessible and relevant. Ranney was born in Middletown, Connecticut. In 1833 or 1834, after working as an apprentice tinsmith, Ranney settled in Brooklyn, where he began to study art. This new interest was postponed in 1836 when, six days after the fall of the Alamo, he enlisted in the Army of the Republic of Texas. In the following year, he returned to Brooklyn and continued his art studies and began to exhibit his work. From 1839 to 1842, his whereabouts are unknown, but from 1843 to 1845, he is listed in New York City directories as a portrait painter. By 1848, he had married and was residing in Weehawken, New Jersey. After moving shortly thereafter to West Hoboken, New Jersey, he became part of a colony of artists who had gathered in the area, including William Mason Brown, Charles Loring Elliott, and Robert W. Weir. It was in Hoboken that Ranney produced many of his most important paintings of Revolutionary War subjects, portrayed the exploits of Daniel Boone, and created genre scenes depicting the daily lives of trappers and hunters. His art was regularly included in exhibitions at the National Academy of Design and the American Art-Union; he became known widely because of his affiliation with the Art-Union, which engraved three of his paintings.

Joseph Raphael (1869–1950)

Joseph Raphael was a painter of sunlit floral landscapes and a noted graphic artist. He was born in San Francisco, California, and studied at the Mark Hopkins Institute of the San Francisco Art Association from 1869 until 1873. He traveled to Paris in 1903 and there attended classes at the Ecole des Beaux-Arts and the Académie Julian. That same year Raphael discovered the artists' colony in Laren, Holland, southeast of Amsterdam. Until 1911 he divided his time between Laren and Paris, and painted tonal genre scenes similar to those of the Hague School. In 1912 he moved to Uccle, a suburb of Brussels, where he adopted a vibrant palette and a broad divisionist brushwork, producing luminous renditions of his own bountiful flower and vegetable garden. He also began to explore etching and sent works home to exhibitions of the California Association of Etchers. In 1934 Raphael moved to Oegstgeest, a suburb of Leiden, where he again planted a vegetable and flower garden that became his favorite subject. While visiting San Francisco in 1939, war broke out in Europe, and Raphael was unable to return. He spent the remainder of his career in his hometown, painting sunlit scenes of the Northern California landscape.

Theodore Robinson (1852–1896)

Theodore Robinson was a leading American Impressionist and an influential member of the Anglo-American art community in Giverny, France. His mature style successfully reconciled modern tenets of light and color with academic pre-cepts of form and structure. Raised in Wisconsin, Robinson studied at the Chicago School of Design (1869–70), the National Academy of Design (1874–76), and in Paris at the Ecole des Beaux-Arts and under Charles-Emile-Auguste Durand (Carolus-Duran). He lived in New York and Evansville, Wisconsin, before returning to France, where he visited Barbizon, Grèz-sur-Loing, and Giverny (1885). In 1887 he helped found the Giverny art colony, becoming friendly with Claude Monet and adopting an Impressionist aesthetic. He settled permanently in New York in 1892 and thereafter painted in upstate New York, New Jersey, Connecticut, and Vermont.

Severin Roesen (ca. 1815–ca. 1872)

A major exponent of the bountiful tradition in American still-life painting, Severin Roesen painted fruit and floral subjects in the meticulous realist style that prevailed in American art circles during the mid-nineteenth century. Thought to have been born in Cologne, Germany, Roesen began his career by painting flowers on decorative porcelains and enamelware. About 1848, he immigrated to America and settled in New York, where he established himself as a painter of elaborate still lifes. His style—characterized by rich color, painstaking detail, high finish, and an emphasis on botanical accuracy—was inspired by the seventeenth-century Dutch still-life tradition and by his earlier work as a decorative artist. His arrangements were typically lavish and opulent, conveying the sense of abundance and optimism that prevailed in pre-Civil War America. In 1858 the artist moved to Pennsylvania, residing in Philadelphia, Harrisburg, and Huntingdon before settling in Williamsport, a thriving lumber town, about 1860. There he painted and taught still-life painting to Henry W. Miller, Lyle Bartol, and others. His lush and highly elegant compositions inspired the work of many of his contemporaries, among them John Francis.

Albert Pinkham Ryder (1847–1917)

A romantic visionary painter, Albert Pinkham Ryder is now considered one of the most important American artists of the nineteenth and early twentieth centuries. His haunting moonlit seascapes and evocations of passages from the Bible, great poetry, and even Wagnerian operas—all were steeped in his deep reverence for nature. To Ryder, painting was not simply a representation of what was seen, but rather a manifestation of an inner vision. It was a creative language that spoke to the senses through color, form, and tone, and Ryder's simplified rhythmic forms foreshadowed many aspects of twentieth-century modernism. Ryder was born in New Bedford, Massachusetts, and was coached by a local amateur painter during his youth. About 1867, he moved with his family to New York. He studied with the portrait painter William Edgar Marshall, whose naive approach to religious and romantic subjects influenced him deeply. In 1871 Ryder enrolled at the National Academy of Design, which had rejected him four years earlier. Ryder trav-

eled to Europe in 1877 and 1882, but was not impressed by the contemporary or old master paintings he saw. In the 1880s Ryder began to create works based on biblical and poetic episodes, manifesting his deeply religious inner vision. In his last years, Ryder became more and more reclusive and eccentric. After a serious illness in 1915, friends took him into their Long Island home and cared for him until his death two years later.

Chauncey F. Ryder (1868–1949)

An important figure in the American Tonalist movement, Chauncey F. Ryder was acclaimed for poetic and lyrical images of New England landscapes, painted in a style characterized by softly blended tones, layered pigments, and broad brushwork. He was born in Danbury, Connecticut, and studied in Chicago at the Art Institute and at Smith's Art Academy. In 1901 Ryder traveled to Paris, remaining there for six years while he attended the Académie Julian and exhibited annually at the Salon. Although he maintained a studio in Paris until 1910, Ryder returned to the United States in 1907 and settled in New York. He made summer visits to the artists' colony of Old Lyme, Connecticut, until 1910, when he established a home and studio in Wilton, New Hampshire. Ryder spent summers in Wilton for the rest of his life, using the town as a base to travel to sites in Massachusetts, Maine, and elsewhere in New Hampshire in search of painting subjects. Although best known for his oils, Ryder was also a proficient draftsman, printmaker, and watercolorist. He received numerous awards and prizes and was named full academician of the National Academy of Design in 1920.

William Starkweather (1879–1969)

Born in Edinburgh, Scotland, William Starkweather and his family immigrated to the United States in 1883, settling in New Haven, Connecticut. He attended the Art Students League in New York and the Académie Colarossi in Paris before going to Seville, Spain, in 1903, where he spent three years studying under the Spanish Impressionist Joaquín Sorolla y Bastida, whose work he deeply admired. He returned to New York about 1906, painting landscapes and urban scenes in which he conjoined Sorolla's bright colorism and fluid technique with his own powerful draftsmanship. An inveterate traveler, Starkweather painted in the northeast United States and eastern Canada—especially Eastport, Maine, and Grand Manan Island, New Brunswick—as well as in Europe and the Caribbean. He exhibited his oils and watercolors at the various national annuals with great success. He taught at several institutions, including the Cooper Union School, Pratt Institute, and the Traphagen School before joining the faculty at Hunter College as an instructor of watercolor painting in 1936. Having served as an assistant curator at the Hispanic Society in New York from 1910 to 1916, Starkweather wrote frequently about Spanish art. He also authored essays and articles on painters including John Singer Sargent, Winslow Homer, and Anthony van Dyck.

Annie Gooding Sykes (1855–1931)

Lauded for her colorful, Impressionist-inspired watercolors, Annie G. Sykes was one of several prominent women associated with the artistic milieu of turn-of-the-century Cincinnati. She was born Annie Sullings Gooding in Brookline, Massachusetts, and studied at the Lowell Institute in Boston and at the School of the Museum of Fine Arts during the late 1870s. After her marriage to Gerritt Sykes in 1882, she moved to Cincinnati, continuing her training at the Cincinnati Art Academy from 1884 to 1894. Despite the birth of two children, she continued to balance the demands of home life with her professional aspirations, exhibiting her watercolors locally and in Boston, Chicago, New York, and Philadelphia. On the occasion of her first one-artist show, held at the Traxel & Maas Gallery in Cincinnati in 1895, critics praised her fresh, vibrant colors and spontaneous technique. A reviewer for the *Cincinnati Enquirer* identified her as representing "the new school of impressionism." Sykes maintained a high standing among her peers and was often invited to serve on juries with such eminent painters as Frank Duveneck, Maurice Prendergast, and Edward Redfield. She painted in and around Cincinnati, Nonquitt, Massachusetts (where her family had a summer home), Bermuda, Quebec, Virginia, and Europe. Her oeuvre includes landscapes and street scenes, but she was most fond of depicting floral environments.

Dwight William Tryon (1849–1925)

Dwight William Tryon was an important American Tonalist painter, best known for misty, serene landscapes and seascapes, which were layered with thin glazes to produce sparkling, opalescent surfaces. He was born in Hartford, Connecticut, and spent his youth sketching the rivers and countryside near his home. Essentially self-taught, he opened a studio in Hartford when he was twenty-four. During a five-year sojourn in Paris from 1876 until 1881, he studied with Jacquesson de la Chevreuse, a former pupil of Jean-Auguste Ingres and received instruction from Charles Daubigny, Henri-Joseph Harpignies, and Gustave Guillemet, who had studied with Camille Corot. He spent time on the Island of Guernsey, Granville as well as in Normandy, Brittany, Holland, and Venice. On his return to the United States, he settled in New York, establishing a studio near those of Thomas Dewing, Will Low, and Robert Swain Gifford. Gifford introduced him to the coastal town of South Dartmouth, Massachusetts, and in 1883, he acquired a summer home in the area and began to record the seasonal changes of the land and sea. Two years later, Tryon joined the faculty of Smith College in Northampton, Massachusetts, where he became a professor of art and the head of the Art Department until his retirement in 1923. Tryon was elected a full member of the National Academy of Design in 1891 and won many prizes in the course of his career. He was a member of the American Water Color Society and the Society of American Artists. Throughout much of his professional life, he was supported by Charles Lang Freer, who commissioned him for a series on the seasons that was installed in Freer's Detroit home.

John Henry Twachtman (1853–1902)

Revered as a "painter's painter," Cincinnati-born John Henry Twachtman was at the forefront of American avant-garde art movements of his time. Much of his early career was spent abroad. He studied in Munich from 1875 to 1878. In 1880, after a period of painting in New York, he went to Florence to teach at the school his friend Frank Duveneck had established there. He lived in France from 1883 through 1885, studying in Paris at the Académie Julian and painting in Normandy and Holland in the summers. After settling in Greenwich, Connecticut, in about 1889, he developed a distinctive Impressionist style, which was communicated to him in part by his friend Theodore Robinson, who had spent many summers close to Claude Monet, and in part by his exposure to French art in New York galleries. Yet Twachtman's Impressionist style may also be seen as evolving naturally from the artistic explorations of his earlier career, and his mature aesthetic was tempered by his personal response to nature and by his versatile and individual technique. In Greenwich, Twachtman focused on painting the familiar motifs found on his own property, modifying his handling to the particular qualities that a subject evoked. In 1897 he helped found the group of American Impressionists known as the Ten American Painters. From 1900 until his death in 1902 Twachtman spent summers in Gloucester, Massachusetts, where he worked *alla prima*, returning to the bold, painterly style of his Munich years but retaining the vivacity of his Greenwich art.

Robert Edward Weaver (1914–1991)

A Hoosier artist who captured the "drama, pathos [and] comedy of the Big Top," Robert Weaver devoted much of his career to depicting circus themes, ranging from clowns, musicians, acrobats, and bareback riders to horse-drawn caravans, floats, and teams of elephants. Admired for their strong draftsmanship and rich colorism, his paintings capture the splendor and excitement of the great American circus and function as important visual records of an institution that has all but vanished. A native of Peru, Indiana, the winter home of many of the country's best-known circuses, Weaver fraternized with circus types as a boy. After high school, he attended the John Herron Art School in Indianapolis (1932–37); he subsequently spent three years studying in New York, Paris, and England. Returning to America, he settled in New York and made his mark as a painter of circus themes. He was also active as a muralist, illustrator, and designer. Weaver served in the U.S. Navy during the second world war and in 1946 joined the faculty of the John Herron Art Institute, teaching painting, drawing, and other courses for thirty-six years. He continued to portray the circus, participating in the various national annuals and in regional exhibits such as those of the Hoosier Salon and the Indiana Artist's Club.

John Whorf (1903–1959)

One of the most accomplished and esteemed watercolorists of the first half of the twentieth century, John Whorf created realist depictions of urban and rural imagery, working in a luminous painterly style often compared with that of John Singer Sargent and Winslow Homer. He was born in Winthrop, Massachusetts, and received his initial exposure to art from his father, Harry C. Whorf, a commercial artist and graphic designer. He went on to study in Boston at the St. Botolph Club and at the School of the Museum of Fine Arts, where his teachers were Philip Leslie Hale and William James. Whorf spent the summer of 1917 or 1918 in Provincetown, Massachusetts, attending classes with Charles W. Hawthorne and associating with such leading contemporary painters as Max Bohn and E. Ambrose Webster. About 1919 Whorf visited France, Spain, Portugal, and Morocco. In Paris, he enrolled briefly at the Ecole des Beaux-Arts, the Grande Chaumière, and the Académie Colarossi. During his time abroad, Whorf turned increasingly away from oil painting and began to focus on watercolor, which he found suited his transient lifestyle and his expressive and aesthetic interests. After his return to Boston in the early 1920s, Whorf was commended in the press as Boston's leading watercolorist. After 1937 he lived in Provincetown, although he continued to travel in the United States and abroad in search of painting subjects. Throughout the rest of his career, Whorf's realistic, fluidly painted works were highly popular and sought-after.

Guy Carleton Wiggins (1883–1962)

Among the finest Impressionists of his generation, Guy Carleton Wiggins produced many views of New England, especially in the vicinity of Old Lyme, Connecticut, where he was a respected member of the local artists' colony. However, according to the artist, his favorite subject was "New York … and New York when snow is falling." Indeed, Wiggins took great delight in exploring the pictorial possibilities of Manhattan, especially during winter, when falling snow envelops buildings and streets in a veil of soft atmosphere. His cityscapes—romantic and suggestive—were highly popular with collectors, who viewed them as pictorial mementos of New York. Born in Brooklyn, Wiggins was the son of Carleton Wiggins, a prominent painter associated with the American Barbizon tradition. He received his training at the National Academy of Design in New York, where his teachers included William Merritt Chase and Robert Henri. Wiggins divided his time between New York, where he could paint urban scenes from the windows of tall office buildings, and his farm in Hamburg Cove, Connecticut. In 1937 he moved to Essex, Connecticut, and founded the Guy Wiggins Art School and the Essex Painters Society. He also made painting trips throughout the United States, going as far west as Montana.

Index to Illustrations

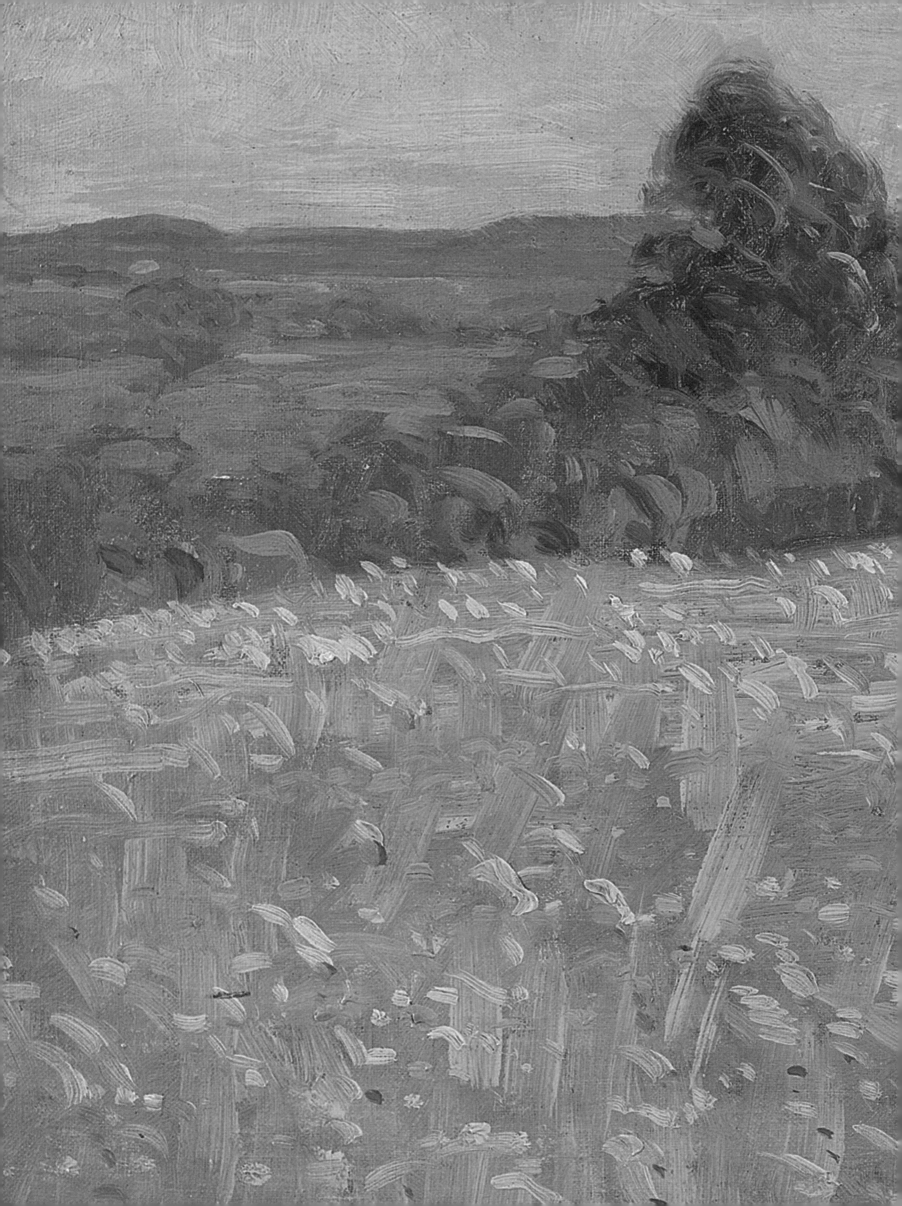